Miami Beach Memories

A Nostalgic Chronicle of Days Gone By

Joann Biondi

INSIDERS' GUIDE®

GUILFORD, CONNECTICUT
AN IMPRINT OF THE GLOBE PEQUOT PRESS

To buy books in quantity for corporate use or incentives, call **(800) 962–0973, ext. 4551,** or e-mail **premiums@GlobePequot.com.**

INSIDERS' GUIDE ®

Design by Casey Shain
Spot art images courtesy Photos.com

Library of Congress Cataloging-in-Publication Data
Biondi, Joann.
 Miami Beach memories : a nostalgic chronicle of days gone by / Joann Biondi. — 1st ed.
 p. cm.
 Includes bibliographical references and index.
 ISBN-13: 978-0-7627-4066-6 (alk. paper)
 ISBN-10: 0-7627-4066-3 (alk. paper)
 1. Miami Beach (Fla.)—History—20th century. 2. Miami Beach (Fla.)—Social life and customs—20th century. 3. Miami Beach (Fla.)—Biography. 4. Interviews—Florida—Miami Beach. 5. Oral history. 6. Miami Beach (Fla.)—History—20th century—Pictorial works. I. Title.
 F319.M62B56 2006
 975.9'381—dc22

 2006013020

Manufactured in China
First Edition/First Printing

For Giovanni Giuseppe Biondi, who first took me to Miami Beach

Contents

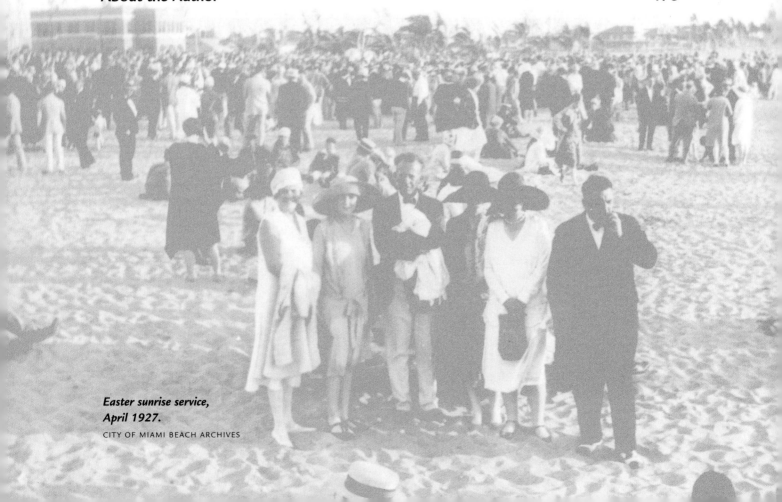

Easter sunrise service,
April 1927.
CITY OF MIAMI BEACH ARCHIVES

Acknowledgments

I owe a great deal of thanks to all of the people who allowed me into their lives and graciously shared their stories and personal photos for this book.

A big hug of gratitude goes out to Herbert Hiller and Rose Rice for playing matchmaker and setting this book in motion. Also, I'd like to thank many others who helped set up interviews, provided information, or lent a hand in one way or another. Among them: Lisa Cole from the Fontainebleau Hotel, Timothy Barber from the Black Archives of Miami, Liliam R. Hatfield from the City of Miami Beach photo archives, Randall Robinson from the Miami Beach Community Development Corporation, Marcia Zerevitz and Ana Rodriguez from the Jewish Museum of Florida, Cheryl Stephenson from the Bal Harbour Shops, Kristin Wherry of PPR Communications, Penny Thurer from Miami Book Fair International, Mitchell Kaplan of Books and Books, Kevin Yelvington from the University of South Florida, Roy Peter Clark from the Poynter Institute, Jose Lima, Bayla Lifter, Ina Oost, Marilyn Treadwell, Anita Grossman, Bob Presner, Mike Segal, Mark "Ari" Goldenberg, Cindy Seip, Joseph Charlemagne, and Samuel Katz.

At The Globe Pequot Press, Mary Norris was a wise woman who knew exactly why this book should be published, Sarah Mazer was an eagle-eyed editor who saved me from much embarrassment, and Casey Shain was a wizard of graphic design.

And lastly, but most importantly, a very special thank you to Bennett M. Lifter.

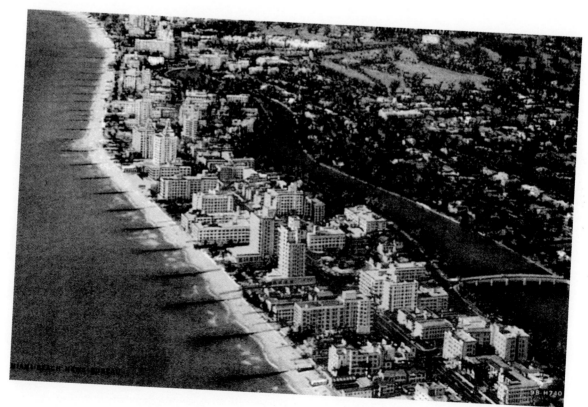

COURTESY OF AUTHOR

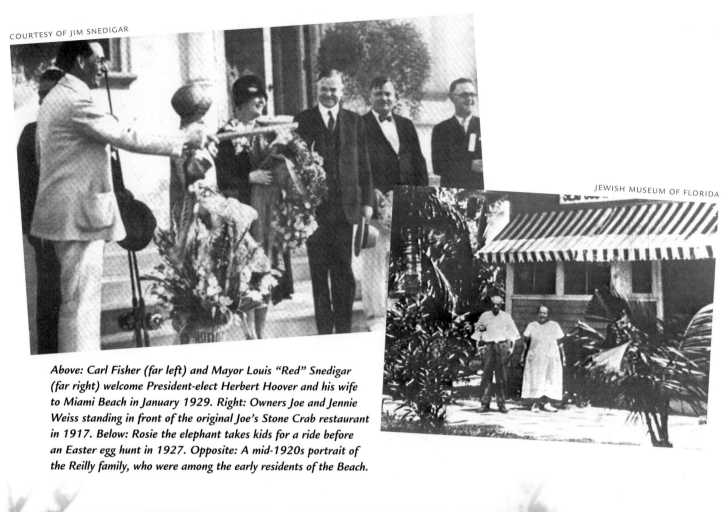

Above: Carl Fisher (far left) and Mayor Louis "Red" Snedigar (far right) welcome President-elect Herbert Hoover and his wife to Miami Beach in January 1929. Right: Owners Joe and Jennie Weiss standing in front of the original Joe's Stone Crab restaurant in 1917. Below: Rosie the elephant takes kids for a ride before an Easter egg hunt in 1927. Opposite: A mid-1920s portrait of the Reilly family, who were among the early residents of the Beach.

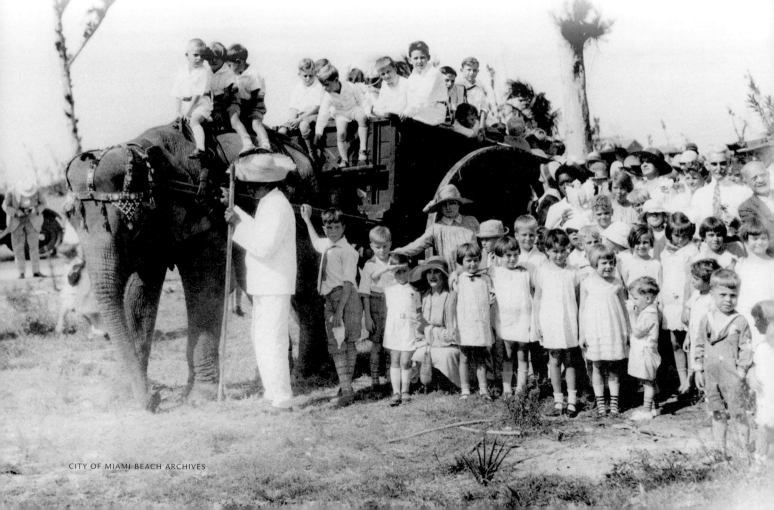

A Chorus of Varied Voices

Miami Beach has lots of memories to share.

Memories of the 1920s, when Johnny Weissmuller flaunted his freestyle skills at local pools; memories of the 1930s, when Desi Arnaz strummed his first guitar; memories of World War II, when Clark Gable romanced more than one local girl; memories of the Fabulous Fifties, when the Rat Pack owned the joint; and memories of the 1960s, when Muhammad Ali snagged the heavyweight championship of the world.

A tiny spit of sand barely fifteen miles long and a mile wide, the island of Miami Beach is known throughout the world as a tropical haven and vacation mecca. A man-made paradise and neon-lit Garden of Eden dedicated to the pursuit of pleasure. Physically separate and distinctly different from its mainland big sister, Miami, it was intentionally created as a tourist town—a city as theme park, if you will. That's what pioneers had in mind back in the early 1900s, when the Beach was a rat-infested barrier island dotted with avocado groves and just a handful of hardy residents. John Collins and Carl Fisher, two can-do visionaries, were determined to hack through the mangroves, dredge out the muck, and re-engineer the landscape in order to fabricate a self-contained playground for the rich. Fisher went a little further, bringing in circus elephants to both work the land and add a little P. T. Barnum spin to the place.

COURTESY OF ROBERT REILLY

Miami Beach is a place, but it is also a state of mind. A state of mind that pays homage to all things shiny and new. A state of mind that encourages the shedding of old skin and the trying on of new personas. A state of mind that always, *always*, shunned the Puritan ethic. Its marketing image was, is, and likely always will be that of a white convertible cruising down Collins with two sun-tanned lovers enjoying the view.

Since it was incorporated as a city in 1917, countless millions of people have come to its shores. They have come to play, work, drink, gamble, and run away from their humdrum lives elsewhere. They also have come to get rich quick and grab a piece of this quintessential American pie. But along with being a holiday getaway and a land of newfound possibilities, Miami Beach is also a small town—one where many innocent children have grown up amid a cozy, old-fashioned sense of security.

Critics have often said that Miami Beach is not a serious place, and in many ways this is true. You can't get buried in Miami Beach; it has no cemeteries. It is a place that has always based its identity on hawking hedonism and feel-good diversions. And yet, serious things have gone on here. Dark, shameful, and *very* serious things. Things such as blatant racism and religious prejudice that have been intentionally forgotten from the collective psyche. In that sense, Miami Beach is a sandbox full of paradoxes.

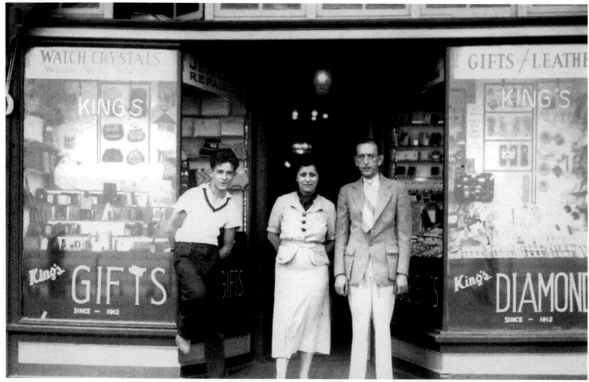

Martin, Anne, and Abe King in front of King's Jewelry Store on Washington Avenue in the 1930s.

While cheesy publicity stunts featuring Paris Hilton tend to symbolize what people think of Miami Beach today, the truth is that Miami Beach has had a long history of notable names coming its way. The list of those who have been entranced by its charms is long—Dorothy Parker, Amelia Earhart, Buster Keaton, Rudee Valley, Heddy Lamar, Anna May Wong, Xavier Cugat, Calvin Coolidge, Guy Lombardo, Dorothy Lamour, Grace Kelly, Ronald Reagan, Ella Fitzgerald, Gloria Swanson, Joseph Kennedy, Heywood Broun, Franklin D. Roosevelt, Charles Lindbergh, Veronica Lake, Harpo Marx, Josephine Baker, Gina Lollobrigida, Milton Berle, the Duke and Duchess of Windsor, Damon Runyon, Al Jolson, Carmen Miranda, Louis Armstrong, J. Edgar Hoover, Jackie Robinson, Jack Dempsey, Marilyn Monroe, Rita Hayworth, Howard Hughes, and Elizabeth Taylor—to name just a few.

In 1948, a brawny young law student named Fidel Castro honeymooned in Miami Beach with his new wife, Mirta, and apparently had so much fun that he had to hock his watch to pay his bills. That same year, a scrawny young Polish writer named Isaac Bashevis Singer paid his first visit to the island. Eating heaping bowls of borscht at kosher delicatessens and hearing the din of heavy Yiddish accents all around him, Singer said he instantly fell in love with Miami Beach. Hard to imagine these two men on this one island at the same time, but it happened.

Although there are no reminiscences from Castro or Singer in this book, there are memories from many other colorful characters instead. Memories of good times and hard times, childhoods and love affairs, boxing matches and bar mitzvahs. Memories of a place and how it has grown and evolved. Most importantly, there are memories of people from all walks of life, the famous and the not-so-famous.

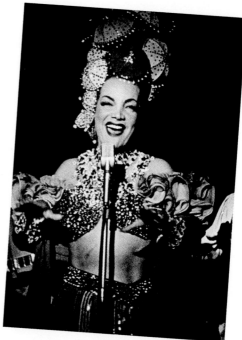

Left: Jack Dempsey holding ice cream cones in front of the Dempsey Vanderbilt hotel in 1941. Above: Carmen Miranda at the Copa City nightclub in 1950. Below: Edward G. Robinson at the Fontainebleau Hotel in 1958, while filming A Hole in the Head.

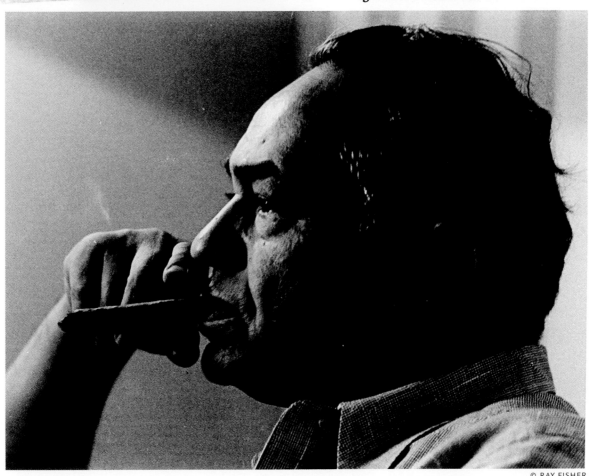

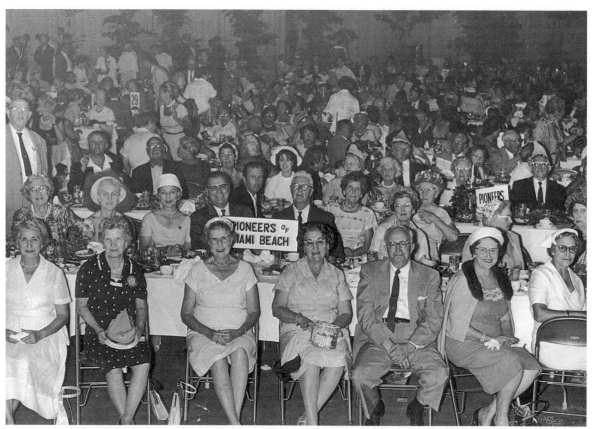

Members of the Pioneers of Miami Beach social club in 1944.

Those who lived the good life of movie premieres and long white gloves, and those who toiled to make that good life possible. Although some of the memories date back eighty years, they are still fresh and vibrant to the people who recount them.

Included in this book are interviews with 101 people—comedians, lawyers, doctors, strippers, developers, bellboys, photographers, waiters, waitresses, politicians, teachers, artists, writers, hoteliers, gardeners, singers, and maids. There's even a Native American chief and a former U.S. attorney general in the bunch.

Over the course of a year, I went about interviewing these people whose memories tell the story of Miami Beach. Whenever possible, I conducted the interviews in person—at nursing homes, condominiums, waterfront estates, business offices, hotel lobbies, and noisy restaurants. Other interviews were conducted by telephone. Although I could have easily found 1,000 people who had great Miami Beach tales to tell, 101 was what time and circumstances allowed. All of the storytellers in this book were unique, with their own point of view and their own way of expressing that point of view.

For months their voices stayed with me, rattled around in my mind, and woke me up in the middle of the night. Voices with distinct accents that ranged from Southern Cracker and German Jew to New York Tough, Midwestern Flat, and Bahamian Lilt. Before I finished the book, four of the interviewees had died; several more may be gone before too long. Although every one of them offered

authentic tidbits as they glanced backward, there were a few that really left a mark on my heart, shattered my preconceived notions, or just tickled my mind.

Honey Bruce Friedman, the former wife of comedian Lenny Bruce, was among them. Honey was living in Honolulu when I interviewed her by telephone. A seventy-eight-year-old former stripper and drug addict who once served time in prison, she had been around the block a few times and was not ashamed to admit it. A few weeks after our interview, she called me, just wanting to talk. Soon after, a pattern formed: She would call me or I would call her, and we would gab like old girlfriends, two redheads who just liked to laugh. She talked about her Alcoholics Anonymous buddies, her happy life in Hawaii, and her beloved new husband (a man twenty years her junior). Then Honey got sick, going in and out of the hospital with colitis and pneumonia. When I saw her obituary in the *New York Times,* I cried. She had become dear to me, a vivacious old bird who was full of joy, generosity, and childlike wonder.

Another unforgettable character was Murf the Surf. A convicted murderer and jewel thief extraordinaire, Jack Murphy was a legendary and controversial figure in Miami Beach. It was not easy to track him down, and I was wary of talking to him. But once our conversation began, I found him funny, engaging, and delightfully articulate. Murf talked about his early days as a pool boy in Miami Beach and how when the weather was bad he taught at the Jewish girls' charm schools. Charm schools? What's wrong with this picture? Truth is, there was nothing wrong with that picture. Murf was a charmer himself. A man who had fallen from grace, did twenty years in prison, and then managed to turn his life around and make amends for his sins. It was a surprise ending that had this cynical journalist scratching her head.

And then there was boxing trainer Angelo Dundee. I asked Dundee if he remembered what he thought when he first learned that Cassius Clay had converted to Islam and changed his name to Muhammad Ali. "Of course," Dundee said. Then, in his thick New Jersey accent, he blurted out: "Who the hell knew what a Muslim was back then? Muslim? I thought it was a piece of cloth."

My, how things have changed.

Ranging in scope from the 1920s through the 1960s, *Miami Beach Memories* is a social narrative that gives voice to that particular era in time. It begins in the 1920s because it was impossible to find any one still alive who had memories before that time. And it ends in the 1960s because that decade ushered in a more modern era that brought about a dramatic transformation of the Beach. A transformation that came about because of the Civil Rights Act, the women's movement, the hippie era, the Vietnam War, and the influx of Cuban refugees. By the late 1960s, Miami Beach had undergone a major metamorphosis that drastically changed the social fabric of the island. Many say that metamorphosis was for the better; others say it was the end of a golden era.

Whether golden or not, the era preserved in this book would likely have been forgotten were it not for the personal memories shared by the storytellers I interviewed. A nostalgic chronicle of days gone by, *Miami Beach Memories* is a chorus of varied voices and diverse points of view, a mosaic of poignant anecdotes, and an eclectic collage that paints a portrait of what life was once like on this tiny but fascinating island.

Son of the Beach

In addition to being a successful Miami businessman, Bennett M. Lifter is a supporter of the arts with a deep fondness for Miami Beach and its colorful history, especially that of the 1930s. His generosity helped make this book possible.

As someone who grew up in South Beach during the 1930s, I'm often baffled by how that offbeat little enclave has totally revitalized itself into one of the trendiest neighborhoods in America. A neighborhood that attracts tourists and celebrities from around the world and has landed on the cover of glossy magazines countless times in recent years.

Many of us old-timers feel this way. When I lived in South Beach, I was almost embarrassed to admit it. At the time, South Beach was the wrong end of the Beach. It was where people without much money came to settle and build new lives. Most of them were East Coast Jews who were striving to make good in the world and create a bright future for their children.

My father, Daniel Lifter, was one of those people. After operating a kosher hotel in New Jersey for several years, he packed up our family and headed south to Miami Beach, where he had heard land was cheap. For $13,000 he bought an ocean-front lot and built a forty-two-room hotel named the Simone. Now known as Art Deco, the architectural style of that hotel was simple and very cheap to produce. Money was tight for most of those early South Beach hotel owners, so poured concrete and plaster decorations did the trick instead of fancy imported marble.

Soon after, my father was standing outside of 321 Ocean Drive waving to tourists driving by, trying to get them to check into his hotel. This was in 1936, and rooms rented for between $5.00 and $10.00 a night. In the summer the rate dropped to $1.00 per person per day and included a continental breakfast. No one was raking in big bucks. But our family, like most other hotel families, lived on-site, and that helped keep expenses to a minimum.

Years later my father would meet a brash and aggressive businessman named Morris Lansburgh; the two of them went on to own and operate many more Miami Beach hotels, including the Versailles, Sans Souci, Sherry Frontenac, and Deauville. Considered the "wonderboy" of Miami Beach during those years, Lansburgh later became famous for his flamboyant style as manager of the Eden Roc Hotel.

COURTESY OF BENNETT M. LIFTER

Bennett M. Lifter as a child in the 1930s.

Looking back, I now realize that growing up in a South Beach hotel during the 1930s was one of the greatest experiences a teenage kid could have had. It was fun—a lot of fun. I went swimming every day and made sand castles by the shore. Parents didn't fret about their kids getting too much sun, so most of us were usually burned to a bright shade of rosy pink.

Fruit vendors sold freshly squeezed orange juice on street corners, and Lincoln Road was the high-class shopping district where we all went to the movies on Saturday night. "Blue Moon" was the hit song on the radio, and John Steinbeck was the hot young writer of the day. Collins Avenue was still dotted with private homes, and there was no such thing as bumper-to-bumper traffic or $20 valet parking. We ate—or overate, I should say—at old-fashioned delicatessens and nobody counted carbs. We rented hotel cabanas in the summer months and acted as if we were tourists. During July and August the Beach was ours and ours alone.

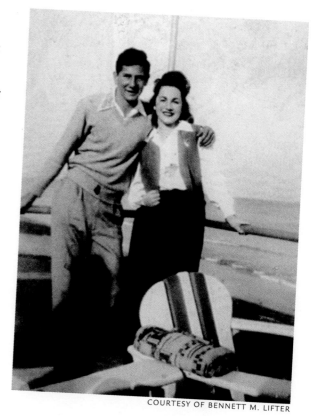

COURTESY OF BENNETT M. LIFTER

Lifter on the beach with his cousin, Shirley, in the 1940s.

There were casinos on the Beach even then, and slot machines and bookie concessionaires were everywhere, even in corner drugstores. In fact, many of the bookies helped finance the new hotels that were sprouting up all over. Odds-hungry bettors flocked to Miami Beach, and gambling—although illegal—was very much a part of the landscape and a boon for the local economy.

The population of Miami Beach back then was about 13,000, so it truly was a small town—one that just happened to sit smack on the Atlantic Ocean. Because it was so small, and because it was an island, everyone knew everyone else. Nobody locked their doors. Miami Beach was a safe, friendly, optimistic, innocent, and carefree place to grow up. Life, for the most part, was good. The biggest worry we had was getting clunked on the head by a falling coconut. There was a strong sense of closeness, and we all felt as if we belonged to a community, especially those of us who attended Miami Beach Senior High. The camaraderie there was so tight that even today—more than sixty years after I graduated—I still feel a kinship with the kids I went to school with.

That atmosphere of camaraderie led to what became known as the Sons of the Beach, a casual fraternity made up of boys who grew up on Miami Beach. Eventually "sisters" got into the act as well, and women became a part of the club. Like tens of thousands of other people who grew up on Miami Beach, I still consider myself a Son of the Beach, and it is something I am very proud of.

— Bennett M. Lifter

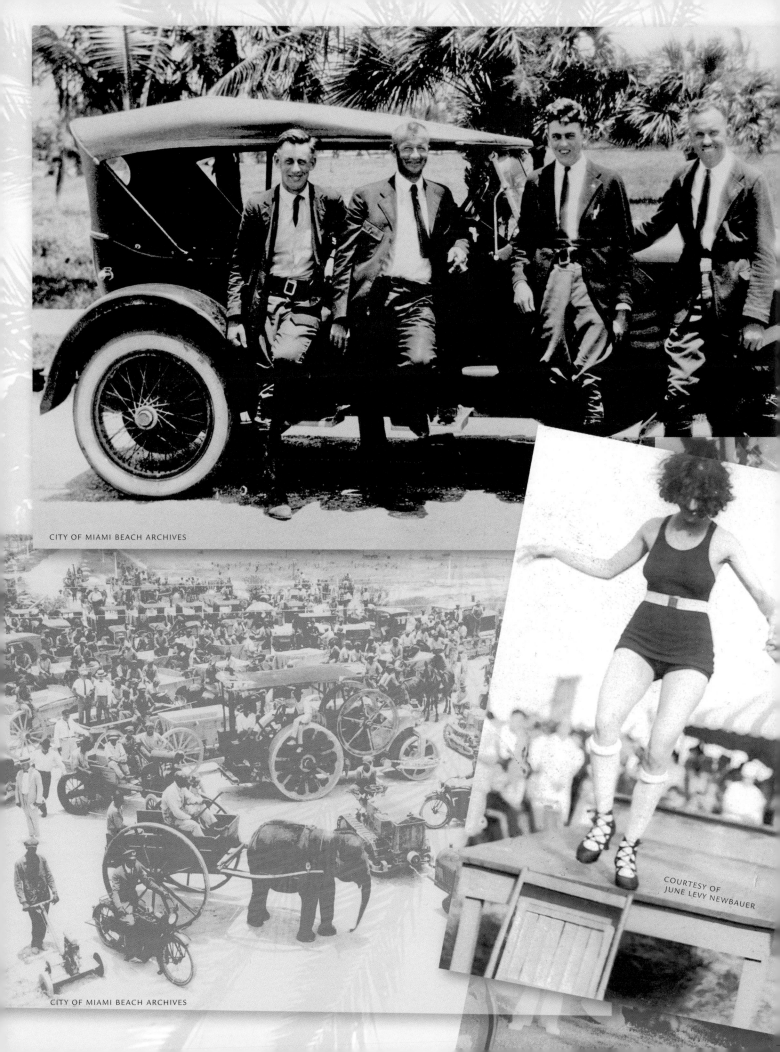

CITY OF MIAMI BEACH ARCHIVES

CITY OF MIAMI BEACH ARCHIVES

COURTESY OF
JUNE LEVY NEWBAUER

The Boom, the Blow, and the Bust

COURTESY OF ROBERT REILLY

CITY OF MIAMI BEACH ARCHIVES

1920–1929

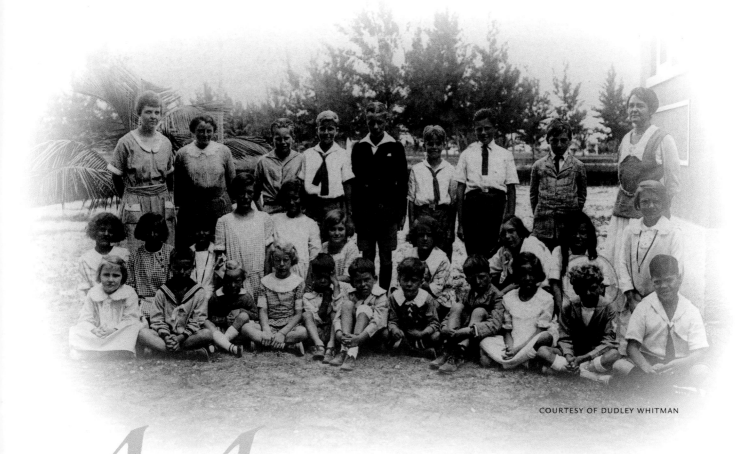

Most people who remember Miami Beach during the 1920s describe it as a lush island paradise where life was simple and buzzing black clouds of mosquitoes were a constant nuisance. Florida's Native American Indians were still thriving in the nearby Everglades, and they often made treks to Miami Beach via dugout canoe across Government Cut, the newly dredged waterway connecting the Port of Miami with the Atlantic Ocean. Local kids hunted for rabbits on Washington Avenue as electric trolley cars hummed along.

Although quiet, the 1920s were also marked by a period of rapid expansion. The local population grew from about 600 to more than 15,000 in just five years. A spirit of hardworking ingenuity encouraged tourism, posh polo fields attracted fedora-clad crowds, and luxury steamer ships sailed to Havana for vacation cruises. Merchandising pioneer J. C. Penney owned a mansion in Miami Beach, and presidents Warren G. Harding and Herbert Hoover came for a visit. So did Dorothy Parker, Gloria Swanson, Will Rogers, Babe Ruth, and Jack Dempsey.

Developer Carl Fisher was the top banana in town, spending much of his time cutting real estate deals, orchestrating

Above: Children outside of Lincoln Road school in the 1920s. Below: A 1924 bathing beauty contest.

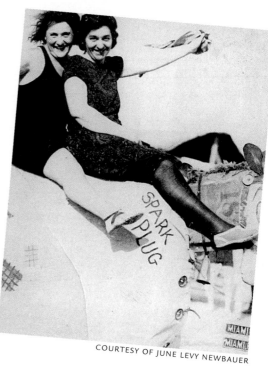

The Boom, the Blow, and the Bust

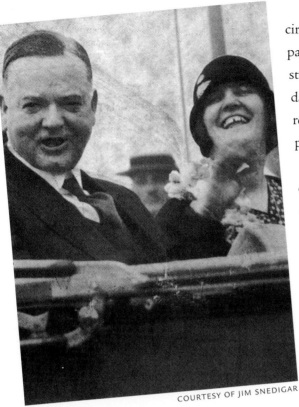

President-elect Herbert Hoover with his wife,
Lou Henry Hoover, in Miami Beach in 1929.

circuslike publicity stunts, and getting drunk with his pals on bootlegged booze. Fisher, however, was also a staunch anti-Semite who spoke openly about his disdain for Jews. He was largely responsible for the restrictive covenants often attached to land deeds that prohibited the sale of Miami Beach properties to Jews.

Yes, Miami Beach in the 1920s was a WASP-controlled island where Old Money ruled and newcomers in the form of northeastern Jews were not welcome. It was, in fact, one of the most anti-Semitic cities in America. Tacked onto country club walls, painted on the outside of apartment buildings, and propped up at hotel front desks were the infamous signs that today are hard to fathom: GENTILES ONLY. Occasionally they were a bit more delicate, whispering one simple word: RESTRICTED. Other times they were shameless: NO JEWS ALLOWED.

From the 1920s through the early 1940s, Jews found it almost impossible to lease or buy property north of Fifth Street and therefore congregated in the lower end of the Beach. This neighborhood, now known as South Beach, was described by many who lived there at the time as a Jewish ghetto, the wrong side of town.

The restrictive real estate deeds did not in any way dampen the economic boom, though, and speculators from across the United States swooped in for the kill. For a while all was well with the world. This came to an abrupt end, however, when a brutal hurricane washed ashore in 1926. The killer storm left the island in shambles and brought about an early start to the Great Depression.

First Impressions

I came to Miami Beach in 1925 when I was five years old, and we lived above a gas station at 100 Ocean Drive. It was so quiet, it felt like a little tropical island. Every day after school we went fishing. It was like living in paradise.

My father had one of the first taxi companies on the Beach. He started with a seven-passenger Pierce-Arrow, and he would pick people up from the train station in downtown Miami and take them to the Beach. They all came with big steamer trunks, so he also had to have a truck just to carry their luggage.

STANLEY SEGAL, FORMER TAXICAB COMPANY OWNER

The Boom, the Blow, and the Bust

Daily Life

Growing up in the Everglades, I knew about Miami Beach and the ocean because the Elders told me about it. They said it was salt water with big fish in it—big fish that could bite you—so I was scared of it. When I saw it for the first time, it looked real high, not like the low waters of the Everglades. We also heard that there were city builders putting up buildings on the beach. These city builders were the opposite of us. We were nature people; we lived in nature and didn't try to change it. The city builders were trying to change nature.

A Miccosukee Indian child.

Our people used to take dugout canoes to Miami Beach all the time. They were not looking for trade, just looking to see what was there. Some of them were medicine men who wanted to find plants to use for healing. When I was a boy in the 1920s, my father would take me in a canoe from the Everglades all the way to downtown Miami and then across Government Cut to Miami Beach. It would take us a long time to get there, more than one day.

In those days, people on Miami Beach treated us OK. They seemed to just accept us, like it was a normal thing to see Indians walking on Miami Beach. In fact, my Uncle Willie Willie was friendly with lots of city people from Miami Beach, rich white men like Al Capone. And some of the Indians actually worked for the city builders doing promotions. I think there was more prejudice toward the black people and the Jewish people than there was to us Indians then. I guess we were just so different that the white man didn't know what to do with us. And they knew we were not going to try to stay and take their land, so they left us alone.

BUFFALO TIGER, A MICCOSUKEE INDIAN

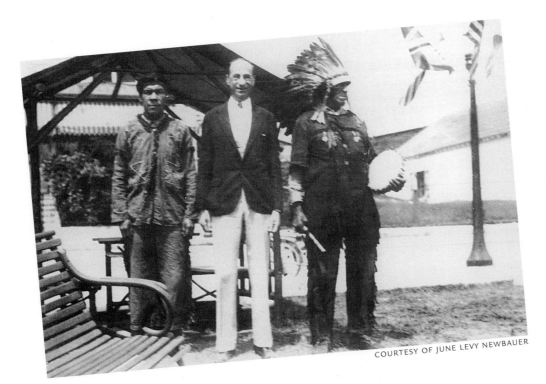

Developer Henry Levy with two Miccosukee Indians he hired to entertain prospective real estate buyers.

The Boom, the Blow, and the Bust

When my mother was pregnant with me in 1926, she was worried that she wouldn't make it to the hospital in Miami on time because there was only a one-way bridge or a ferry from the Beach, so she got cold feet and wound up going to Cincinnati for my birth.

As a child I lived in a coral rock home at 1030 Washington Avenue that my parents built in the early 1920s. There were tall pine trees running down to the ocean and a sand trail to get to our house. The mosquitoes were so thick that they would carry you away. We had a wood-burning fireplace, and it seems to me that the winters were much colder then, because we used that fireplace a lot. One winter we ran out of firewood and had to burn coconuts to keep warm. When they started exploding it sounded like the Fourth of July.

There were only 500 permanent residents on the Beach at the time, and when we finally got a telephone, we had to have a four-party line. The Courshon family had one line, another family had the second line, and a drunk had the third. The drunk would use the phone all the time, and it messed us all up.

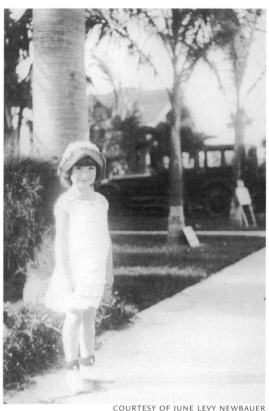

COURTESY OF JUNE LEVY NEWBAUER

June Levy Newbauer in front of her Washington Avenue home in the late 1920s.

We had a saltwater pump in the backyard, and my mother washed all of our clothes with salt water. Our drinking water was brought over from Miami by ferry. Every day the milkman came to the house and delivered eggs and cream, and an iceman brought big blocks of ice. Once a week we went to the market in downtown Miami. If our family went out on a Sunday afternoon, my mother would leave a note on the screen door, saying "Come in. Help yourself to some lemonade." Nobody even thought about locking a door. The Beach still felt like the Old South then, the real Old South. My mother had an older black woman who came in to iron our clothes. She used the old-fashioned irons you had to heat on a stove. She was from somewhere in Georgia, and she was a former slave. I used to sit at her feet and listen to her tell stories—stories that were the last remnants of another era.

JUNE LEVY NEWBAUER, REAL ESTATE MANAGER

The beautiful Miami Beach of the 1920s was nothing but a barrier island full of mangrove swamps, carpenter ants, mosquitoes, and scorpions. I went to elementary school with about thirty other kids, and most of them came to school barefoot. My childhood was very water oriented—I swam,

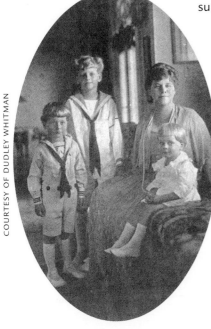

Above: Stanley, William, Leona, and Dudley Whitman inside their Collins Avenue home in 1923. Below: Stanley and Dudley with their Model T Ford.

surfed, fished, and took a rowboat all over the place. We climbed coconut trees and picked fresh mangoes. Later I built a Model T Ford and drove that around the Beach. It was a simple life.

My family had the second phone ever put in on the Beach, and our number was 567. You had to talk to an operator first, and she would put you through to who you wanted to call. Eventually the phone book grew to about a page long. We were not here during the 1926 hurricane, but when we arrived home there was a fishing schooner sitting right in the middle of our dining room. Had to chop the darn thing out.

My mother and father knew John Collins and Carl Fisher very well. On our birthdays, Fisher would bring Rosie the elephant to our house for rides. My mother didn't like it, however, when Rosie pooped in our driveway. She called the fire department to come clean it up.

Later my father was involved with N. B. T. Roney [a local developer with extensive real estate holdings, including the Roney Plaza Hotel] when he was trying to create Espanola Way. At the time they were going to call it Whitman Way. My parents were glad that didn't happen because for a while it was a real red light district—full of whores. My parents would have been terribly embarrassed.

DUDLEY WHITMAN, FILMMAKER

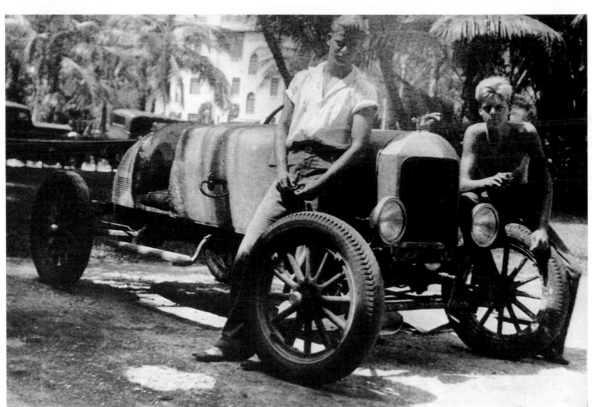

The Boom, the Blow, and the Bust

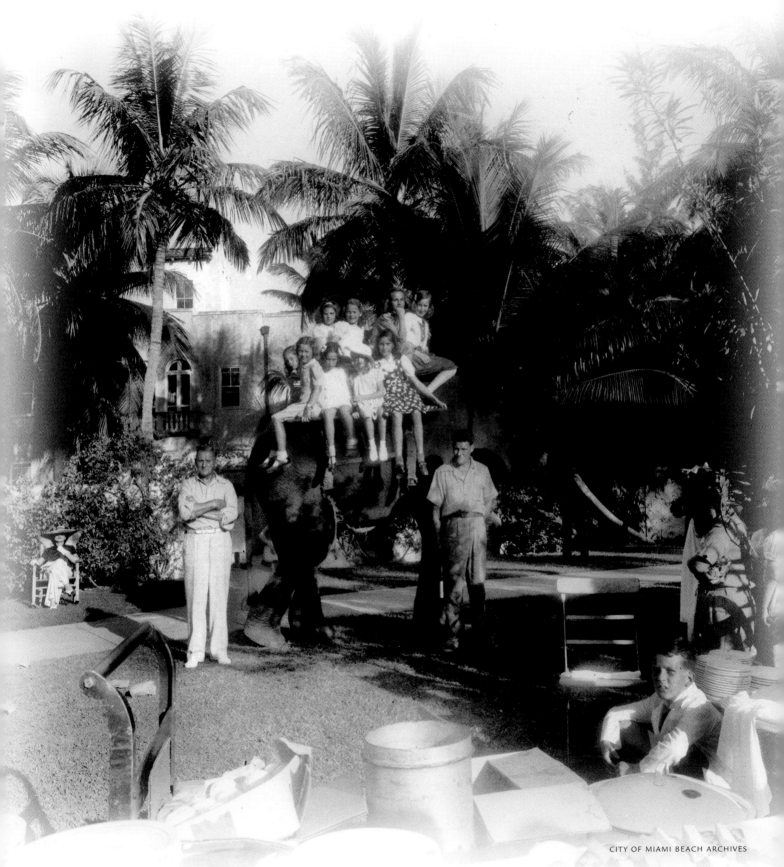

Rosie the elephant entertains children at a birthday party in the late 1920s.

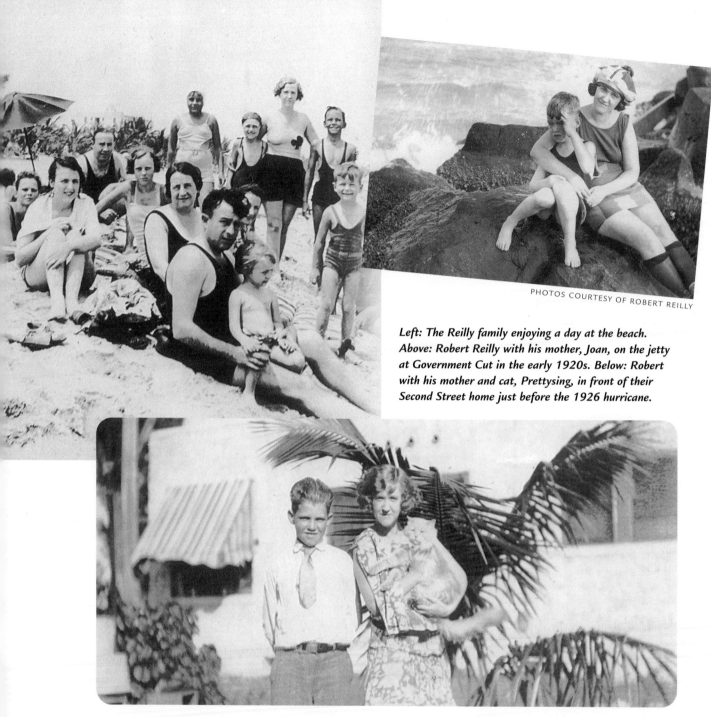

Left: The Reilly family enjoying a day at the beach. Above: Robert Reilly with his mother, Joan, on the jetty at Government Cut in the early 1920s. Below: Robert with his mother and cat, Prettysing, in front of their Second Street home just before the 1926 hurricane.

I arrived in Miami in 1923 in November, on Armistice Day. When the train stopped in downtown Miami, there was a big parade marching up Flagler Street, and my grandmother told me the parade was for me. I was properly impressed. The Beach in those days was barren and wide open. This was during Prohibition, and we used to see boats going in and out of Government Cut, bringing in rum from Bimini. For kids, carrying a gun was not unusual, and I remember shooting my first rabbit on Eleventh Street and Washington Avenue. We also shot birds, and whatever we shot we ate for dinner. We all hunted on the same land where today there are so many damn hotels that you can't even breathe.

ROBERT REILLY, RETIRED BUSINESSMAN

The Boom, the Blow, and the Bust

I first came to Miami Beach in the early 1920s, and I took a wood-burning train from Chicago to get there. Had to pick the cinders out of my ears the whole way down. I could see the road from the train, and it was full of Tin Can Tourists—people who drove down from the North in Model T Fords and slept by the side of the road. Hotels then cost a dollar a night. At the time, my grandparents owned the Miller Hotel on Miami Beach. But it was severely damaged during the 1926 hurricane, and shortly after those Binder Boys [real estate loan sharks who optioned to buy land from distressed owners by offering them a pittance of the property's true value] came in, swooping it up for 5 cents on the dollar.

There weren't many restaurants, so we all went to Joe's [Stone Crab]. Back then it was just a little shack. But we got to eat all the stone crabs we could hold for about a buck. Miami Beach was a great place in the 1920s, and the early settlers did some wonderful work. I know that everybody credits Carl Fisher with the building of Miami Beach, but nobody wants to remember that he was also addicted to the grape and was one of the worst bigots in town.

CHUCK BRANSFIELD, RETIRED OIL DRILLER

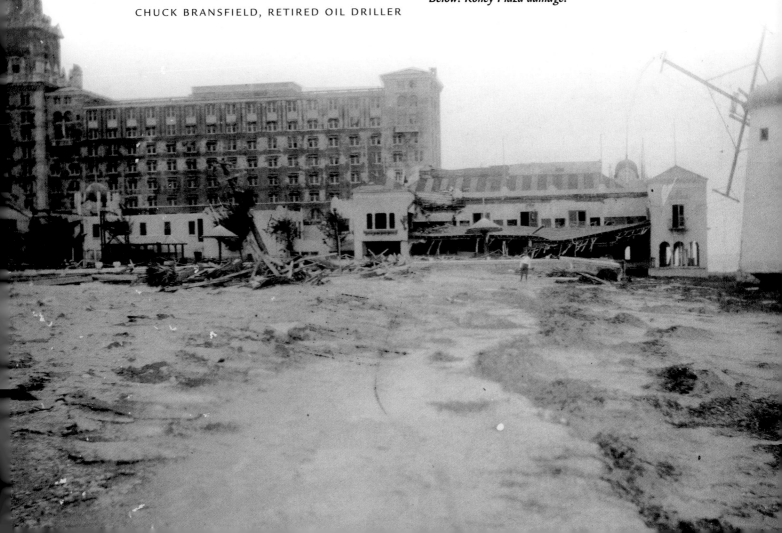

BOTH PHOTOS CITY OF MIAMI BEACH ARCHIVES

Above: Drexel Avenue damage after the 1926 hurricane.
Below: Roney Plaza damage.

Jim Snedigar (left) with his father, Louis "Red" Snedigar;
his mother, Edna; and his brother, Louis Jr., in 1929.

Growing up in Miami Beach in the 1920s was like growing up in Tahiti. It was lush and exotic. You could go in the ocean and gig a lobster for dinner. Our feet were so full of calluses from running around barefoot that we would put out cigarettes for tourists with our feet just for kicks. And we had two sets of clothes: one wet and one dry. For fun we went to the Roman Pools and watched the shows—Johnny Weissmuller and all the great swimmers.

I also went for a lot of rides on Rosie the elephant. My dad and Carl Fisher were good buddies, drinking buddies. They would put on tuxedos and go out and get loaded. Fisher would say to my dad, "Hey Red, let's wrestle." And they would—right in the middle of a fancy cocktail party. They also went on fishing trips together. Fisher even took my dad to Cuba on a private yacht during Prohibition. When they came into port, Fisher was worried about the booze, so my father volunteered to solve the problem— he drank all of it. My dad held the record for being the biggest alcoholic in Florida, but eventually he turned his life around and got sober.

My dad liked to say he was mayor during the boom, the blow, and the bust. He was in office during the 1926 hurricane. We lived on Collins Avenue at the time, and our brick home almost got blown away. The entire island was under water, three feet deep. I was only two and half years old, but I remember it. My father tied the whole family together with sheets, and we swam across the Dade Canal to the Boulevard Hotel for shelter. The next day they were digging the bodies out of Government

Cut, and my dad had to set up the burials. It was a sorry sight. The storm wiped the place out, and the real estate boom ended instantly. Soon after, the Depression rushed in and it was rough. For the rich people it wasn't so bad, but there were many poor people who ate nothing but grits and grunts for months.

JIM SNEDIGAR, SON OF EARLY MIAMI BEACH MAYOR LOUIS "RED" SNEDIGAR

I moved to Miami Beach in 1929, and I remember the Depression as being tough—about three-fourths of the people on the Beach were on welfare. I felt lucky because I got a paper route job. Sold the *Miami Herald* and the *Pink Sheet,* a paper that had stock market returns. I got up at 4:00 a.m., rode my bike to the beach, laid it down in the sand, and did my deliveries. When I was finished I went swimming. And my bike would still be there.

For fun I went to the Plaza Theater at the southern end of the Beach, near Joe's restaurant. The Plaza had no air-conditioning, of course, but it had big fans and screen doors. All us kids went there on Saturday to see the features and the serials and Movietone news. It cost about a dime to get in, and I have a confession to make: Sometimes one of the kids would pay to get in and unlock the screen door so the rest of us could sneak in for free.

For a special treat we went swimming at Smith's Casino pool. The bathing suits then were something else—wool trunks and a tank top that scratched the daylights out of you. Must have been designed for swimming up North. The women wore wool suits, too, with a top and a skirt and a cap. Just about the only things showing were their faces and hands. Wasn't very sexy.

NORMAN GILLER, ARCHITECT

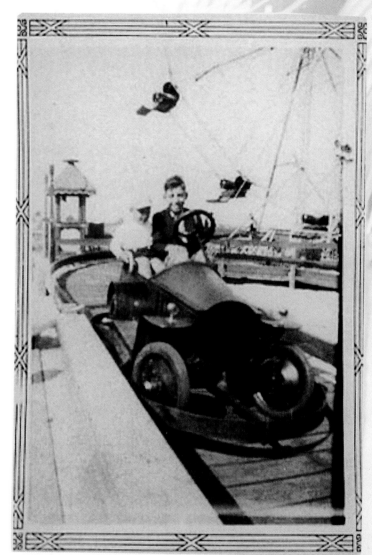

COURTESY OF GILLER & GILLER ARCHIVES

Norman Giller (right) on go-kart.

Gentiles Only

My family moved to Miami Beach in 1909 when my father was five years old. My grandfather was lucky to get a job at Smith's Casino—he was one of the first Jewish employees on the Beach, and it was a big deal at the time. I know for a fact that my family always lived south of Fifth Street because the rest of the Beach was restricted. And when I was a kid, the South Beach where I lived was the poor ghetto for Jews.

JO ANN BASS, OWNER OF
JOE'S STONE CRAB RESTAURANT

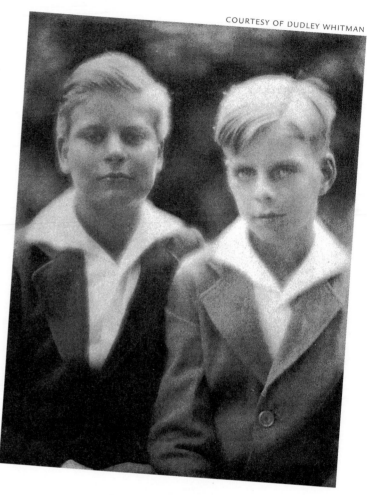

COURTESY OF DUDLEY WHITMAN

In the 1920s everything north of Fifth Street was Carl Fisher's fiefdom. There were mostly midwesterners living on the Beach then, people who were clearly anti-Semitic. Carl Fisher did have some Jewish friends—rich Jewish friends. But if you were Jewish and not a friend of Carl Fisher, you weren't likely to go anywhere.

STANLEY WHITMAN,
REAL ESTATE DEVELOPER

**Stanley and Dudley Whitman
in the late 1920s.**

I went to elementary school in downtown Miami; took the cable car from the Beach across the causeway every day. When I was in the third grade, in about 1920, I remember getting angry at my teacher—really angry, red-face angry. She was teaching anti-Semitism in class as part of the normal studies. She would stand in front of the students and go down a list of negative things about Jews. I was just a kid, but I knew this was wrong. I demanded that she give me the material she was teaching; I wanted to show people on the Beach what I was being taught in school. I caused a lot of trouble for that teacher.

BURNETT ROTH, CIVIL RIGHTS ATTORNEY

As a child growing up on the Beach, most of my friends were not Jewish, and at times social situations got a little sticky. I remember going to a birthday party where I won the game prize, but they wouldn't give it to me because I was Jewish. In small ways I often felt ostracized.

My father did as well. In the 1920s he wanted to get into real estate development, so he paid a visit to Carl Fisher. He went dressed to kill, in his best suit. Fisher, being the anti-Semite that he was, gave my father the cold shoulder—didn't want to do business with him. But my father was determined to show Carl Fisher, and he did. He wound up filling in a group of spoil islands and turned them into Normandy Isle. A few years after that, he had an incident at the Bath Club. Somebody accused him of being unethical and called him a dirty Jew. My father sued for defamation of character and won the case.

JUNE LEVY NEWBAUER, REAL ESTATE MANAGER AND
DAUGHTER OF EARLY MIAMI BEACH DEVELOPER HENRY LEVY

The Levy family home at Tenth Street and Washington Avenue.

Gentiles Only

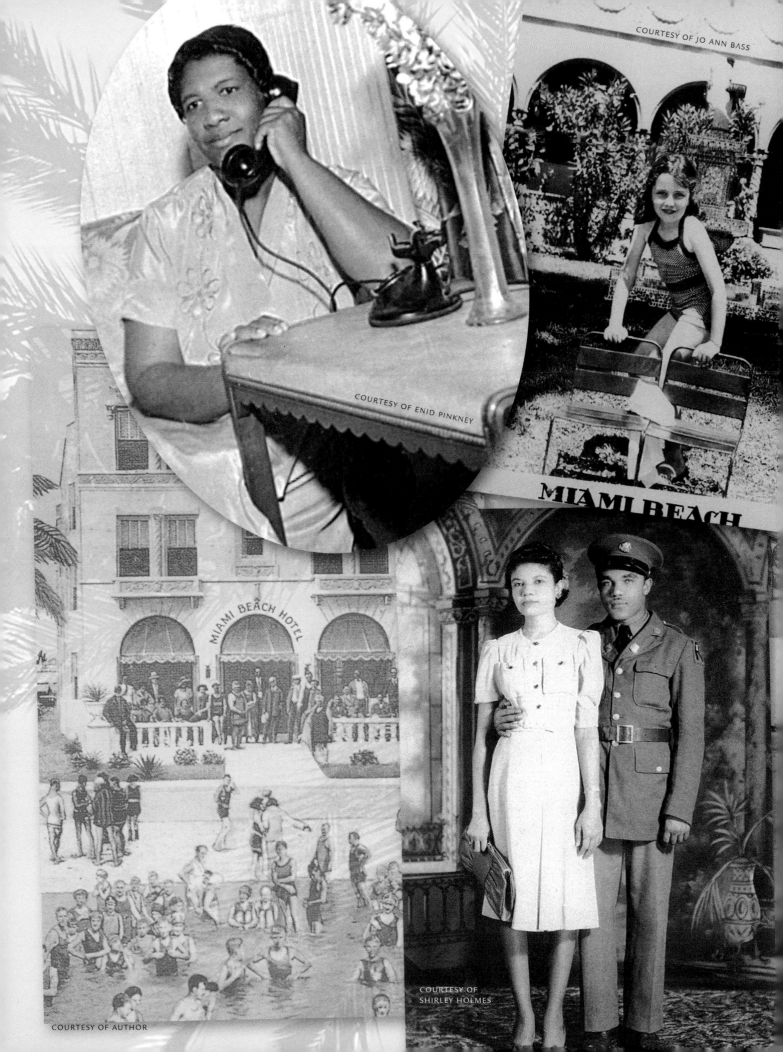

MIAMI BEACH

MIAMI BEACH HOTEL

COURTESY OF AUTHOR

MIAMI BEACH, FLORIDA

ON THE OCEAN — PRIVATE BEACH

A Very Big and Exclusive Club

1930–1939

COURTESY OF SISSI PERLMAN FELTMAN

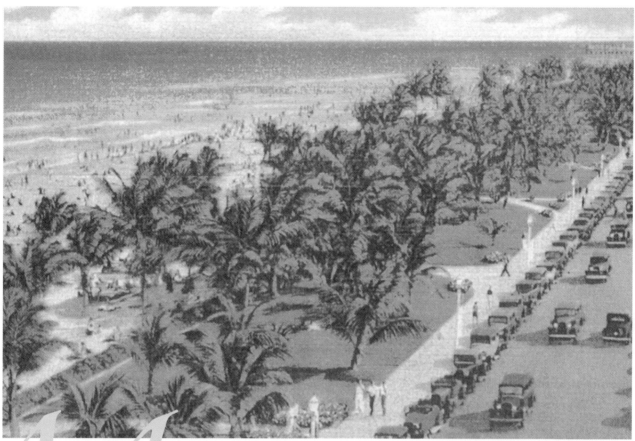

Above: Vintage postcard of Ocean Drive in the 1930s. Below: 20th Century Fox movie poster for Second Honeymoon, which opened in 1937.

Miami Beach may have been small, but its reputation grew exponentially in the 1930s. Among its most famous residents was Chicago gangster Al Capone, who had moved to the Beach in the late 1920s. Not at all welcomed by the local community, he was often harassed by the authorities and landed in prison twice—once for possession of a concealed weapon and another time for tax evasion. After being released, Capone lived out the remainder of his life at his plush Palm Island home When he died in 1947, his once agile mind was completely gone, ravaged by advanced syphilis.

In the meantime his son, Sonny, tried to avoid the inevitable attention that came with his last name. He befriended another outsider—a cocky Cuban kid who had settled with relatives in Miami Beach and enrolled in St. Patrick's High School. The kid didn't remain unknown for long: Soon after Xavier Cugat "discovered" him, Desi Arnaz began performing in his own band. He later married Lucille Ball, of course, and the two of them went on to become entertainment icons. But for those who remember him from St. Patrick's, Arnaz was not the most popular kid in school.

Along with Arnaz, another icon evolved in Miami Beach during this decade: the playful architectural style known as Art Deco. The Art Deco

A Very Big and Exclusive Club

boom was the antithesis of what was happening across the country at the time. Although Miami Beach hurt economically during the late 1920s, it was spared the wrath of the Great Depression because many wealthy developers managed to keep it afloat. With their electrifying neon lights and splashes of color that slid across the rainbow from erotic pink to lizard green, the eye-candy Art Deco hotels were exactly what the American public needed to lift its spirits after enduring the hardships of the times. And fifty years later these buildings would serve as the cornerstone of Miami Beach's cultural revival.

Although Jewish investors built some of the Art Deco hotels, old-guard WASPs still had economic and political control of the Beach throughout the 1930s, and anti-Semitism remained egregious. Jewish doctors could not get jobs, and the "no Jews north of Fifth Street" policy prevailed. One oceanfront hotel even used this now-unthinkable slogan to advertise: "Always a View, Never a Jew."

According to some locals, Irish Catholics didn't have it so good either, and African Americans had it far, far worse. Like much of the American South, Miami Beach from the 1930s to the 1960s was a bastion of Jim Crow laws that forbade commingling of the races. And yet dozens of big name African-American entertainers came to the Beach to perform—Billie Holiday, Cab Calloway, Duke Ellington, Louis Armstrong, Dorothy Dandridge, Nat King Cole, Ella Fitzgerald, Dizzy Gillespie, Sam Cooke, and Count Basie among them. What these entertainers could not do, however, was stay in local "whites only" hotels. Most finished up their sets on the Beach and then drove across the causeway to downtown Miami or neighborhoods such as Overtown, where they were welcome to bed down for the night.

In 1936 the situation worsened. That's when the City of Miami Beach, citing security and health concerns, passed an ordinance that required everyone working in the tourism industry to obtain an official identification card as a prerequisite for employment. While it is true that the law applied to all, it was African Americans who were regularly singled out by local police for "routine" ID checks. There were also nonwritten "rules of conduct" that required African Americans to be off the Beach after sundown and that barred them from swimming in the ocean and walking on the sand. For the most part Miami Beach remained segregated until the Civil Rights Act of 1964.

First Impressions

My mother gave me $50 as a graduation present in 1936, and I took a bus from New York to Miami Beach. I loved the place the first time I saw it—the sun, the water, the tropical feeling of hanging loose and being carefree. I walked into a real estate office on Ocean Drive and the Realtor fixed me up with a chorus girl from Radio City; we shared a room at the Edison Hotel for several days. I ate 50-cent meals, and the whole trip cost me $50. Fabulous.

MAIDA HEATTER, COOKBOOK AUTHOR
AND DAUGHTER OF RADIO COMMENTATOR GABRIEL HEATTER

Daily Life

Miami Beach in the 1930s was intoxicating. It had racetracks and movie stars and gangsters—guys like Baby Face Nelson and Al Capone. It was not at all frightening. Instead, there was a certain element of excitement about it all.

My parents owned a drugstore on Michigan Avenue. It was called a drugstore, but it was more of a luncheonette that catered to racetrack men—guys who called me "kid." It was a real horsey place. At the time Miami Beach was basically a resort town, and resort towns are notorious for not being able to teach kids the hard facts of life. The whole town was geared around taking care of the rich. Any society that has as its main goal taking care of the rich is a poor society, and that's what we were up against as kids. There was not much of a social conscience and very little political awareness.

However, there were a few out-and-out Communists on the Beach. I remember a Jewish family that ran a bakery, and they hosted gatherings to talk politics. They passed out workman strike posters. I also remember a contingent of twelve eager Jewish boys who joined the Abraham Lincoln Brigade and went to Spain to fight with the Loyalists in the Spanish Civil War. They provided a little political excitement in this otherwise unaware tourist town.

STELLA SUBERMAN,
AUTHOR OF *THE JEW STORE*

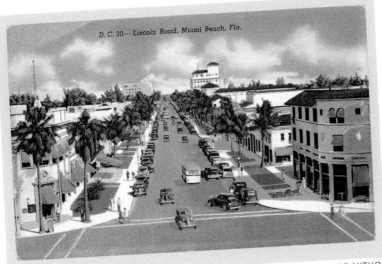

D. C. 30—Lincoln Road, Miami Beach, Fla.

COURTESY OF AUTHOR

Vintage postcard of Lincoln Road in the 1930s.

Growing up on Miami Beach in the 1930s was magical. Here was this tiny island about eight blocks wide, and you had to travel across the bay to get there. Because of this, the sense of camaraderie was very tight, and we all felt as if we belonged to a very big and very exclusive club. It was also a great place for kids because it had a lot of interesting back alleys—alleys used to service the tourism industry. I would go from place to place by the back alleys, and it was so different than the front streets—like moving from a major key to a minor key. And in the summertime, before air-conditioning, Miami Beach was like a theater that just closed down. The show ended and the curtain was drawn. But as kids we loved it because it meant that the Beach was finally *ours*.

PAUL NAGEL, RETIRED PROFESSOR AND DOCUMENTARY FILMMAKER

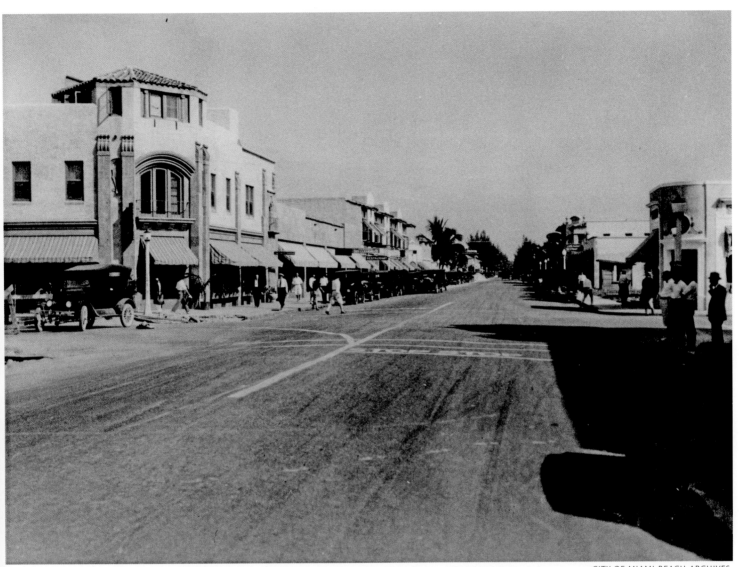

Washington Avenue near Biscayne Street in 1930.

When I was a kid in the 1930s, my dad had a bar on Washington Avenue called Casey's Oasis. He ran it from 1935 until the war, and it was like an old-fashioned western saloon. It was a real popular place, especially with cops.

My dad was a bit of a prankster, and he did some crazy things in that bar—things that you could not get away with today. He had a little pipe near the front door that would blow the women's dresses up when they walked in the bar. He had a box that said PUSH THIS BUTTON AND HEAR A FREE SONG. When people pushed the button, it pricked their finger. And he had a cardboard cutout of a nude woman in the men's room with a fig leaf over her crotch. If you lifted up the fig leaf, there was a little sign that said SUCKER, and a bell rang in the bar so everyone would laugh at you when you came out.

JIM CASEY, RETIRED POLICE OFFICER

Daily Life

In the 1930s there was a law on the books in Miami Beach that said you had to be covered from your shoulders to your knees if you were west of Ocean Drive. Well, I once went swimming at Smith's Casino, and I got arrested afterwards because I was in my swimsuit—shirtless—and I was west of Ocean Drive. The police hauled me off to jail and called my parents. They had to pay a fine to get me out. And then we actually had to go to court to settle it—all because I had too much skin showing.

HAL KAYE, PHOTOGRAPHER

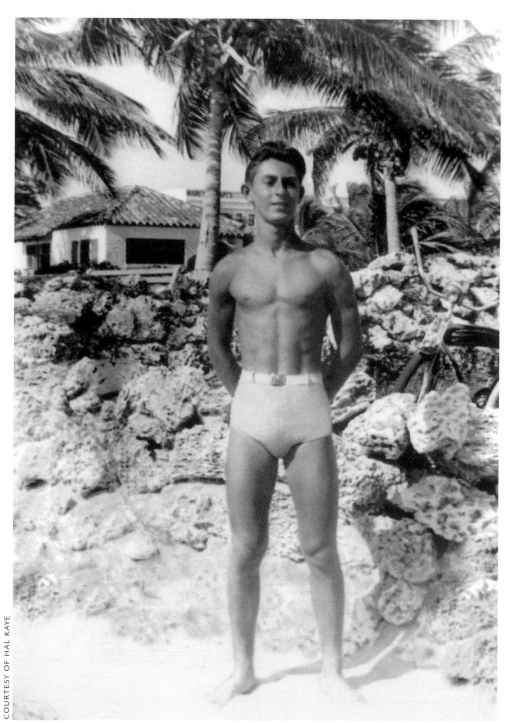

Hal Kaye in bathing trunks.

COURTESY OF HAL KAYE

A Very Big and Exclusive Club

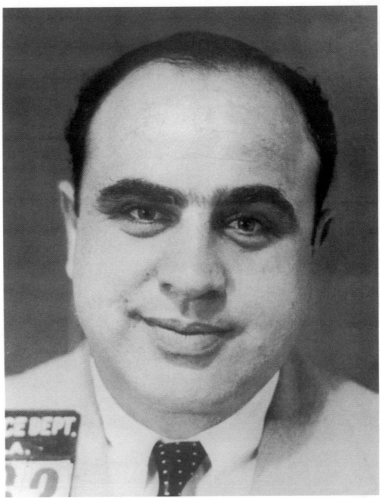

Police mug shot of Al Capone.

Gangsters and Guitars

When I went to St. Patrick's in the 1930s, one of the kids I went to school with was Al Capone's son, Sonny. He used the name Sonny Francis to make his life easier. Sonny was like an old-fashioned Italian Catholic—he went to Mass and took Communion every day. He was a real good boy. Desi Arnaz went to St. Patrick's then, too, and he was just a pock-marked Cuban kid who was a real pain in the ass. People made fun of him, and nobody ever thought he would amount to anything. I was with him at a party when someone gave him his first banjo.

Desi and Sonny were best friends who used to hang out together a lot. But that Desi turned out to be a real stinker for Sonny. Years after we went to school together, Sonny got into some trouble. He was in a grocery store, and he got accused of stealing a vial of sprinkles for his kid's birthday cake.

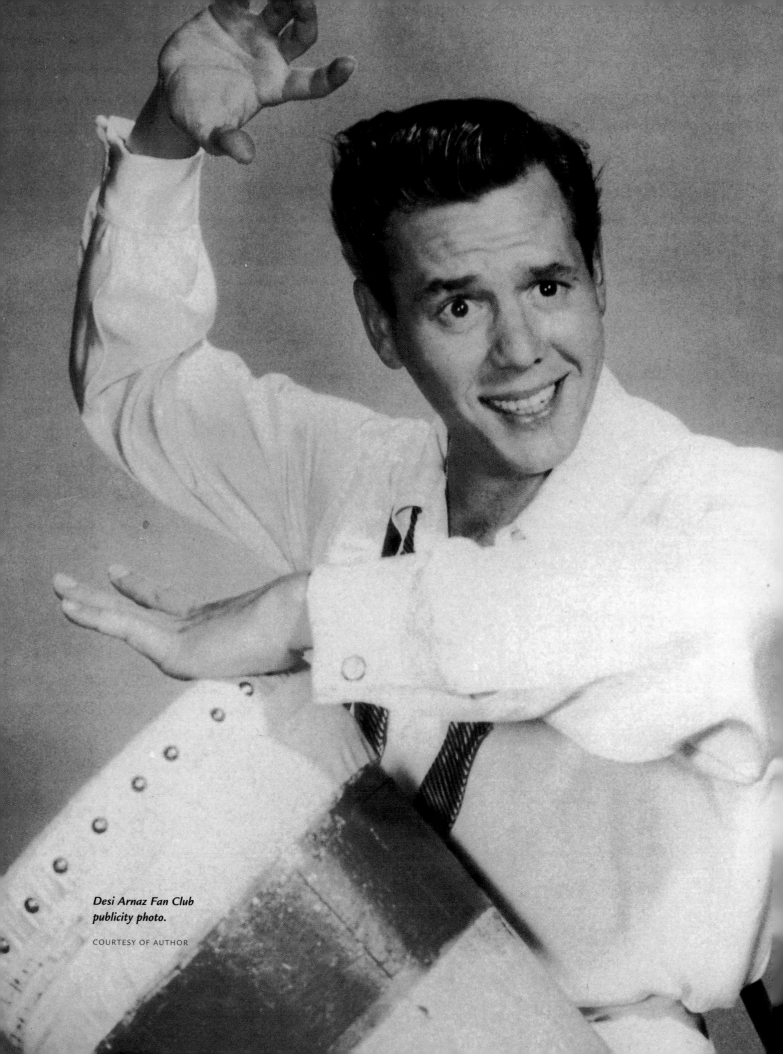

Desi Arnaz Fan Club publicity photo.

He was planning to pay for it, but the counter girl saw him slip it in his pocket, and she screamed that he was shoplifting. She knew who he was. The newspapers hounded the hell out of the story—wouldn't leave the poor guy alone. Sonny called Desi and asked for help, but Desi wouldn't do a damn thing— just turned his back. I had to loan Sonny $10,000—which he paid back—to get him out of trouble. It was a sad case of the sins of the father falling on the child, and it ruined Sonny's life in Miami Beach.

CHUCK BRANSFIELD, RETIRED OIL DRILLER

Desi Arnaz was a year ahead of me at St. Pat's, and I remember him as woman wild—a big girl chaser—even when he was a kid. Nobody on the Beach was impressed with Desi, including me. He was just another Cuban kid who showed up at school. At St. Pat's every time there was a revolution in Cuba or some other Latin American country, we had a new crop of kids—rich Cuban kids, rich Nicaraguan kids, rich Dominican kids.

Along with Desi, I knew Sonny Capone, and he was in my Boy Scout troop. When Sonny went to school, there was always a car parked outside with bodyguards waiting for him. He had a lot of stupid cousins who came down from Chicago, but he was a nice kid. I used to go to his house on Palm Island to go swimming in his pool. No matter what people say, his father was a good man. He was always nice to us kids, and he never bothered anybody on Miami Beach. Sonny's mother was as sweet as can be, too. When Sonny went off to Notre Dame, I visited Mrs. Capone. I told her that I had heard from Sonny and that he wasn't happy, that he couldn't wait to get out. She said, "Same goes for his father." Capone was in Alcatraz at the time.

ROBERT REILLY, RETIRED BUSINESSMAN

When I went to Beach High in the 1930s, the well-to-do northerners who lived on the Beach didn't put their kids in prep schools, so there was a great diversity among the student body. It wasn't racially diverse, but it was economically diverse. There were kids from some of the richest families in America—the Paleys, the Chases, the Bonwits. And there were poor kids, both Jews and Gentiles, whose parents worked in the tourism industry. The poor kids lived in South Beach, specifically at Smith Cottages, a group of shanties where families who worked as servants lived. And the rich kids lived in big houses, where these servants worked.

For fun we all went to the Pig Trail Inn. We ordered 5-cent Cokes and 15-cent hamburgers. I remember that some of the kids—I won't name names—spiked the Cokes with rum and smoked a lot of cigarettes. We danced the Lindy Hop to big band music and learned how to rumba from the Cuban kids. Al Capone's son would come to our Saturday night parties at Beach High even though he didn't go there. Desi Arnaz came, too. Desi was a big show-off who played his guitar whether you wanted him to or not. We all just rolled our eyes and tolerated him.

STELLA SUBERMAN, AUTHOR OF *THE JEW STORE*

*Lois Finder Applebaum on a diving board
with her father, Nat Finder.*

When I was a little kid, I remember seeing Al Capone at Phil's barbershop. He wasn't very old, but he looked very old. He had gotten out of prison and was a sick man—a really sick man—who just stood outside the barbershop surrounded by bodyguards with a wad of comic books in his hand. He still had an athletic body, but his brain was gone, insane from the syphilis. Every time my dad went for a haircut, he took me with him just so I could trade with Capone. Lots of grown men did it, too, just to say they traded with Al Capone.

LOIS APPLEBAUM,
SCHOOLTEACHER

Art Deco

What I remember most about the 1930s is that it was when the Art Deco hotels really started to take off. And for the most part, people loved them. If they were on Ocean Drive, you could sit on the front porch and just stare out at the ocean. The ocean was a lot closer to the land then; the beach hadn't yet been extended. Many of the people who built the Art Deco hotels lived in one of the units and earned enough from renting the rooms that they didn't have to work. They were an easily affordable venture for the owners, these Art Deco hotels.

Of course at the time they were not called Art Deco. They were just the modern buildings of that era. The architects who designed them didn't sit around and say, "Let's build these things called Art Deco hotels." It's the same as when the Greeks and Romans built their great temples. Today we have sophisticated ways of describing that ancient architecture, but when they were built they were just contemporary buildings. The architects didn't think, "Hey, let's call this Corinthian or Doric." The same is true with Art Deco. The name didn't come till decades later when preservationists tried to save them [the hotels]. That's when people really took a look at what they stood for, and the term Art Deco came into vogue.

NORMAN GILLER, ARCHITECT

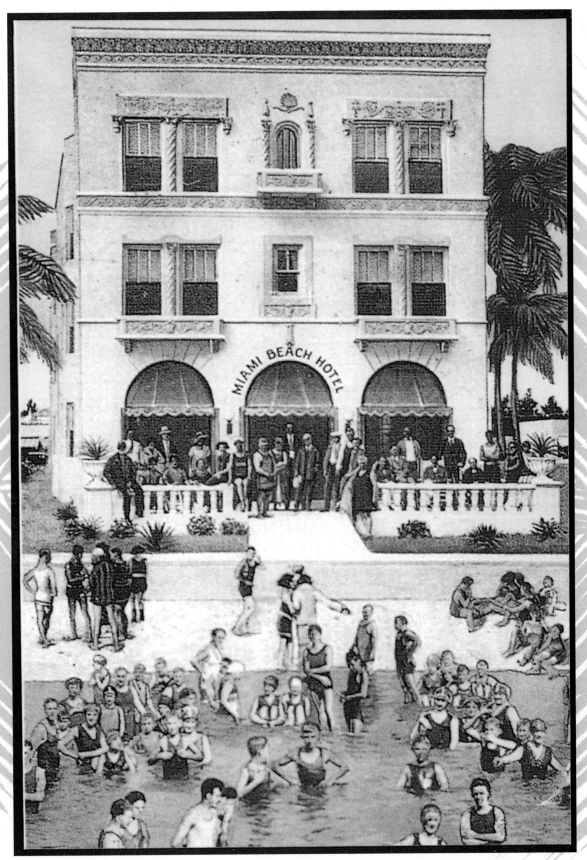

Miami Beach Hotel postcard.

Food, Glorious Food

My family has always said that they opened Joe's in 1913, but there are people who claim it opened a few years later. What I do know for certain is that it was originally in a little white house and then moved to its current location in 1931.

During the 1930s, we lived in an apartment upstairs where there was a communal kitchen. We were really just working-class people, and times were not easy for us. Although we knew a lot of rich people, the sheriff was often at our door. The restaurant was successful, but my family almost lost it many times because my father was a big spender, and gambling and women were his vices.

When I was a child, my dad hid nothing from me—he taught me how to count by playing gin rummy, and he took me with him to nightclubs. Although he was a restaurant man to the core, my father was really a frustrated gangster. He loved the horses, he loved the fast life, and he loved the aura that surrounded the Mob scene. The Mob scene was big then, and my Dad had a lot of contact with them—they owned the meat companies and waste companies that serviced restaurants. Al Capone was a regular customer, and when he came in he used the name Al Brown. He and my grandmother were very friendly. He always sent her flowers on Mother's Day, addressed to Mama Joe. My grandmother once threw him out of the restaurant when he showed up with a woman who was not his wife.

Even in the 1930s Joe's attracted an eclectic group of people—Al Jolson, Amelia Earhart, Damon Runyon, Calvin Coolidge, the Duke and Duchess of Windsor, Charles Lindbergh, and Anna May Wong. They all came to dinner.

JO ANN BASS,
OWNER OF JOE'S STONE CRAB RESTAURANT

Above: Jo Ann Bass as a young child. Left: Bass outside Joe's Stone Crab restaurant in the 1930s.

A Very Big and Exclusive Club

When my parents opened Joe's Broadway Deli in the 1930s, it was one of the few places to go besides Joe's Stone Crab. We were on Washington Avenue, and we had lines of people waiting to get in, especially on Sunday nights. It wasn't kosher, but it was an authentic deli. We had our own bakery in the back where we made the rye bread, and we cured our own pickles in big wooden barrels. We cooked big pots of brisket, and my brother was always stationed in the front window, carving a big roast beef. As a little kid in the late 1930s, I remember seeing Al Jolson come in all the time. He was real jovial, and he let us be silly and sit on his lap. Another regular was Ham Fisher, the cartoonist who created the *Joe Palooka* comic strip hero.

SISSI PERLMAN FELTMAN, RETIRED TEACHER

PHOTOS COURTESY OF SISSI PERLMAN FELTMAN

Top: A party catered by Joe's Broadway Deli. Above: Sissi Perlman Feltman in front of her home in the late 1930s. Left: Joe Perlman outside of Joe's Broadway Deli on Washington Avenue.

Food, Glorious Food

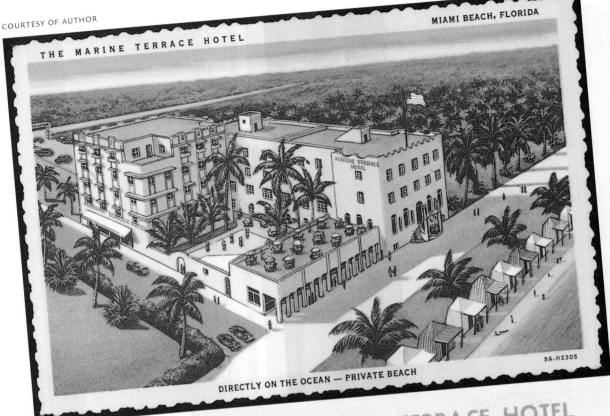

THE MARINE TERRACE HOTEL

MIAMI BEACH, FLORIDA

DIRECTLY ON THE OCEAN — PRIVATE BEACH

9A-H2305

GENUINE CURTEICH-CHICAGO "C.T. ART-COLORTONE" POST CARD (REG. U.S. PAT. OFF.)

PO

THE MARINE TERRACE HOTEL
On the Oceanfront at 27th Street
MIAMI BEACH, FLORIDA
Strictly Gentile Clientele — All Outside Rooms with
Bath — Dining and Dancing Patio — Parking Facilities —
Open the year around —
PRIVATE BEACH

Above: Vintage postcard of The Marine Terrace Hotel. Right: The back of the card carried an unsubtle message for those interested in the accommodations.

Gentiles Only

When I first came to Miami Beach in 1935, the anti-Semitism was pervasive; you just could feel it all around you. I once tried to play a game of golf, and when I walked into the country club the manager looked at me, pointed to a sign at the front desk, and said, "Can't you read?" The sign said NO JEWS ALLOWED. I was told to leave.

LEONARD WIEN, CIVIC LEADER

A Very Big and Exclusive Club

Coming from the South, where I had never known or lived with any other Jews, and moving to Miami Beach, a town that was rich with Jews, was like moving to a new world. But in the 1930s religion was in the background of Miami Beach. There was only one synagogue, so it was a lot of trouble for Jews to be Jewish. You had to go to Miami, and most just didn't want to bother.

When I talked about the business my parents had owned in Tennessee and used the expression "Jew Store," Miami Beach Jews reacted very negatively to it. My family had used that term all the time, but the Beach Jews were taken aback by it; they looked at me with horror.

I do remember seeing that famous Miami Beach hotel ad that promised "Always a View, Never a Jew"—right there in print.

<div align="right">STELLA SUBERMAN, AUTHOR OF THE JEW STORE</div>

During the 1930s my family belonged to the Bath Club. It was a real family-oriented place that had lots of activities for children, and as a kid I remember going there for egg hunts on Easter. There were a lot of older WASPs who went there just to drink. I remember one day when there was a big storm, and some old woman sat at the bar and would not budge. Furniture was blowing all over the place, and she just sat there drinking her martini from a silver cup.

The Bath Club was definitely restricted, and there were signs saying that Jews were not welcome. They also didn't want you as a member if you were divorced. And they didn't particularly like Irish Catholics; they allowed them to join, but they preferred if they only came late at night.

It was a real Waspy place full of northern industrial folks. These old WASPs had money and power, and they wanted to keep it. They saw the Jews—and anyone else not like them—as threats. They were the top dogs, and they didn't want any new dogs coming into the kennel. The anti-Semitism was a unique trick in Miami Beach, something that wouldn't fly up North. Looking back, I think it was as much about snobbery as it was about bigotry.

<div align="right">CHUCK BRANSFIELD, RETIRED OIL DRILLER</div>

The prejudice against the Jews was blatant, but you know, the Catholics didn't have it so good, either. Catholics were a minority, and they weren't welcome at the Gentiles' clubs. During the 1930s there were still a lot of southerners in Miami Beach—southern Crackers, if you will. They were anti-Semitic and anti-Catholic and they sided with the Ku Klux Klan. For the longest time Catholics couldn't get jobs with the City of Miami Beach—not even blue-collar jobs like firemen and garbage collectors.

<div align="right">JOSEPH L. WESSEL, RETIRED FIREMAN</div>

The Color Line

I worked as a maid at the Mayfair Hotel in the 1930s, and I remember the sign they had in the lobby: NO DOGS, NO JEWS, NO COLOREDS. Miami Beach was segregated to the finish. It was rough for Jews, but it was worse for us black folks. Every time I left my apartment in Miami to go to work in Miami Beach, my mother would hug me and kiss me and tell me to be careful. She knew what I had to face out there. After work I had to get off the Beach by sundown, take the last bus back to Colored Town. I was making about $7.00 a week, and from this I had to pay for bus rides back and forth. I also had to get an ID card and pay for that, too.

COURTESY OF SHIRLEY HOLMES

Iona Holmes and her brother, Godfrey "Precious" Holmes.

Work was scarce for blacks, and so you took whatever you could get. Women got jobs as maids, but the men could only get jobs as porters—never as bellboys or waiters, jobs where they interacted with the guests or went near the money. This was tough because the white bellboys usually got to the rooms first after the guests checked out, and they would often take the money that was left for us as tips. But we wouldn't dare complain. We didn't want to be branded as troublemakers. Lord no. God only knows what would have happened to us then.

I once went in to clean up a room after some guests had checked out, and the people had stolen everything: bedspread, towels, even the curtains. And there was a little dog sleeping in the bed—a Chihuahua stretched out on his back. The dog looked at me and I looked at him. I got scared. There weren't supposed to be dogs in the hotel. So I called the manager and told him to come up to the room immediately. When he got to the room, he said the people were still in the driveway with their car. I told him to go after them and get the things that they stole. The manager said he couldn't do that, or they would sue. I thought to myself, "Damn, this man searches me every time I leave the hotel to see if I stole a little bar of soap, and he won't go after these people who stripped the room bare and left a stupid dog in the bed." It wasn't right.

We couldn't even use the toilets in the hotel where we worked. If we had to go to the bathroom during our eight-hour shift, we had to walk three blocks away to another hotel that had a special servants' bathroom for blacks—even when it was raining. We couldn't drink a glass of water at the hotel. Had to go outside to use a public water fountain, one that said COLOREDS. My brother was working in a Miami Beach hotel, and he once drank from a glass of water. When he finished drinking, the manager took the glass and smashed it on the floor.

We couldn't shop on the Beach, either—not that we really wanted to because it was so expensive. But I once saw a pair of shoes in the window of a store on Lincoln Road. I wanted to go in and try

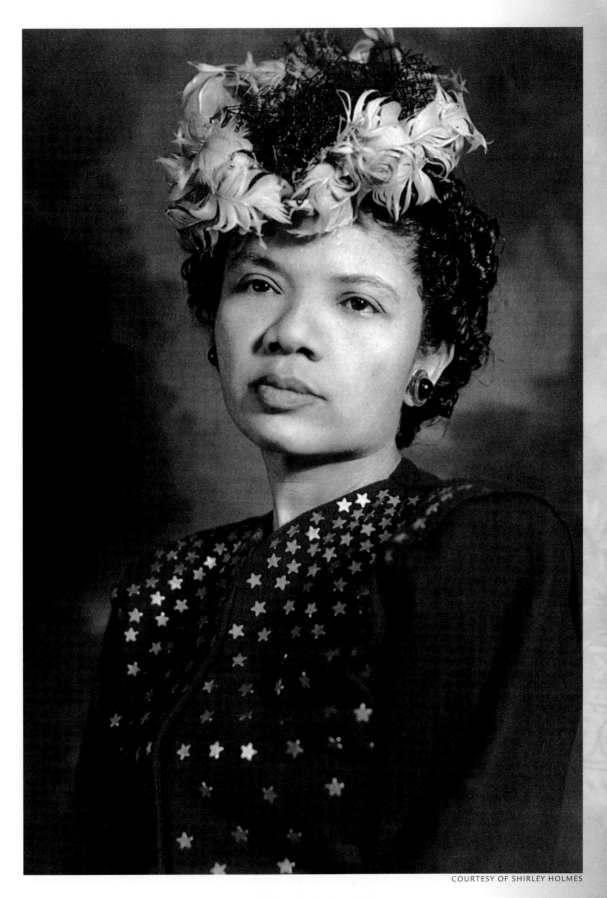

Iona Holmes in the late 1930s.

them on. The man in the store told me that I could buy them, but I couldn't try them on. The same thing was true with clothes.

When we got on a bus, we had to get on the back door and pass our money up to the front. Couldn't even walk by the white people. One time I got on a bus and went to the back, and it was full of white people sitting where they weren't supposed to be sitting. I said, "I'm going to count to three, and if someone doesn't get up and give me a seat, I'm going to sit on somebody." Sure enough, I counted and no one moved, so I just sat down on some white man's lap.

There was once a big storm on Miami Beach—a hurricane—and I was listening to the battery-powered radio. A news announcer came on and he said, "Ladies and gentlemen, God must be a Negro, 'cause the Beach has been torn apart while there was absolutely no damage done to the little shotgun houses in Colored Town." Can you imagine that? Said it right on the radio.

IONA HOLMES, RETIRED MAID

My father came to Miami Beach from the Bahamas and he worked for Carl Fisher, cutting down the mangroves so he could build the hotels. When I was about eight years old, in the 1930s, my father took me to Miami Beach for the first time to show me around and explain to me how it worked. He told me to always keep my mouth shut to avoid trouble—just do what I was told.

PRINCE GEORGE GORDON, RETIRED RESTAURANT COOK

As a young girl in the 1930s, I never went to Miami Beach. People of color were not allowed to go there—at least not for fun. It was the law, so I had to obey the law. If we wanted to have a church picnic on the beach, we had to go up to Broward County. The only people I knew who went to Miami Beach went there to work. There were many young colored women who had college degrees, and the only job they could get was working as a maid on Miami Beach, and they all had to get ID cards. Even my husband, who was in the clergy, had to get an official letter from city hall saying that he was allowed to go to Miami Beach. And he was only allowed there for official business.

LEOME F. CULMER, WIFE OF THE LATE FATHER JOHN E. CULMER

From the 1930s through the 1950s, my mother worked as a maid and my father worked as a gardener on Miami Beach. There weren't many options at that time, so it was a good job for them. They worked in private homes and were highly respected, because the folks trusted them enough to let them live on the premises. But at sundown every night, they abided by the law and never left the house—just stayed in their servants' quarters. My mom did cleaning and laundry, and when the women of the house had children, they turned them over to my mother to raise. The good thing about this for me was that the women passed their clothes on to us. When I went off to college, I was wearing Bergdorf

Goodman dresses, the finest of the fine, courtesy of rich white women from Miami Beach.

In 1933 my parents were living on Pine Tree Drive, and my mother gave birth to my brother in the servants' quarters. When my mother went to the Bureau of Vital Statistics to have his birth registered, they refused to put Miami Beach on his birth certificate. No black people were supposed to be living on Miami Beach, let alone be born on exclusive Pine Tree Drive, and they just wouldn't give in about it. So his birth certificate says he was born in Miami.

ENID PINKNEY,
RETIRED TEACHER AND SCHOOL PRINCIPAL

My father was mayor when the Beach created the ordinance for ID cards in 1936. It was not a bad ordinance; it didn't exclude anyone. There were big fancy homes on the Beach and people were worried about robberies, so they wanted to control what kind of element was coming onto the Beach. You have to remember that the KKK was around in those days. The ordinance applied to everyone—blacks, whites, Hispanics, Asians. They all had to have ID cards if they worked on the Beach.

JIM SNEDIGAR, SON OF EARLY MIAMI BEACH
MAYOR LOUIS "RED" SNEDIGAR

I had grown up with segregation in Tennessee, so the ID cards and curfews for blacks in Miami Beach did not seem abnormal to me. Like most genteel Southerners, my motto at the time was "Don't be ugly to darkies, but keep them in their place." Today it sounds shocking, but when I spoke those words in the late 1930s, nobody even blinked.

STELLA SUBERMAN,
AUTHOR OF *THE JEW STORE*

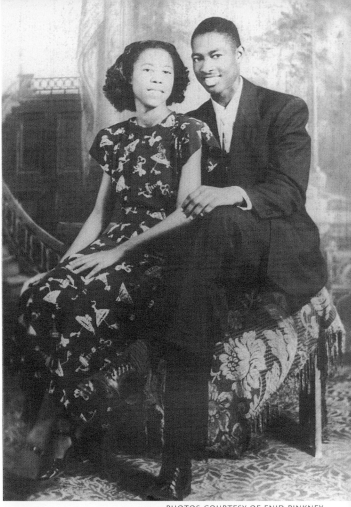

PHOTOS COURTESY OF ENID PINKNEY

Above: Enid Curtis Pinkney with her brother, Israel Curtis. Below: Lenora Curtis answering the phone. Curtis, mother of Enid Pinkney, worked as a maid.

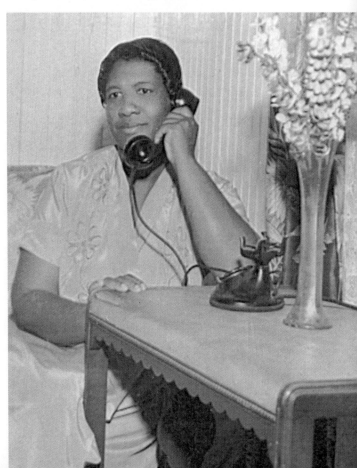

POSITIVELY
NO ONE IS ALLOWED TO STAND
OR BLOCK the ENTRANCE
AT ANY TIME
This Means You.

FIVE O'CLOCK CLUB
MIAMI BEACH, FLA.

Drinks on the House
at Five o'clock

COCKTAIL ROOM at 5 O'CLOCK
CLUB·COLLINS AVE. & 22ND ST.
AIR·CONDITIONED·A COMFORTABLE
TEMPERATURE AT ALL TIMES

OPEN ALL NIGHT

DINING
DANCING

CLOSE COVER BEFORE STRIKING MATCH

The Joint Was Jumpin'

1939–1949

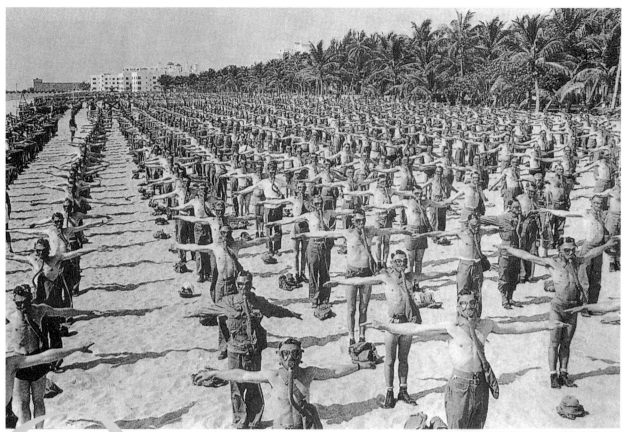

Above: Soldiers training on the beach. Below: Rosie the Riveter motivational poster.

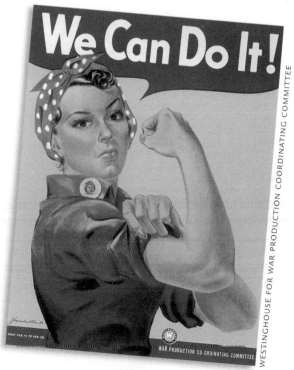

On May 13, 1939, the luxury cruise ship SS *St. Louis* set sail from Hamburg, Germany, for Havana, Cuba. On board were 937 Jewish refugees fleeing Nazi Germany. As the ship approached Havana, the Cuban government declared the passengers' visas invalid and denied their entry into the country. Shortly afterward, the *St. Louis* sailed to Florida, where it hovered off the shore of Miami Beach for days, awaiting permission to enter the United States.

U.S. Coast Guard boats patrolled the waters, making sure no one onboard jumped to freedom. Citing the U.S. government's strict immigration quotas, President Roosevelt denied the ship's entry into the Port of Miami. It was forced to return to Europe, where it eventually docked in Belgium. Most of the passengers later died in the Holocaust. For residents of Miami Beach, the SS *St. Louis* served as a harbinger of the horrors soon to come.

Once World War II officially began, Miami Beach was very much a part of the home-front effort, with scrap drives, rationing, and a we-can-do-it attitude. Between

1942 and 1945 more than one hundred local hotels were commandeered by the U.S. government and transformed into barracks and hospitals, and more than 400,000 handsome young military men came to town. While German U-boats roamed the waters offshore, American soldiers marched through the streets and locals cheered them on.

As the war raged on, segregation remained an acceptable policy in Miami Beach. The line separating whites and blacks was firmly in place, even among the military men stationed on the Beach for duty. White soldiers were warmly welcomed at USO concerts and parties; black soldiers were not. By the latter part of the decade, however, the idea that racism was unacceptable had begun to take hold. Little by little, area whites began to push the envelope. White doctors started accepting black patients, baseball legend Jackie Robinson checked into a Beach hotel along with his white teammates, and socially conscious teachers began introducing their students to the latent injustices of 1940s society.

Following World War II, Miami Beach slipped into a period of unbridled optimism. Many of the soldiers who had been stationed on the Beach returned, both as tourists and as permanent residents wanting to start a new life. The local economy was in great shape, and the island was once again a vacation haven.

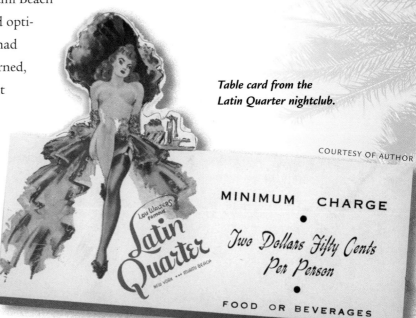

Table card from the Latin Quarter nightclub.

COURTESY OF AUTHOR

President Harry Truman came for a visit, and long-legged showgirls paraded around local nightclubs. At Miami Beach High, a bright young girl named Barbara Walters studied hard while keeping a low profile. At the time, her father, impresario Lou Walters, ran the Latin Quarter nightclub. Radio personality Gabriel Heatter moved to the Beach and started broadcasting his nationally syndicated show with his trademark opening line, "Ah, there's good news tonight." And gossip columnist and radio commentator Walter Winchell was a regular man about town.

The demographics of the Beach began to change dramatically in the post-war years as Jews from Europe—as well as from New York and elsewhere in the United States—started moving to the island in record numbers. Jewish hotel owners from New York's Catskills Mountains also expanded their operations southward, opening new hotels on the Beach that catered specifically to a Jewish clientele.

At first Miami Beach's steadily growing Jewish community was passive, focused on getting ahead and eager not to rock the boat. But eventually this group developed into a powerful political and

cultural force—one that influenced commerce and politics locally, as well as politics on the world stage. It was around dinner tables in Miami Beach that political activists planned Zionist strategies and were instrumental in the creation of the state of Israel. Such conversations might have also taken place at Wolfie's or The Famous—Jewish restaurants that gained a cultlike following among diners who always went home stuffed.

Another, very different group also wielded financial and political power in Miami Beach throughout the 1940s. Known as the S & G, these homeboy hustlers made a living from the "juice" of bookmaking, placing bets on horses, ball games, and any other event that lent itself to the point-spread rules of turf accountants. With some of their profits ($40 million annually by late in the decade), the S & G funded local politicians running for reelection, paid off more than a few cops, and put up the front money for new hotels in exchange for a piece of the action. They also used the money to buy

JANTZEN SWIM SUITS

three-bedroom homes, put their kids through college, and live comfortable middle-class lives. It is estimated that the S & G had ties to more than 200 Miami Beach hotels, and they did the bulk of their business out of poolside cabanas.

What the letters S and G stood for is debatable. Some claim they meant "stop" and "go"; others said "sex" and "gambling." Regardless, the joyride came to an end when Estes Kefauver came to town. This Democratic senator from Tennessee led a federal investigation into interstate organized crime that played out in a series of dramatic televised hearings. Many locals sat in front of their TVs mesmerized by the proceedings as neighbor after neighbor was called forth to testify. The S & G's lawyer, Ben Cohen, argued that the group was nothing more than a quasi-legal organization that had been condoned for years. The judge didn't buy it. In the end the S & G

was forced to disband, and Miami Beach lost a major source of income—albeit an illegal one.

Along with backroom gambling, another form of employment provided above-average income for a few in Miami Beach, but this one required no affinity for numbers. Old-fashioned bump-and-grind burlesque was a major form of entertainment in the postwar era, one that was as American as apple pie. It started a decade earlier when the famed Minsky family from New York opened Minsky's Burlesque on the Municipal Pier. It continued well into the 1940s with places like Chez Paree, where the audiences included men and women from all strata of society.

Not at all like the tacky pole dancing of today, stripping in those days was more about the tease than the strip. Performances were well-choreographed cabaret acts that told a story, and live bands

almost always accompanied the show. Clad in sequin gowns with feathers and fans as props, these women disrobed s-l-o-w-l-y, one glove at a time. Full nudity was forbidden; pasties and G-strings were the norm, as were tassels, which were used in a rather impressive manner. Bawdy and beautiful, these full-figured women flaunted their sexuality with humor and style. They were Miami Beach's temptresses of the tease.

All over town, local clubs sizzled with musicians, comedians, and other celebrities. Latin rhythms from the likes of Tito Puente and Xavier Cugat echoed late into the night, and the mambo and cha-cha were all the rage. Martha Raye and Shecky Greene played for laughs at the Five O'Clock Club. A young Dean Martin and his sidekick, Jerry Lewis, were just getting started, and many other venerable idols were around as well including Elizabeth Taylor, Buster Keaton, Louis Armstrong, Billie Holiday, Veronica Lake, Maurice Chevalier, Jimmy Durante, Tony Martin, Lena Horne, and Nat King Cole.

By the end of the decade, the joint was jumpin'.

© RAY FISHER

Lucille Ball at the beauty parlor in the Versailles Hotel in 1948.

First Impressions

I first came to Miami Beach on a family vacation in 1945, and my first impression was that it was heaven. The skies were bluer than any skies I had ever seen, and it looked like an exotic South Sea Island. Reminded me of all the Dorothy Lamour movies I had watched as a kid. And I became acquainted with mangoes.

BUNNY YEAGER, PHOTOGRAPHER

I'm a Miami girl, so growing up I really didn't have much contact with Miami Beach. But I do have a vague memory of my first visit there; it was to some sort of circus in the 1940s. And then I remember going to the Delido Hotel for a slumber party with a group of classmates. We all just sat around in our pajamas and talked.

JANET RENO, FORMER U.S. ATTORNEY GENERAL

The War Era

I was about sixteen when I heard about the SS *St. Louis*. There was vague talk about it on the Beach, and we didn't really understand it until the *Miami Herald* published a small item about it. We didn't realize that the people on the ship were trying to save their own lives.

I saw the boat offshore, and it was an eerie sight. It came close to shore and then went farther away and then came back again—did this for days. We called it the mystery ship. Then it disappeared for good. When we learned that it was turned away, we were horrified. There was an awareness of what was going on in Europe at the time, and yet there was no real outrage in the community.

STELLA SUBERMAN, AUTHOR OF *THE JEW STORE*

I was able to see Miami Beach from the boat [the SS *St. Louis*] because we were very close to shore. I could see the Art Deco hotels and the lights of the cars, especially at night. I was just a boy, traveling with my parents and my brother and sister.

This was after the Cuban government had turned us away. That's when we came to Florida, because we thought for sure the U.S. would let us in. We were looking for asylum—any place that would take us. But the U.S. government turned us down. We sent telegrams from the ship to Mrs. Roosevelt

Soldiers with Miami Beach girlfriends in 1942.

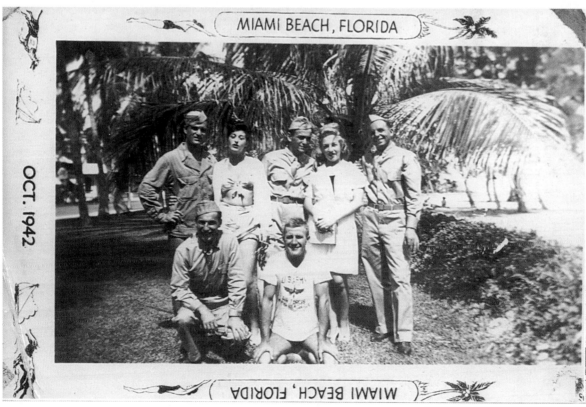

MIAMI BEACH, FLORIDA

OCT. 1942

MIAMI BEACH, FLORIDA

COURTESY OF SHIRLEY YOUNG ZARET

asking her to at least let the
children off, but we heard
nothing back from her. And
then the Coast Guard
chased us away.

The mood on the ship
at that point was very grim.
People were terrified about
what was going to happen
to them—terrified about
what was going to happen
to their children. We then
sailed to Belgium, and three
months later the war broke

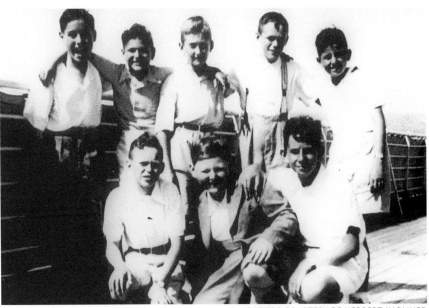

out. Except for my brother and me, my entire family died
in the Holocaust.

I remember thinking to myself while on the ship,
"Someday I'm going to go back, back to Miami
Beach." And I did. I moved here in 1948. It was a mir-
acle that I survived and an even bigger miracle that I
came back to Miami Beach. When I finally saw Ocean
Drive, I was crazy with happiness. Then, in 1950, I got
a letter from Uncle Sam saying he needed me to serve
in Korea. In 1939 he didn't need me. But he needed
me now, so I served in the war.

You know, when we were on that ship, we didn't
ask anything from the U.S. We didn't ask for money
or assistance—just entry. That's all we wanted. The
problem was we were Jews. It still makes me sick to
think about it. Here we were denied entry, and years
later hundreds of thousands of Cubans were
allowed in and given asylum and money and all
kinds of government assistance.

GERMAN-BORN HERBERT KARLINER,
ONE OF THE FEW SURVIVORS
OF THE SS *ST. LOUIS*

*Above: Herbert Karliner (bottom row, first
on left) with a group of boys on the sun deck
of the SS* St. Louis *in 1939. Below: Karliner
with his sister, Ruth, and father, Joseph, on
the SS* St. Louis.

The War Era

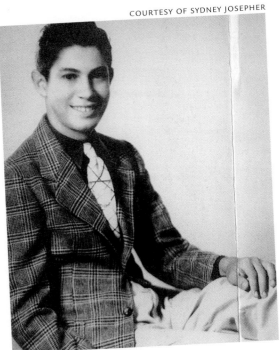

In 1941 Eleanor Roosevelt gave a talk at Miami Beach High. I was an editor at the school newspaper, and later I was sent out to interview her at the Roney Plaza with kids from other schools. We asked questions about the looming war—Germany was already bombing England, and there were dark clouds on the horizon for the U.S. Mrs. Roosevelt's answers were clear and intelligent. She seemed to know exactly what was going on politically. And she was very down to earth and made us feel very comfortable. It was a big scoop for a young kid, and I still remember my headline—"Mrs. Roosevelt Comes and Goes."

SYDNEY JOSEPHER, STOCKBROKER

Above: Sydney Josepher in 1940.
Below: Vintage postcard
of Winston Churchill.

While vacationing in Miami Beach in 1946, my grandfather [British prime minister Winston Churchill] was the perfect tourist, which was quite unusual for him. He normally chose to go to places that he called paintable—places where he could get a good landscape. He usually spent his holiday time writing and working, but while in Miami Beach he did a lot of tourist things.

He was there for several weeks. He and my grandmother were guests of Colonel Frank Clarke, and they stayed at his private home. They held a press conference, and he flashed his victory symbol. He was also invited to a cocktail party at a home on Delido Island and he went. This was very unusual; going to cocktail parties wasn't his way of life. While at the party he noticed a wall that was under construction, and he told the hosts that he was an excellent bricklayer. He picked up the trowel and just started laying a row of bricks. The guests were amazed.

He also went swimming in the ocean and then set up his easel and did a few paintings of the sea. I think he very much enjoyed his time in Miami Beach and found it restful and peaceful and inspiring, because it was in Miami Beach that he wrote his famous "iron curtain" speech. He also received a visit from American Secretary of State James Byrne, and they discussed the arrangements for a U.S. loan to Britain.

CELIA SANDYS, GRANDDAUGHTER
OF SIR WINSTON CHURCHILL

The Joint Was Jumpin'

The Miami Beach that I knew as a kid during the 1940s was fabulous. It was the place to be. I was a hotel kid at the Shelbourne and grew up watching water ballet shows and meeting famous people. Everyone I knew had yachts. We had big parties, and we all knew the mayor and the governor. It was a charmed life.

President Harry Truman came to dinner at our family house on North Bay Road. I was a young kid and didn't think it was a big deal, especially since I was introduced to him as Uncle Harry. General Douglas MacArthur came to our hotel after the city named the causeway after him, and I sat on his lap. My parents always invited politicians for dinner, and I think I was ten years old before I realized Uncle Sam wasn't a member of my family.

MARGORIE COWAN, DAUGHTER OF SAM FRIEDLANDER,
FOUNDER OF THE FOOD FAIR GROCERY CHAIN

I was in high school during the war, and I started singing at USO concerts on the Beach. At the time my father owned a company that manufactured military uniforms, so some of the more famous guys would come by my house to get measured for their uniforms. John Wayne came by to get fitted; so did Clark Gable. When Gable showed up, my mother started playing the piano for him. She called me into the living room and said, "Meet my daughter Judy. She sings." She made me stand up and sing for Clark Gable right there in our living room. I was so embarrassed I thought I was going to die.

Judy Nelson Drucker
(in long gown, on left) with musical troupe.

COURTESY OF JUDY NELSON DRUCKER

JUDY NELSON DRUCKER, ARTS IMPRESARIO

Clark Gable in barber's chair before training in the Army Air Corps.

I loved seeing the celebrities on the Beach during the war. I once saw Clark Gable. Actually, my friends and I stalked him while he was out marching. His wife, Carole Lombard, had just died, but he didn't appear to be grieving too badly, because he dated lots of girls on the Beach. And when Hank Greenberg (the Jewish player with the Detroit Tigers) came to the Beach, we all squealed with joy—just squealed.

STELLA SUBERMAN,
AUTHOR OF *THE JEW STORE*

My wife worked at the Red Cross, so she was able to pull a few strings and she got to meet Clark Gable while he was in uniform. That's all she talked about for weeks—Clark Gable, Clark Gable, Clark Gable. Not long after that I remember seeing a young Frank Sinatra, who was also here. He was in a uniform and looked very handsome. Fortunately my wife did not get to meet him.

LEONARD WIEN, CIVIC LEADER

What I remember most about World War II is the enforced blackouts. We all had to hang dark curtains on our windows and draw them tight every night. If the patrols saw lights shining through your windows, it was considered an offense and you were fined. We also had bomb drills at school and we had to crawl under our desks.

Many of us had little victory gardens where we grew radishes and carrots. I don't think anyone really ate those carrots, but it was a fun thing to do. We also went to the beach to look for burlap bags full of sugar and flour that floated onto shore from cargo ships that had been torpedoed by German U-boats.

The best part of the war was when I set up a lemonade stand on the Bayshore Golf Course with a group of friends. The soldiers did their calisthenics there, and it was hot so we had a real monopoly. We sold drinks at 2 cents apiece and made a bundle.

ANN BROAD BUSSEL, FORMER TEACHER

**Ann Broad Bussel
as a young girl.**

I was a teenager during the war and worked for the patrol in charge of making sure everyone's car headlights were darkened. The rule changed from half-darkened at the beginning of war to completely dark during the middle of the war, when German submarines were off the coast.

BURTON YOUNG, ATTORNEY

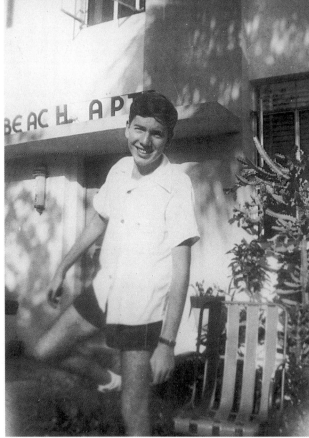

COURTESY OF BURTON YOUNG

Above: Burton Young in front of the Beach Apartments. Below: Jo Ann Bass playing on the beach near her apartment above Joe's Stone Crab restaurant.

I was about ten years old during the war, and I remember the army soldiers marching down the street right under my bedroom window. Hundreds of them at a time singing the same song morning, noon, and night: *Around her neck she wore a yellow ribbon. She wore it in the springtime and in the month of May. And if you asked her why she wore it, she'd say, "It's for my lover who is far, far away."*

I also remember having to get my supply of bubble gum from a bookie who was married to a cousin of mine. Uncle Louie was his name, and he had the key to everything. He told me to go to a specific storefront next door to Dolly's ice cream parlor and knock on the door, saying "Louie sent me." I don't know what else went on in there, but Uncle Louie came through, and I got my bubble gum.

Joe's still functioned during the war, but we had to deal with rations. We had plenty of stone crabs because they came from Cuba, but we had a hard time getting meat. I do remember that local society ladies would come in and bring a group of soldiers as a gift to the war effort. I also remember that these society ladies stuffed their pocketbooks with sugar and ketchup, and my parents never said a word to them.

JO ANN BASS,
OWNER OF JOE'S STONE CRAB RESTAURANT

COURTESY OF JO ANN BASS

There weren't any tourists, just soldiers who didn't have any money, so it was rough for our taxi business. In order to make money, my dad charged 25 cents per person for a ride anywhere on the Beach. Gas was expensive and hard to get,

A fleet of Segal Safety Cabs.

so if there were three guys you made money, but with only one you lost money. Our competitor thought they would break our business by giving guys quarters for our rides. But we wound up loading up the cars with six guys at a time, and we ended up making a lot of money while our competitor almost went broke.

STANLEY SEGAL, RETIRED TAXI COMPANY OWNER

During the war the doors to Temple Emanu-El were always open. We had a member called Mother Bloom, an old woman who loved to cook, and she put on suppers for the servicemen. Word got out, and we were always packed. Jews, non-Jews—it didn't matter. They all came to eat hamburgers—thousands of them.

BELLE LEHRMAN, WIFE OF THE LATE RABBI IRVING LEHRMAN

World War II was a happy time for me because I met my husband at a USO dance. It was at a temple on Third Street—the same temple where we later got married. After we met he would come by my window with his troop, and they would all sing "Someone's in the kitchen with Shirley." His best buddy was the drill sergeant, so he got away with it. He also brought me big roast beefs and hams. Food was rationed, and I was very happy to get it.

The Joint Was Jumpin'

One of the other things that we couldn't get was nylon stockings. The military wanted the women to feel that this was not such a big deal, so they started this campaign and got me involved. I looked a little like Betty Grable at the time, so they painted a line down the back of my legs that looked like a stocking seam and they had me model for them. Then someone took my picture for the *Miami Herald,* and there was a story that said, "Look ladies, you don't need stockings, just paint your legs."

SHIRLEY ZARET,
RETIRED SECRETARY AND BOUTIQUE OWNER

World War II brought a lot of hookers to Miami Beach. Before the war there were not many around, but during the war we had a bunch. They came from all over the U.S. and mostly stayed in Miami, not Miami Beach. But they came over for business and went to the USO parties. A lot of local girls got invited to the USO parties, but many mothers didn't want their daughters going because it was bad for their reputation. And us local guys were rarely invited. They didn't need more guys.

HAL KAYE, PHOTOGRAPHER

The U.S. military used to take the German prisoners swimming down on First Street, near the pier. I guess they didn't have bathing suits, because they always wore their clothes—with PW printed on the back of their shirts. Those guys had a blast on the beach, kidding around, playing ball. Didn't look like a hardship to me.

BERNIE ROSENFIELD,
RETIRED SERVICE MANAGER

I saw the German POWs on Miami Beach and let me tell you, they had it made. They were dressed well, they got three meals a day, and they got to exercise on the beach. Compared to POWs of today, theirs was not a bad life. If the German army knew how well these guys were being treated on Miami Beach, they would have all laid down their guns, and the war would have ended sooner.

SHELDON MILLER, REALTOR

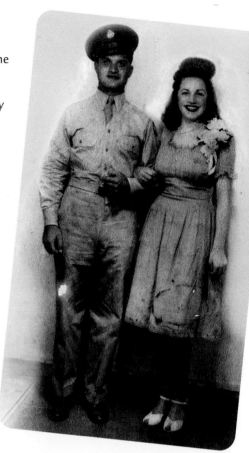

Above: Shirley and Karl Zaret after their 1943 wedding. Below: Shirley and Karl (left) with another soldier.

PHOTOS COURTESY OF SHIRLEY YOUNG ZARET

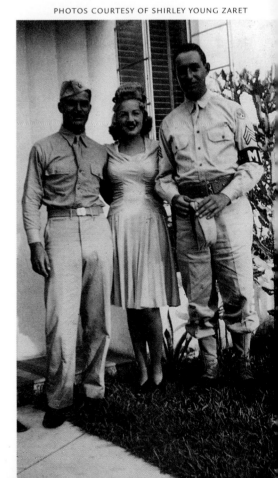

The War Era

The Color Line

If you were black and served in the military on the Beach during World War II, you had to be back in the barracks by 9:00 p.m. You had to be off the streets, or you would get in trouble. White guys were able to go to nightclubs and USO shows and restaurants, but blacks weren't allowed to travel around at all. It was as if people just didn't want to see black faces. If we went to a movie theater—and that was rare for us to be allowed in—we had to sit in the black section way up in the balcony. It was not pleasant, and it was an everyday discussion with us. Why do we have to go through this?

ANTONIO BENJAMIN,
FORMER SOLDIER AND CHAUFFEUR

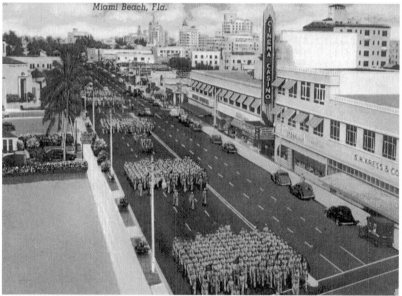

COURTESY OF EVERETT M. LASSMAN

Vintage postcard of soldiers on parade.

During World War II I worked as a shoe-shine boy on Miami Beach. After school I would take the bus from Overtown with my little shoe-shine box and set up on a street corner. The soldiers loved it, and it was a good way for me to make some school money. I charged 25 cents a shine and did real well until the police came along and chased me away—told me to go home where I belonged. Blacks weren't welcome on the Beach, not even little shoe-shine boys.

FRANK PINKNEY,
RETIRED BUSINESSMAN

I was once taking the trolley car over the County Causeway, coming home from work in downtown Miami, and I sat down next to a black man. A white passenger on the bus got up out of his seat and came over to me. He yanked me up out of my seat by my collar and said, "Don't you know you shouldn't be sitting next to those people?" The segregation was a very frightening thing, even to us whites. I had never seen anything like it before—certainly not up North, where I came from.

SHIRLEY ZARET,
RETIRED SECRETARY AND BOUTIQUE OWNER

Even as a young boy in the 1940s, I felt uncomfortable with the social climate of Miami Beach. The place was permeated by a sense of inequality. This point was made crystal clear to me in the seventh grade when my civics teacher, Harold Matheson, took our class on a field trip to Overtown to see the little shacks where poor black people lived. Matheson was a social activist who wanted us Miami Beach kids to see how privileged we were. He told the class, "This is where your maids live. The women who take care of your little brothers and sisters. The women who iron your clothes." It was shocking to us—absolute squalor and yet so close to Miami Beach.

BURTON YOUNG, ATTORNEY

During the late 1940s my dad owned the Lord Tarleton Hotel. There were always a lot famous people around—Al Jolson, Henny Youngman—and it was not a big deal. But one day he got a call from the manager of the Brooklyn Dodgers saying that he wanted to bring the team to Miami Beach. And that he wanted to house the entire team—blacks and whites—in one hotel. My dad had no qualms about it and said sure. Jackie Robinson had just joined the team, and my dad knew that there might be some controversy, so he went about it in a really clever way. He called the *Miami Herald* and the radio stations and suggested that they cover it like a news event—made it all about the team. Reporters showed up and took pictures of the players checking in. And because of the way my dad handled it, nobody was able to say anything negative about it. It was sneaky, but it was how people had to work around the racism of the day.

RICHARD JACOBS, RETIRED FINANCIAL PLANNER

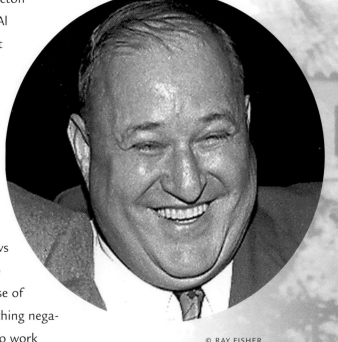

© RAY FISHER

Walter Jacobs, owner of the Lord Tarleton Hotel.

I almost got tarred and feathered when I let it be known that I was willing to allow black children to come to my office for care. I let them sit in my waiting room and drink from the water fountain. There were only about four pediatricians on the Beach in the late 1940s. What was I going to do? These children needed medical treatment. I also took care of a lot of black maids and janitors who worked on the Beach, because they had nowhere else to go. Most of the good old Southern-boy doctors who were practicing then would not even touch a black person. I would and I got hell for it, but I didn't care.

HOWARD ENGLE, PEDIATRICIAN

The Color Line

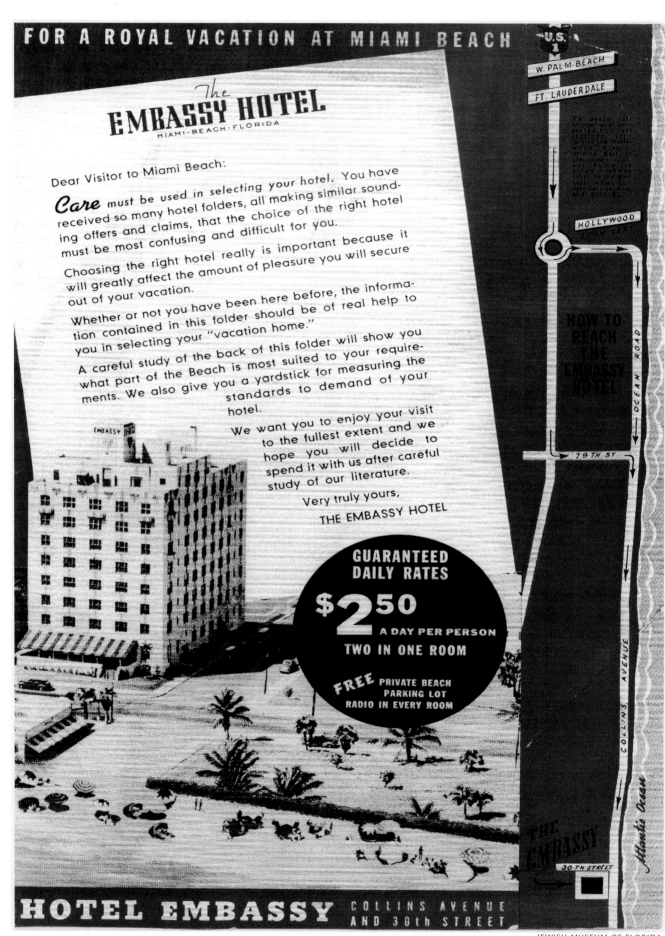

FOR A ROYAL VACATION AT MIAMI BEACH

The
EMBASSY HOTEL
MIAMI · BEACH · FLORIDA

Dear Visitor to Miami Beach:

Care must be used in selecting your hotel. You have received so many hotel folders, all making similar sounding offers and claims, that the choice of the right hotel must be most confusing and difficult for you.

Choosing the right hotel really is important because it will greatly affect the amount of pleasure you will secure out of your vacation.

Whether or not you have been here before, the information contained in this folder should be of real help to you in selecting your "vacation home."

A careful study of the back of this folder will show you what part of the Beach is most suited to your requirements. We also give you a yardstick for measuring the standards to demand of your hotel.

We want you to enjoy your visit to the fullest extent and we hope you will decide to spend it with us after careful study of our literature.

Very truly yours,
THE EMBASSY HOTEL

GUARANTEED
DAILY RATES
$2.50
A DAY PER PERSON
TWO IN ONE ROOM

FREE PRIVATE BEACH
PARKING LOT
RADIO IN EVERY ROOM

U.S. 1
W. PALM BEACH
FT. LAUDERDALE
HOLLYWOOD TURN LEFT

HOW TO REACH THE EMBASSY HOTEL

OCEAN ROAD
79TH ST.
COLLINS AVENUE
Atlantic Ocean
THE EMBASSY
30TH STREET

HOTEL EMBASSY
COLLINS AVENUE
AND 30th STREET

Gentiles Only

I worked as a handyman at an apartment building on Belle Isle in the 1940s, and it had a sign outside that said NO JEWS NO DOGS. The people who lived in the apartment building (all Gentiles) didn't want the Jews—or us blacks—walking by the mailbox, a public mailbox where you put letters. So they moved it. Had workers from the city come and move the mailbox just so they wouldn't have to look at Jews or blacks walking by their building.

PRINCE GEORGE GORDON,
RETIRED HANDYMAN AND RESTAURANT COOK

Throughout the 1940s my family's taxi company used big four-door Chevys for their fleet. Why Chevys? Because my father would not buy cars from Henry Ford. Ford was an anti-Semite, and my father had had enough of anti-Semitism living on Miami Beach. We had a driver who worked for us at that time named Sam. One day Sam was picking up a lady at the airport, and she told him, "Take me to Miami Beach—to a hotel that doesn't have any Jews." So Sam took her to the worst hotel in the black neighborhood of Miami and told her to get out of the car. He said to her, "Here lady, there are no Jews in this hotel."

STANLEY SEGAL, RETIRED TAXI COMPANY OWNER

COURTESY OF MIKE SEGAL

Stanley Segal of Segal Safety Cabs lifting weights in his auto garage.

As a photographer—a Jewish photographer—I never had a problem with the anti-Semitism. Most of the restricted hotels and clubs wanted to get photos of their guests in the paper, so they let me in to shoot. But just for the hell of it, I always wanted to show up at the Surf Club—which was restricted—wearing a T-shirt that said *Jewish Floridian,* the newspaper, and say, "Hi, I'm here to shoot the bar mitzvah."

RAY FISHER, PHOTOGRAPHER

There was a real connection between the Catskills and Miami Beach in the 1940s. Up North the season was Memorial Day to Labor Day, so it made sense for the hotel owners to open winter places in Miami Beach. That's what my father did. He owned the Stevensville Hotel in the Catskills, and he used that mailing list of guests' names as a marketing tool to bring people to his Miami Beach hotels. He had a built-in clientele base that knew him, and that's how many of the early Jewish tourists started coming here. He also already had the staff—the waiters, the maids, the bellboys—and they, too, schlepped south for the winter.

The seasons dovetailed so well that it was a natural progression. And at the time, there was still a lot of anti-Semitism on the Beach, so Jews were happy to stay at Jewish-owned hotels. But one thing was different: Most of the Catskills hotels were kosher. That wasn't true in Miami Beach. By that time many of the immigrant Jews had assimilated and moved into higher economic brackets. It was also more expensive for the Catskills guests to drive to Florida, so it naturally attracted the wealthier guests, more sophisticated people—people who read the *New York Times* rather than the *Forward.*

KEN DINNERSTEIN, LAWYER AND HOTELIER

There was still plenty of anti-Semitism when I was growing up in the 1940s. There were real estate covenants that disallowed the sale of property to Jews—it was written into deeds. When my father was pumping landfill for Bay Harbor Islands, he had to get a special pass from Indian Creek Village just to stand on the golf course in order to oversee his development. When the authorities realized that my father was going to allow Jews to live there, they wouldn't renew his pass.

So as a Jew, I knew my place in the society. I did have a few Gentile friends who invited me to parties at the Bath Club. But before I went my mother would give me a talking-to. "Remember who you are and what you are," she said. "You are not welcomed there in the first place, so if someone says something bad about you being Jewish, just ignore it and don't start crying."

I remember when Rabbi Kronish was trying to build a group of parishioners, trying to create a community of Jews. He actually went out door-to-door looking for Jewish kids. He came to the playground at my school and recruited us—gave us jelly donuts. He was a like a camp counselor, a fun young guy, so we liked him and told our parents that we wanted to sign up. That's how he built up Beth Sholom.

This was about the time when all the Zionists came to our house for dinner and had these deep philosophical conversations about what they were going to do for Israel and how they were going to do it. Abba Eban came and so did Ted Kollek, who later became the mayor of Jerusalem. A lot of Holocaust survivors were in Miami Beach by then, and they were very active, too. Even Meyer Lansky was involved. He donated a lot of money. These were the early days of planning, between 1945 and

Top: Ann Broad Bussel (far left) with family at her brother Morris's bar mitzvah at Temple Beth Sholom in 1948. Above: Rabbi Leon Kronish with his wife and children.

1948, and they all sat around our dining room table eating brisket and plotting their next move.

My father [attorney Shepard Broad] had been recruited by David Ben-Gurion, and together they drafted a game plan for getting a bunch of boats together for an exodus—an exodus that would take Jewish refugees to Israel. My father outfitted some old Central American freighters, and they became

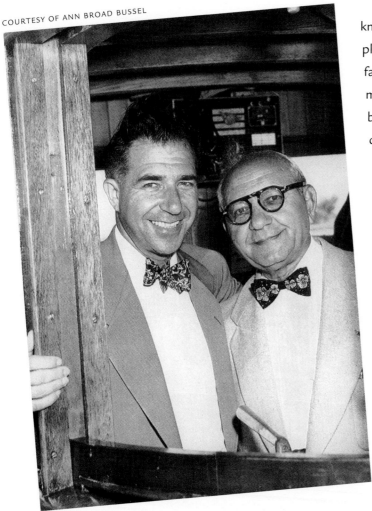

Shepard Broad and his uncle, Daniel Broad, on the dredge boat that pumped the landfill for Bay Harbor Islands in the 1940s.

known as the Secret Fleet. They also got airplanes and guns from Central America. My father even recruited us kids to help out. Now, mind you, we were not helping to secure guns, but we did scrape the brisket off the dirty dishes after people ate at our house.

ANN BROAD BUSSEL, FORMER TEACHER

When people refer to the Miami Group in relation to the creation of Israel, my father was one of the major players, along with Max Orovitz. They were a part of a Miami Beach subculture that operated in a secretive way. They went about what they were doing and didn't want any publicity. They worked hard to make things happen; they raised money and set things in motion. My Dad even went to Israel and helped schlep the refugees off the boats. His function was to pay off the boat captains and make sure people arrived safely. And my mother was there, too, making sure everyone was fed.

For years our home was always full of interesting Jews. Even Golda Meir came to our house. She loved Miami Beach. She would come for dinner and sit and talk with Belle Barth and Sophie Tucker. They were a bunch of smart, strong Jewish women. An odd group, but when they all got together they were like girlfriends, laughing and telling stories and having a grand old time.

MARGORIE COWAN, DAUGHTER OF SAM FRIEDLANDER,
FOUNDER OF THE FOOD FAIR GROCERY CHAIN

My husband and I came to Miami Beach in 1943 to take over Jacob Joseph Congregation because it was having a lot of trouble. The rabbi there, Samuel Bension, got into a lot of fights and got thrown off the pulpit. It was a mess. The congregation was small, really about fifty people who gave themselves a name in order to get together and daven. The kind of people who came to Florida then were real rebels—escapists who were leaving old lives behind—so there was a lot of bickering.

The Joint Was Jumpin'

Shortly after we got here, my husband befriended Father Barry, the leader of St. Patrick's Church. He was one of the most powerful people on the Beach, and he took my husband on as his protégé, advised him about how to get things done. There was very little interaction between Christians and Jews at the time, so Father Barry's support was very generous. When we wanted to expand the synagogue but didn't have the funds, he told my husband, "You build a synagogue when you need to build a synagogue, not when you have money." So we did, and the congregation grew and grew.

BELLE LEHRMAN, WIFE OF THE LATE RABBI IRVING LEHRMAN

After the war there were a lot of young Jewish doctors in Miami Beach who had been trained by the government to serve in the war. But they couldn't get jobs because of the anti-Semitism. They just weren't allowed to practice. So in 1946 a group of us found an old hotel called the Nautilus that had been turned into a veteran's hospital after the war. We approached the government with the idea of letting us run it, and we turned it into a regular hospital. Then we went to the Jews who were beginning to form a community on the Beach and asked them to contribute money. Eventually we raised enough and were able to build Mount Sinai Hospital. And that's how the Jewish doctors finally got jobs.

LEONARD WIEN, CIVIC LEADER
AND COFOUNDER OF MOUNT SINAI HOSPITAL

COURTESY OF LEONARD WIEN JR.

Mount Sinai Hospital poster with Leonard and Marjorie Wien at a fund-raiser in the late 1940s.

I came to Miami Beach in 1946, right after getting out of the service. I had grown up in a Jewish neighborhood in the Bronx, and in the military I was the only Jew in my outfit. When I got to Miami, I took a jitney across the causeway from downtown, and when I stepped off that jitney in Miami Beach I heard Yiddish. People were speaking Yiddish on the street. I knew I was home.

MIKE COOPER, MOTEL OWNER

Being one of the few non-Jews on the Beach was interesting, especially at Beach High. When I turned thirteen, all my buddies were coming to school with new watches. I asked them where they got them, and they told me at the bar mitzvah. Bar mitzvah? I had no idea what a bar mitzvah was. I went home and told my mother about all the great things the other kids were getting at the bar mitzvah. My mother was a real Southerner, and she said, "The bar mitzvah? Is that a store like Burdines?"

In my homeroom class there were two Gentile boys—me being one of them—and three Gentile girls. Everyone else was Jewish. On Jewish holidays the teachers gathered all of us goyim together to watch movies. I can't say I ever experienced any reverse discrimination, but then again, I never got any dates.

<div align="right">

PAUL NAGEL, RETIRED PROFESSOR
AND DOCUMENTARY FILMMAKER

</div>

*Paul Nagel wearing his Colony Theater usher's uniform and holding up his draft notice,
shortly after his graduation from Miami Beach High in 1944.*

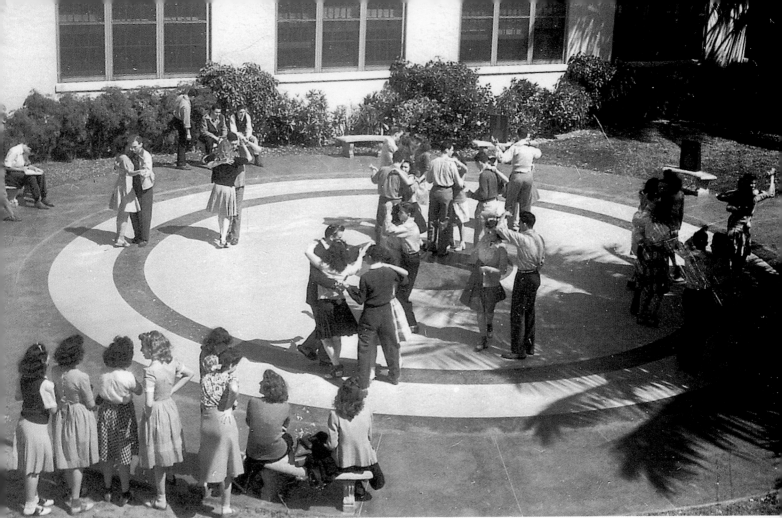

Students dancing at lunchtime on a patio at Miami Beach High School.

Miami Beach High

When I went to Beach High in the 1940s, Barbara Walters was in my homeroom class. I know we are the same age, but for some reason, according to her bio, she keeps getting younger and younger than me.

I'll tell you what she was like then. Go to a Yiddish dictionary and look up the word *lachman*—a pitiful young girl. She had an overbearing SOB of a father and a mentally retarded sister. She spoke with a lisp, and she never seemed happy. She wasn't part of the "in" crowd. She was excluded from the sororities, and it hurt her feelings.

A couple of my friends dated her, and we were all invited to her sweet-sixteen party at the Colonial Inn. The Colonial Inn was a nightclub, and for many of us it was the first time we had ever been to a place like it. But because her father was a big shot, that's where her party was. All I remember is that we all brought expensive presents and the Duncan Singers performed.

STUART JACOBS, INSURANCE AGENT

At Beach High in the 1940s, most of the girls were very stuck-up and obsessed with sororities. I didn't fit into any of them. So a friend and I created our own club, Emanon, which is "no name" spelled backwards. "We'll fix them," we thought. It was at this time that I became friendly with Barbara Walters. I was singing at the Latin Quarter, and she was often there because of her father. She and I would sit together between shows and drink hot tea. I had a mentally retarded brother and she had a mentally retarded sister, so we bonded over our siblings. It was a sad time for Barbara. She didn't have many friends. She was always quiet and shy.

JUDY NELSON DRUCKER, ARTS IMPRESARIO

Food, Glorious Food

Miami Beach was full of Jewish delis; just about every corner had one. And the food was so good—matzo ball soup, chopped liver, pastrami—that you ate so much you could burst. And there was always a big bottle of seltzer on the table. The seltzer—I think that's why we felt like we would burst.

SHIRLEY ZARET, RETIRED SECRETARY AND BOUTIQUE OWNER

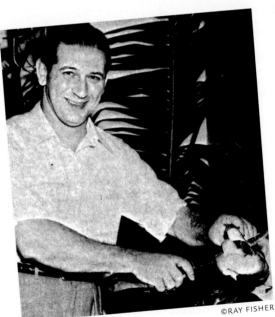

©RAY FISHER

Wolfie Cohen cutting bread.

Find me a Jewish person in Miami Beach who didn't go to Wolfie's. Go ahead—just try. There aren't any. The Jewish culture of Miami Beach was all about eating. Even if you went out to dinner, you stopped at Wolfie's before you went home. The way that New York had Lindy's, Miami Beach had Wolfie's. It was an institution. And I'll tell you why people loved it: because the portions were enormous. The cheesecake was huge. Everybody got their money's worth and went home stuffed and happy.

I built the building where the original Wolfie's was on Twenty-first Street, and I knew Wolfie Cohen. His real name was Wilfred Cohen. Before he and his partners opened the restaurant, they didn't know what to name it, so they had a contest. They put a sign in the window that said name this restaurant. For some odd reason, a kid from the University of Miami submitted the name Wolfie's, and they liked it. Years later Wilfred legally changed his name to Wolfie. That's how the restaurant—and Wolfie—got named.

JERRY COHEN, GENERAL CONTRACTOR

The Joint Was Jumpin'

58

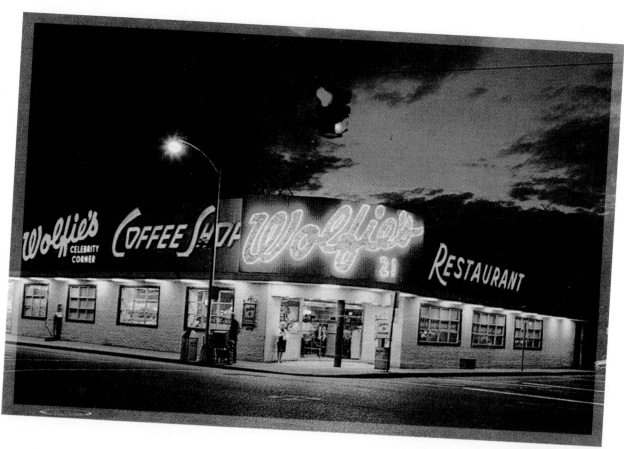

As a kid, Wolfie's was my playground. I lived in the kitchen and ate more corned beef and apple pie than I care to admit. In fact, my doctor had to clear it all out with an angioplasty a few years ago.

I remember one time there was a fire in the kitchen. The firemen came and were trying to evacuate the place, and there was this guy sitting at the counter and he would not leave until he finished his pastrami sandwich. Just sat there—smoke all around him, fire going up the walls. Ignored it all until his plate was clean.

Wolfie's was famous for its food, but it was also famous for its waitresses. They were all take-charge, hardworking girls. Whenever we had to hire new waitresses, they always wound up interviewing us. And I can tell you, it was not a beauty contest. But they were the greatest. They knew everyone's name and exactly what

Above: Wolfie's restaurant postcard.
Right: Everett M. Lassman as a young boy.

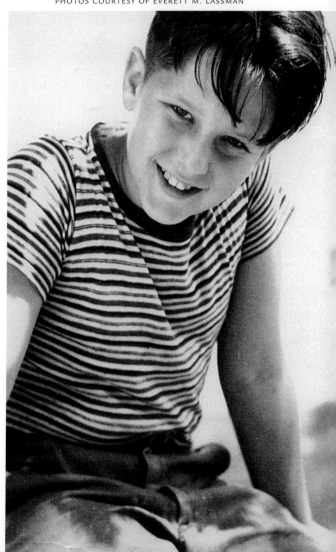

their favorite thing on the menu was. And although it was hard work, it was a good job. Even back in the 1940s, they were making $100 a day.

<div align="right">

EVERETT M. LASSMAN, STOCKBROKER AND
SON OF ORIGINAL WOLFIE'S CO-OWNER EDWARD LASSMAN

</div>

My father and Morris Lerner came to Miami Beach from New York in 1945 with peanuts in their pockets and opened The Famous on Washington Avenue. It wasn't kosher, but it was Jewish—old-fashioned Jewish. And in its heyday it was always packed. If people wanted a good steak, they went to Embers, but if they wanted a good everyday meal, they came to The Famous. All the locals came, especially the young guys who worked the tote boards for the bookies.

We sat 100 people and did about 600 dinners a night. The turnover was phenomenal. Food cost next to nothing then, so we were able to offer prices nobody could beat: a seven-course meal with appetizers, knishes, sauerkraut, soup, salad, an entree, and dessert for $1.85. Lock, stock, and barrel, a buck eighty-five.

I worked as a host at the restaurant, and what I remember most is the pushing and shoving, the pushing and the shoving. People in line outside would just push and shove each other to get in the front door. They had no patience. It was a mob scene. They also ate a lot, so much so we had to call an ambulance at least once a week because some old guy from Brooklyn stuffed himself silly and then had a heart attack. It was the same type of thing that went on in the Catskills—people eating till they couldn't move. Must have been because we all kept hearing about the children starving in Europe.

<div align="right">

MIKE COOPER, MOTEL OWNER AND SON OF SAUL COOPER,
ORIGINAL CO-OWNER OF THE FAMOUS

</div>

Picciolo Restaurant postcard.

<div align="right">

COURTESY OF AUTHOR

</div>

Crime and Punishment

When the S & G were around, every fruit stand on Miami Beach had a bookie in the back. You could place a $20 bet on a horse and buy a bunch of bananas all at the same time. It was great.

STUART JACOBS, INSURANCE AGENT

Everybody tried to make a big deal out of the S & G. The *Miami Herald* ran stories saying they were murderers. They were nothing but small-time bookies who ran cabanas where guests placed bets on the horses. They never bothered anybody.

BERNIE BERCUSON, FORMER HOTEL MANAGER

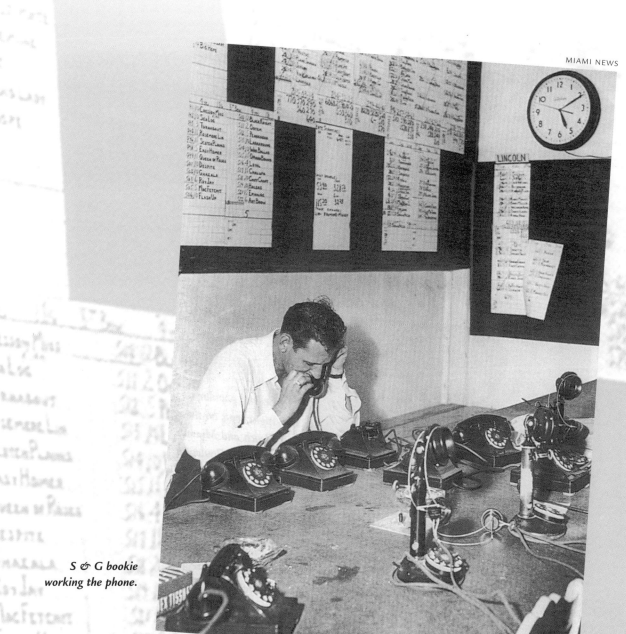

MIAMI NEWS

S & G bookie working the phone.

They were a bunch of sweet guys. When I got my first speeding ticket, one of them came with me to court. Sat next to me and told me to say, "Not guilty, your honor." The judge dismissed the case, and after he put the gavel down he winked and said, "OK, guys, I'll see you in a few hours at Wolfie's."

EVERETT M. LASSMAN, STOCKBROKER AND
SON OF ORIGINAL WOLFIE'S CO-OWNER EDWARD LASSMAN

Those guys kept this town clean and crime free. They were a group of criminals, but their only enterprise was gambling—not prostitution or drugs or anything else. They wanted their operations to function without any problems, so it was in their best interest to keep the Beach safe from ordinary thugs. I hate to admit it, but they did a lot of good for the Beach.

HAL KAYE, PHOTOGRAPHER

We all thought it was normal to a have a bunch of bookies around, and almost everyone I knew was somehow "connected." Sometimes we had no idea how some families earned a living, but then we'd hear that so-and-so's father was called in to testify [at federal hearings investigating interstate crime], or that so-and-so's uncle had to leave town.

KAY ROSENFELD, *MIAMI HERALD* COLUMNIST

My uncle, Charlie Friedman, was one of the main figures of the S & G. He was a lovely man, as were all the others. They made a lot of money, but they were not into rough stuff, and nothing was ever a secret about what they did. And they surely weren't related to any New York Mafia group, because if they were they wouldn't have been hit so hard by Kefauver. Uncle Charlie never went to jail, but he was ruined by the ordeal. He died shortly after the government came down on him.

LOIS APPLEBAUM, SCHOOLTEACHER

Nobody was really opposed to gambling in Miami Beach—not even the churches—but after Kefauver came, things changed. They were politically powerful, the S & G. They had plenty of money, and they controlled who got elected and what went on in city government. Let's say they influenced things. And they used their influence for their own benefit, not for the benefit of the community.

After the government brought charges, I was called in to be the prosecutor and I sparred with Ben Cohen in the courtroom. The bigger guys paid $5,000 fines, and most of the smaller ones pleaded guilty and paid a $500 fine.

Few people know it, but it was because of the S & G that there was a shortage of telephones in

Senator Estes Kefauver (in glasses).

Miami Beach in the late 1940s. Many locals just couldn't get one. Southern Bell was low on equipment because bookie rooms were using fifty to one hundred telephones each. Every time the cops raided the bookie places, they confiscated the phones. I became the angel for Southern Bell, because after the trial we released the phones back into the community.

IRVING CYPEN, PROSECUTOR FOR THE CRIMINAL TRIAL AGAINST THE S & G

I met Mr. Kefauver when he took the Beach by storm, saying he was going to "clean things up." Well, I thought he was a dirty old man who never took a sober breath in his life. One time he dropped his keys down the front of my dress as a joke and just laughed out loud. I wasn't impressed. I thought he was a hypocritical old letch.

MARGORIE COWAN, DAUGHTER OF SAM FRIEDLANDER,
FOUNDER OF THE FOOD FAIR GROCERY CHAIN

Crime and Punishment

Temptresses of the Tease

There used to be a lot of great strip clubs on the Beach, and I started going to them as a kid in the 1940s. Actually, I followed my dad there. He used to go out for a walk after dinner, and one time I followed him all the way to Chez Paree. It was a real eye-opener.

Nudity was forbidden then, so they worked around the law by sometimes having the girls pose topless—just pose. They couldn't move. If they moved they would get arrested, so they just stood still and claimed it was art. Art was OK, but nudity wasn't. But even when they stripped, the girls never got completely naked. They wore G-strings and pasties. And there were also plenty of B-girls around who made money by getting guys to buy them drinks. It was a real racket.

SHELDON MILLER, REALTOR

Two of the most famous strippers in Miami Beach were Carrie Finnell and Zorita. Carrie Finnell had been a Minsky's girl, and she was the original breast twirler. She'd come out on stage wearing a gorgeous green dress. She would open it up and one breast would jump out, then the other would jump out, and then she would make them do whatever she wanted. One would twirl left while the other twirled right. Then they went clockwise and counterclockwise. She'd tell the women in the audience, "Do not try this at home." She was something else—could put Janet Jackson to shame

Zorita was the other great one. She was famous for her snake. She did a sexy strip dance with a live boa constrictor as a prop, and people went crazy. She was a good businesswoman who later opened her own club. She was also good at getting free publicity—she once walked down Collins Avenue with her snake and got arrested for not having it on a leash. The story made all the papers. More people went to see her show. So much for the stereotype of the stupid stripper, huh?

RAY FISHER, PHOTOGRAPHER

In the late 1940s, before I met Lenny [Bruce], I went to Miami Beach for the first time, and it was everything I had dreamed it would be—sunny during the day and gaudy at night. I was drawn to it like a wild animal drawn to a raw steak. I started out working as a dancer on the Beach at a place called Tropics, where I did this silly "blue bird" routine. I wore a big feathered headdress and had blue tail feathers attached to my little G-string. I had to dance around with that darn costume on and talk guys into buying expensive bottles of champagne.

After that I worked at Chez Paree, doing three shows a night six nights a week. That's where I really learned how to strip. It was a lot of work, but I had a great time. Chez Paree was wonderful—a real elegant, tease 'em kind of place. There was always a bunch of dark Italian guys from Chicago

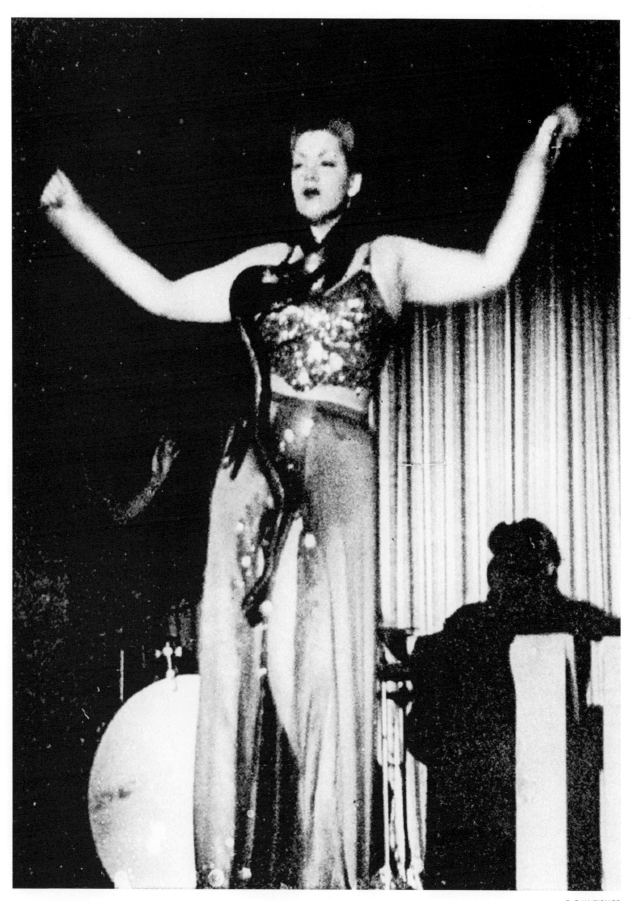

Zorita the stripper on stage with her snake in 1941.

there who looked like they were in the Mafia. Martha Raye was playing at the Five O'Clock Club, and she would come over to see me at Chez all juiced out of her mind, carrying on and being wild.

There were a lot of gay people in Miami Beach then, especially on the beach at Twenty-second Street, and it was the first time in my life I had ever experienced that. Believe it or not, I was once an *innocent* young girl. At Chez Paree I worked with a gay guy—a female impersonator named Bobby Drake. He had natural blond hair and was handsome as a man and even more beautiful when he dressed up like a woman. We hit it off like two sisters and eventually rented an apartment together. We would drive down Ocean Drive in my convertible, and Bobby would yell, "Eat your heart out, you bitches." Bobby and I had fun together, but that came to an end when we discovered that we were dating the same man. One day I got flowers from one of the owners of Chez Paree. The next day Bobby got flowers from him, too. After that Bobby and I broke up.

HONEY BRUCE FRIEDMAN, FORMER STRIPPER AND WIFE OF LENNY BRUCE

Xavier Cugat at Copa City nightclub in 1948.

© RAY FISHER

The Joint Was Jumpin'

The Club Scene

The 1940s in Miami Beach was a time of great Latin music. I mean *great* Latin music. It was swinging, and the aura on the Beach was incredible. Had I known then that it was going to be an era, I would have paid more attention.

All the best Cuban and Puerto Rican performers were here—Tito Puente, Tito Rodriguez, Xavier Cugat. Walking down the streets at night, you could just hear all these great sounds coming from the clubs. Desi Arnaz was around now and then, and I remember running into him at the Musicians' Union. He was never considered very good as far as real Latin music goes. But he knew how to front a band, and he was gorgeous. Then he did that "Babalu" routine, and his career took off. Truth is, there were dozens of other Cuban musicians around then who were ten times better.

I started playing Latin music at that time because it was so hot. I changed my name from Marvin Baumel to Rey Mambo because when I called the *Miami Herald* to promote my act, the guy at the paper said, "You've got to have a better name." So here I was, a Jewish kid from Brooklyn, and I became Rey Mambo, King of the Mambo. I even learned how to speak Spanish. I played with Cuban guys from Tampa and we were performing at Ciro's, and Walter Winchell came in to see the show. He made a nice mention of my act in his column, and after that I had no choice but to stick with the name. I remember one night when Louis Armstrong went on stage just before us, and Nat King Cole came over to check us out.

This was also the time of dance classes. Everyone sent their kids to dance class—cha-cha, mambo, merengue, you name it. I played in the band at a lot of the dance contests, and let me tell you, they were rigged. Parents would show up with a group of their friends and make sure they all cheered when their kids came on. So little Harriet Goldstein with no rhythm at all would win the cha-cha trophy. And her parents, who probably spent $18,000 on dance lessons, were happy.

© RAY FISHER

Rey Baumel (Rey Mambo) with drum.

SINGER REY BAUMEL,
STAR OF REY MAMBO AND HIS COMBO

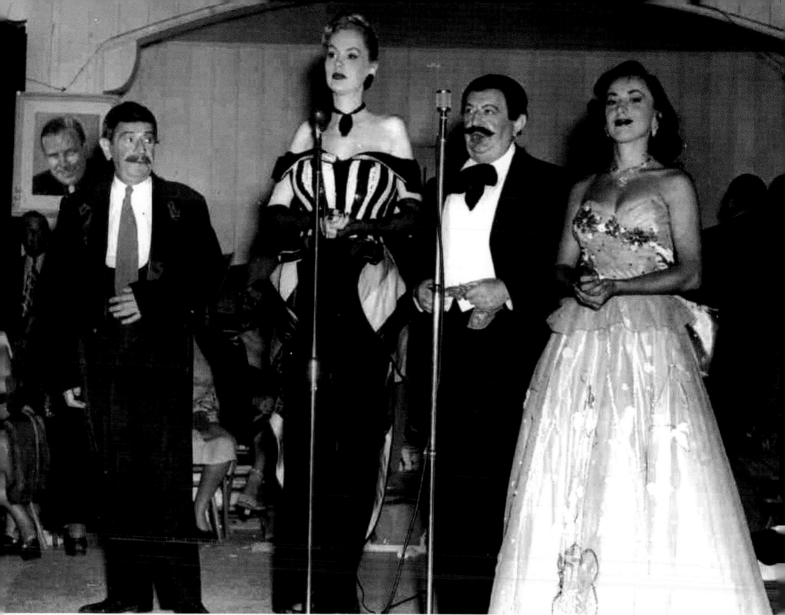

Judy Nelson Drucker (far right) performing in **Rigoletto** *at the Latin Quarter.*

In the 1940s the Latin Quarter was looking for a young singer to perform. Hank Meyer, the PR man, was doing promotions for the club, and he created a fake news story about a young girl who is infatuated with a singer named Larry Ross. The girl supposedly goes from Miami Beach all the way to Jacksonville to get his autograph. Well, I played the part of that young girl—set up by Hank Meyer, of course—and it made the front page of the newspaper. It was all a stunt, but afterwards, the Latin Quarter hired me to sing on a regular basis.

I had never been to a nightclub before that, and I didn't even own a gown. Can you imagine . . . a girl living in Miami Beach who doesn't own a gown? That was rare. Anyway, I wound up doing two shows a night while going to school during the day. I was just sixteen years old, and I was surrounded by all these showgirls with their big boobies hanging out. There was one who walked around completely naked, but she held a white fur muff in front of her crotch. Inside the muff was a little Chihuahua dog—

a live dog. But the girls were great, and we formed a club: the Latin Quarter Show Girls. Years later we would get together and laugh about the fact that we were all turning into little old ladies.

JUDY NELSON DRUCKER, ARTS IMPRESARIO

I began working in a hair salon on Lincoln Road in the late 1940s. This was when women used to walk by the shop carrying parasols to protect their delicate Southern-belle skin from the sun. Soon after, I started working for the Folies Bergère at the Latin Quarter doing hairpieces for the girls. They had the real showgirls who were almost six feet tall, and then they had what they called the ponies— the shorter women. I saw interesting things go on behind the scenes at that club, shocking things. Those girls were something else.

RUTH REGINA, HAIR AND MAKEUP ARTIST

I moved to Miami Beach with my family in the mid-1940s because my father had hay fever—you can't broadcast with a stuffy nose. My dad loved it here. Walter Winchell was around then, and he and my dad were good friends. Walter was great to us, but he could be very brusque with people he didn't know—a little cold, to tell you the truth.

My dad started doing his show here in the late 1940s when Frank Katzentine, a former Miami Beach mayor, invited him to the radio station he owned. Most of the time dad had the engineers come to the house, and he would broadcast his live 9:00 p.m. show from there. We hung bathmats and blankets on the walls to insulate for sound. I remember one time I got a call at my father's house from a man who claimed to be Cary Grant. I said, "Yeah, right, and I'm Joan Crawford." Anyway, it was Cary Grant, and he wanted to come over and talk to my father about a new movie he was doing.

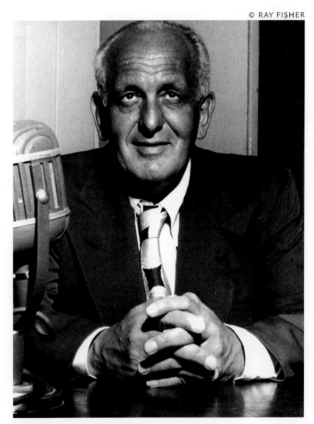

© RAY FISHER

Gabriel Heatter in the lounge of Copa City nightclub in 1948.

At about that time I set up a little shop at the Copa City nightclub, selling handmade jewelry. Barry Gray was doing his broadcast from the nightclub, and a few times I filled in for him when he was out of town. One night Maurice Chevalier was performing at the club, and I went to see the show with

my mother. We got a front-row table. I don't know what possessed me, but I wrote Chevalier a little note on a napkin and asked the waiter to pass it on to him. After the show he invited me to his dressing room. I gave my mother the car keys and said, "Goodbye, Mom." We wound up having a two-week love affair. He was a delight—an absolute delight. Should I be admitting this?

MAIDA HEATTER,
COOKBOOK AUTHOR AND
DAUGHTER OF RADIO
COMMENTATOR GABRIEL HEATTER

Left: Photographer with bathing beauty Maida Heatter. Below: Maurice Chevalier singing on stage at the Diplomat Hotel.

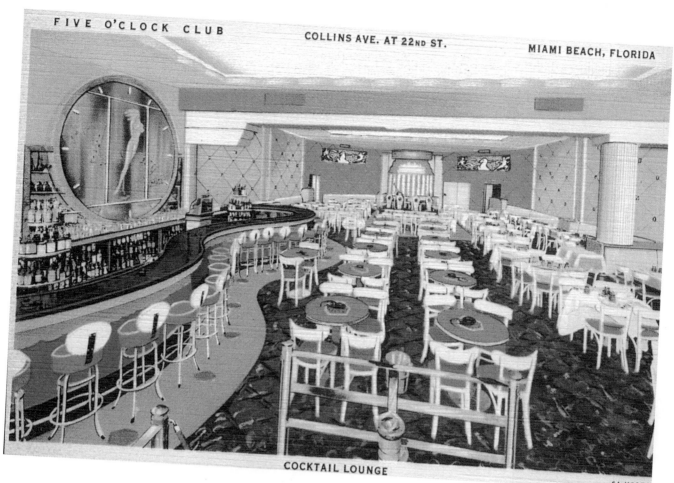

Above: Vintage postcard from the Five O'Clock Club.
Below: Matchbook cover from the same wild place.

Sometime in the late 1940s, a union guy offered me a job at the Five O' Clock Club with Martha Raye. I had nothing else lined up, so I took it. The place was full of amyl nitrate sniffers. Couldn't figure out what that smell was—I thought there was a dog pooping in the back room somewhere. It was a wild place. I normally did a free-form act, but Martha demanded that I do regular routines. And I know why. She would come in and say, "Shecky, don't do your French routine tonight." Meaning she was going to steal it and use it herself. She was a trip.

SHECKY GREENE, COMEDIAN

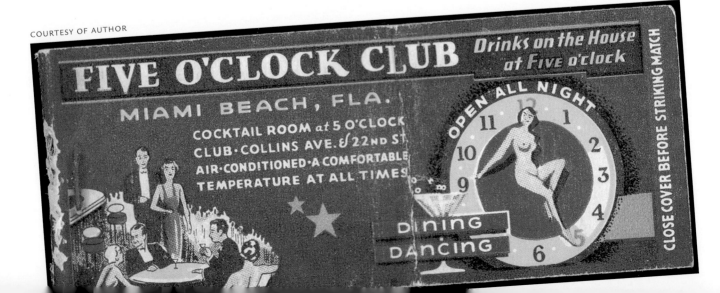

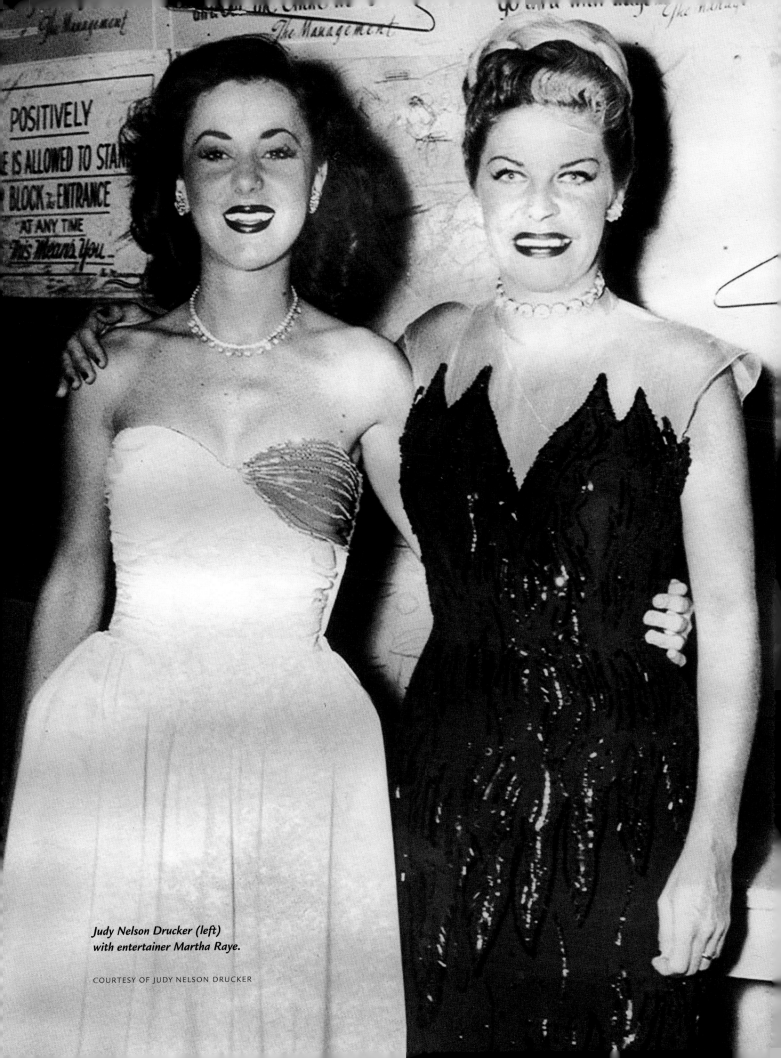

Judy Nelson Drucker (left)
with entertainer Martha Raye.

COURTESY OF JUDY NELSON DRUCKER

I started performing in Miami Beach in the late 1940s and did club dates with everyone—Tony Martin, Lena Horne, Spike Jones, Alan King, even jugglers. So many great people were around then— Mickey Rooney was doing plays; the McGuire Sisters were singing; Steve Allen and Jayne Meadows were around. Jerry Lewis and Dean Martin were just starting their act. Rose Marie was doing her show with Jan Murray and the Vagabonds. We all stuck together then; there was a great camaraderie among the performers.

I remember going to a club with Dick Haymes when he was married to Rita Hayworth. Some lady tried to steal Rita's shoe. Rita was sitting in the audience, and I guess the lady wanted to take it as a souvenir. Rita was a feisty little devil, so she picked up her other shoe and hit the lady over the head with it. And she got the stolen shoe back.

At the time, people didn't have televisions at home, so they went out at night—they went to clubs for entertainment. In fact, it was in Miami Beach that Rose Marie pulled me aside and told me that television was going to be the next new thing and that I should think about trying to get into it. She was right.

WOODY WOODBURY, COMEDIAN

STEREODDITIES

Above: Woody Woodbury album cover.
Below: Publicity print of Rose Marie.

COURTESY OF AUTHOR

I first went to Miami Beach in the late 1940s. I worked at the Clover Club with Jan Murray and the Vagabonds in Miami, not Miami Beach. We played for eleven weeks and were the hottest act in town. All the other big stars were playing on Miami Beach at the time—Sophie Tucker, Joe E. Lewis, Jimmy Durante. It was show business back then, real show business. People had talent, real talent. They took their work seriously and respected the audience. It wasn't like the silly young broads of today who can't even walk a line but think of themselves as stars.

All of us entertainers wound up becoming friends because we all stayed on the Beach and went water-skiing every day. I would work till 3:00 a.m. and then wake up at 10:00 a.m. to go to a water-skiing school at a hotel. Everyone did it, even though we were exhausted from working. Even my husband, Bobby, flew in from California just so he could go water-skiing with us. It was the thing to do, and we had a blast. That's my real memory of Miami Beach—going water-skiing. And I got pretty good at it.

ROSE MARIE, ACTRESS

Celebrity Sightings

Starting in the early 1940s, I worked as a celebrity photographer—one of the paparazzi, I guess, although there was no such thing as paparazzi back then; we were just photographers. It was a much easier time to work then, because celebrities were more accessible. They weren't surrounded by press agents and a stupid entourage telling you what to do. None of the bullshit of today. You showed up at their hotel and you took their photo. No one said, "Only my left side."

I shot just about everyone who came to the Beach then—Lawrence Welk, Buster Keaton, Ella Fitzgerald, Henry Fonda, Dinah Shore, Sammy Davis, Milton Berle, Louis Armstrong, and Eartha Kitt. When the movie *Moon Over Miami* opened in 1941, I took photos of Betty Grable, who was in town for the opening. She had come from New York by train with her mother, and there was a big party for her at the Beachcomber nightclub. And in 1949 I remember shooting the writer Herman Wouk, who came for the opening of *Slattery's Hurricane,* starring Veronica Lake.

RAY FISHER, PHOTOGRAPHER

Eartha Kitt at the Americana Hotel.

© RAY FISHER

© RAY FISHER

Above: Betty Grable at the Beachcomber nightclub in 1942. Right: Photographer Ray Fisher with camera. Below right: Everett M. Lassman in the late 1940s.

When I was a kid, I went to a sweet-sixteen party for Elizabeth Taylor. I don't remember who hosted it, but it was a big fancy party where all the girls wore poodle skirts and crinoline dresses. Elizabeth was going out with some Latin guy at the time, and he was there, too, so none of us guys got close to her, but she looked gorgeous. Years later I ran into her at the office of the Sheridan Theater. *Around the World in 80 Days* was playing, and Mike Todd, the director, was there with her. When she came into the room, I offered to get up and give her my seat. She said, "Don't bother," and then just sat down in my lap. I didn't complain.

EVERETT M. LASSMAN,
STOCKBROKER

© RAY FISHER

COURTESY OF EVERETT M. LASSMAN

When I was a young girl, I saw Elizabeth Taylor walking down Lincoln Road—just strolling down the street, oblivious to all that was around her. She was stunning, breathtakingly beautiful. And she had an aura about her that was so intense it practically knocked me over.

MARY LEE ADLER, ARTIST

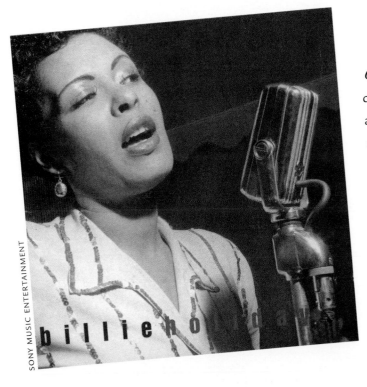

One time I was with a group of guys in the middle of the afternoon, sometime in the late 1940s, and we saw Billie Holiday out on the street just north of Lincoln Road. She was playing at a nightclub nearby, and there were signs advertising her show. She was just standing there in a long dress, sweeping the street, smoking a cigarette—the only person on the whole block. I guess she came outside to have a smoke and wanted something to do. I said, "Hey, Billie, how ya doing?" She smiled and said, "Fine, how are you boys doing?" That was it.

HANK KAPLAN, BOXING HISTORIAN

I used to see Frederick Snite around the Beach in the 1940s. We all knew him as "the man in the iron lung." But I actually knew him before he got sick. His father took him on a trip around the world, and he got polio in China. From then on he was stuck in the iron lung. He used to go to Mass every Sunday with his wife, Teresa. He would show up in a big trailer, and they would wheel him into the church. He had a mirror in front of his face so he could see what was going on.

ROBERT REILLY, RETIRED BUSINESSMAN

Above: Billie Holiday album cover.
Left: Frederick Snite in an iron lung.

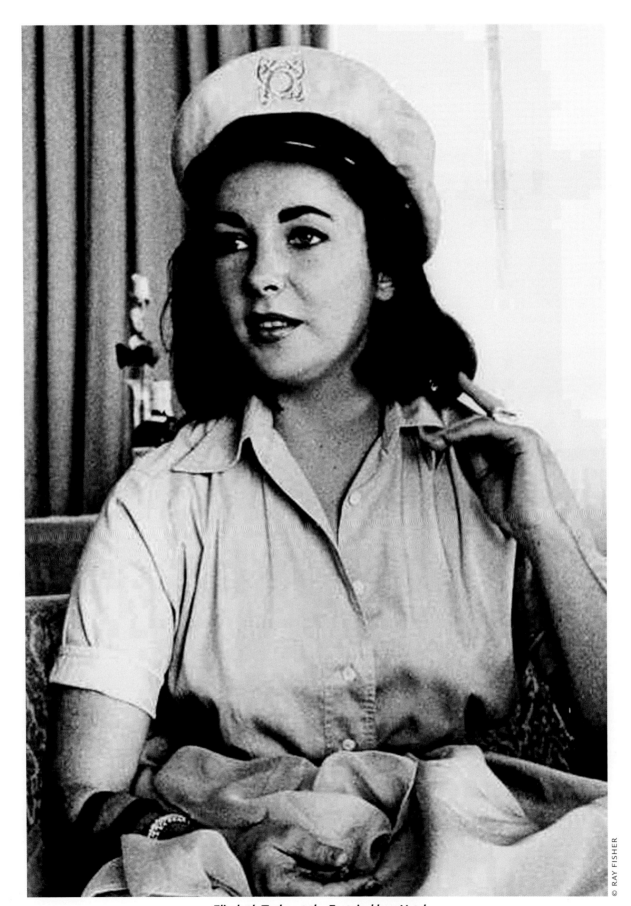

Elizabeth Taylor at the Fontainebleau Hotel.

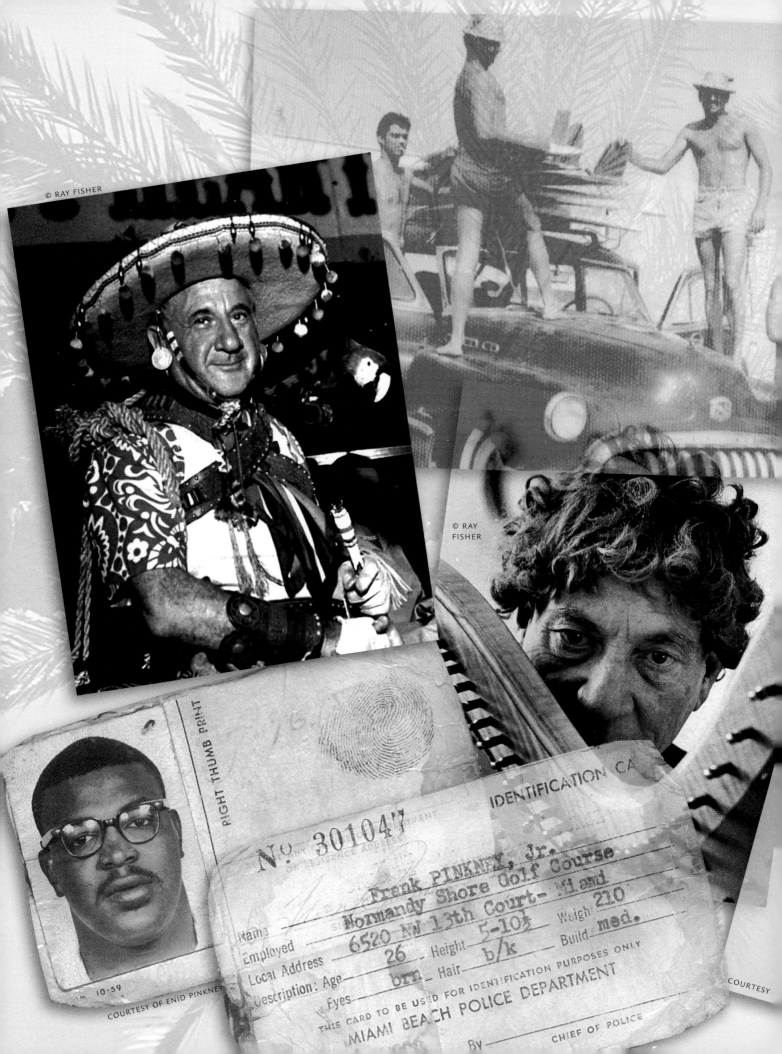

© RAY FISHER

© RAY FISHER

RIGHT THUMB PRINT

IDENTIFICATION CA

N° 30104'7

Name Frank PINKNEY, Jr.
Employed Normandy Shore Golf Course
Local Address 6520 NW 13th Court - Miami
Description: Age 26 Height 5-10½ Weight 210
Eyes brn Hair b/k Build med.

THIS CARD TO BE USED FOR IDENTIFICATION PURPOSES ONLY

MIAMI BEACH POLICE DEPARTMENT

By CHIEF OF POLICE

10-59

COURTESY OF ENID PINKNEY

COURTESY

The Center of the Universe

Universe

COURTESY OF JACK MURPHY

To Joann Biondi
Love
Tempest
Storm

PEST STORM

1950 – 1959

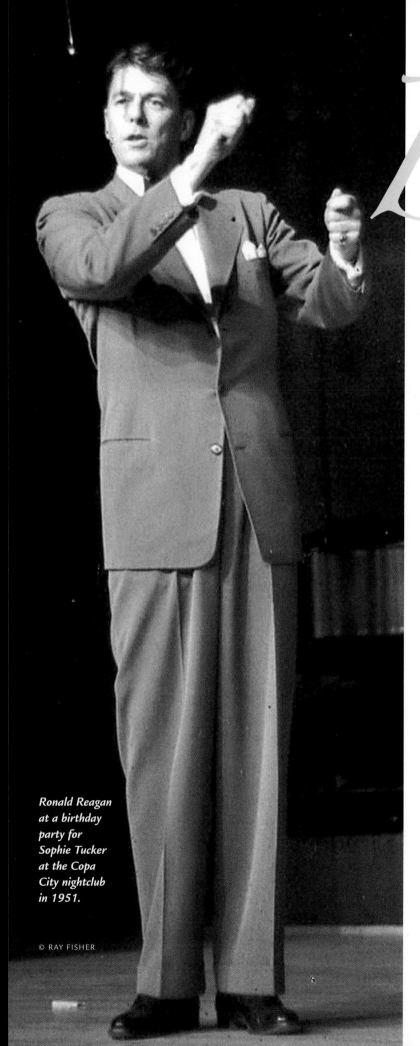

Ronald Reagan at a birthday party for Sophie Tucker at the Copa City nightclub in 1951.

© RAY FISHER

Big cars, big diamonds, big bucks, and lots of booze. Miami Beach during the 1950s represented the epitome of America's super-size Baby Boom era—an era marked by boldness, self-assuredness, and a willingness to walk on the wild side.

Bettie Page posed for cheesecake photos, guys with names like Ice Pick Willie came for a round of golf, and tennis pro Bobby Riggs strutted his stuff. Dozens of hot comedians—Buddy Hackett, Shecky Greene, Don Rickles, Joey Bishop, Jack Carter, Rodney Dangerfield, Dick Shawn—had audiences rolling in the aisles.

Celebrities came to Miami Beach in droves then. If the paparazzi that shoot for today's supermarket tabloids were around, they would have run back to their newsrooms with a treasure trove of "gotcha" images—images of Eddie Fisher, Debbie Reynolds, Harry Belafonte, Roberta Sherwood, Josephine Baker, Henny Youngman, Johnny Mathis, Walter Winchell, Belle Barth, Harpo Marx, Sophie Tucker, and a pre-political Ronald Reagan.

A few famous jewel thieves lived on the Beach, trolling for their next heist by checking out the girl's-best-friend baubles in nightclub front-row seats. *Playboy* founder Hugh Hefner came for his first visit, a place called the Dream Lounge served up plenty of Pink Ladies, and high-class hookers were easy to come by. A guy named Silver Dollar Jake hung around the Beach, doling out silver dollars to kids; he's also fondly remembered for some of his more X-rated antics.

And then there was the Shah of Iran and his empress wife, who had a bizarre infatuation with plastic dog poop.

Although the golden age of burlesque was coming to an end, there were still a few brand-name strippers who shimmied and shook and wowed the crowds. These curvy bombshells with cheeky names were celebrated in all their gyrating glory, and many well-known people—Joe DiMaggio, Fulgencio Batista, Mickey Rooney—came to watch them take it off.

Over at Miami Beach High, the values of the student body reflected that of the community surrounding it. Sweet-sixteen parties were held at glitzy hotel ballrooms, more than a few kids arrived at school in chauffeur-driven sedans, and several lucky boys snagged the most coveted graduation present of all: a shiny red Corvette. Some of the students of that era who went on to achieve national acclaim include Tony Award–winning playwright Mark Medoff and former U.S. Treasury secretary Robert E. Rubin.

Many girls who attended Miami Beach High in the 1950s painfully remember the overindulgence of the times, especially when it came to food. Their social lives revolved around eating, eating, and eating again. They were then hauled off to the infamous Fat Doctor, who loaded them up with amphetamines to control their weight. Also on the food front was a newly opened hole-in-the-wall hotdog joint called Lums, which went on to become one of the biggest fast-food franchises in the world.

Frank Sinatra and Frank Lloyd Wrong

Starting in the 1950s and continuing for about twenty years, Frank Sinatra and his Rat Pack pals—Dean Martin, Jerry Lewis, Peter Lawford, Joey Bishop, and Sammy Davis Jr.—were the hotshots around town. They always lived up to their reputation as the Kings of Cool. With $1,000 suits and handmade Italian

© RAY FISHER

Above: Henny Youngman at the Copa City nightclub. Below: Harpo Marx at the Deauville Hotel in 1959.

© RAY FISHER

shoes, they were babe magnets who had it all—talent, money, fame, and power. They also achieved success in many genres—music, nightclubs, television, film—and had close connections with both the Kennedy clan and the Mob.

Everyone wanted to bask in their glory: ordinary folks who came to see their shows, movie stars wanting to advance their careers, hatcheck girls looking for a ticket out, and mild-mannered bankers who got vicarious thrills from their tough-guy bravura. One of the most hedonistic gatherings of narcissists in entertainment history, the Rat Pack knew how to live the good life and made no apologies for it—even if that meant having a bunch of hired goons on hand to keep things in line.

"We're not setting out to make *Hamlet* or *Gone with the Wind*," Sinatra once said. "The idea is to hang out together, find fun with broads, and have a great time." In Miami Beach they did all that.

One of Sinatra's favorite hangouts was the Fontainebleau Hotel, which was constructed on the Firestone estate, one of the oldest and most elegant private homes in the area. The opening of the Fontainebleau in 1954 signaled a major change in the nature of tourism on the Beach. Its presence altered the skyline dramatically, and never again would new hotels here be small in scale—or modest in design.

One word usually comes to mind when people think of the Fontainebleau: gaudy. Gaudy, and proud of it. Designed to reflect the bigger-is-better attitude of the United States in the 1950s, this pleasure palace was ostentatious to the core. If architectural styles can have a goal, this one's was to inspire fun, pleasure, and joy.

When owner Ben Novack hired architect Morris Lapidus to draw up the plans for the 1,250-room hotel, he told him that he wanted a modern French provincial design. Since there was no such architectural animal at the time, Lapidus went about creating it. He did this by incorporating lots of polished marble, glittery gold chandeliers, a sweeping staircase, and shiploads of imported antiques. For fun he threw in a kiddy pool shaped like a cat, a bowling alley, and an indoor ice-skating rink. He also created a convention hall that could seat 5,000—unheard of at the time.

*Jayne Mansfield
at the Eden Roc pool.*

Along with building the most modern hotel in Florida, Novack was dreaming of something else that he thought would one day come back to the Beach: casino gambling. Unfortunately for him, Florida's large population of Bible Belt Baptists would never let that dream come true.

Soon after the Fontainebleau opened, another hotel was built next door. Also designed by Lapidus, this one was called the Eden Roc; it was owned by Harold Mufson, a former business partner of Novack. This time around Lapidus used an Italian Renaissance theme with an ultramodern slant. The Eden Roc was slightly smaller than the Fontainebleau but no less ostentatious. Angry that his former architect would go to work for a rival hotelier, Novack got even by constructing an annex to the Fontainebleau that blocked the sun from shining on the Eden Roc's pool. So there!

It was the Eden Roc, under the direction of Morris Lansburgh, that brought the American Plan to Miami Beach. An arrangement that gave guests a room plus breakfast and dinner at the hotel for one fixed price, the American Plan is thought by many to have been the beginning of the end for Miami Beach's once sizzling nightclub and restaurant scene. Independent establishments just couldn't compete with the self-contained, enclave nature of the new hotels, where guests could get everything they wanted—food, liquor, entertainment—without ever leaving the grounds.

Although there is no doubt that the American public loved the over-the-top luxury of both the Fontainebleau and the Eden Roc, critics often were not kind. Some began calling Morris Lapidus the Frank Lloyd Wrong of hotels, and

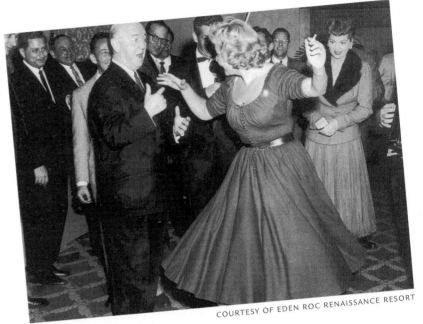

Above: William Frawley and Vivian Vance dancing at the Eden Roc with Lucille Ball looking on in background. Below: Harold Mufson (far left) eating lunch with Ed Sullivan and guests at the Eden Roc.

one *New York Times* writer invented a new word to describe his style: superschlock. Decades later, however, history was more kind, and a new term was coined—MiMo, or Miami Modern.

A few years after the building of the Fontainebleau and a few miles to the north, another Miami Beach architectural boom took place. This one catered to a less affluent clientele, but it also used fantasy-like themes for decor. It became known as Motel Row.

A New Promised Land

Although most big hotels such as the Fontainebleau hired prominent African-American entertainers during the 1950s, they still were not allowed to stay at the hotels as guests. And African-American tourism workers were still expected to be off the Beach by sundown. But as civil rights marches rocked the American South and brought race relations to the forefront of American politics, Miami Beach began to experience the winds of change. A black Methodist church group came to town for a meeting, a local taxi company started hiring black drivers, and desegregation of the public school system began. There were some rumblings going on—rumblings that would eventually lead to the dismantling of Jim Crow laws.

The social situation for Jews had also changed. Although some anti-Semitism still existed and a few area hotels still disallowed Jews, by the 1950s Miami Beach was very much a Jewish enclave. Bar mitzvahs and bat mitzvahs were extravagant affairs, and Borscht Belt comics performed their shtick at flamboyant hotels on the Collins Avenue strip.

"Have you heard about that new Florida wine?" went the setup.

"So vhen are you going to take me to Miami Beach?" came the punch line.

In less than twenty years, Miami Beach had transformed itself from a place where GENTILES ONLY signs hung in hotel lobbies to a new Promised Land, where Jews felt very much at home and ugly ethnic slurs were a thing of the past.

The Jewish population had become so large and influential that one particular Jewish mobster blended right in. A brilliant financier, Meyer Lansky had ties to Miami Beach that dated back to the 1930s, when he ran gambling operations in South Florida. But by the 1950s—and through the 1970s—Lansky was frequently spotted around town walking his little dog, dining in restaurants, and visiting the public library, where he was a regular patron. Reading was one of his passions, and people who knew him well remember how he loved to talk about philosophy, politics, and the arts.

For years Lansky had vast business ties to Miami Beach hotels, motels, and laundry services. Federal authorities, who called him the biggest crook in the world, claimed that he was also tied to bootlegging, drug smuggling, pornography, prostitution, and extortion. Two of his best buddies were Lucky Luciano and Bugsy Siegel, and Lansky supposedly served as the inspiration for Hyman Roth, a character in the film *The Godfather: Part II*.

Although indicted on criminal charges ranging from tax evasion to attempted murder, Lansky always managed to avoid doing time in the slammer. With his slicked-back hair and stacked heels, he was a small man with an agile mind who to this day is most often described as gentle, wise, and mild-

Golda Meir speaking at the Fontainebleau.

mannered. Lansky lived out the remainder of his years at the Imperial House condominium on Collins Avenue, and life was good for him.

For a while it seemed as though Miami Beach was the center of the universe, with planeload after planeload of vacation-hungry tourists flying in to check it out—the sun, the sea, the sand, the strippers. Frank Sinatra, Meyer Lansky, Joe DiMaggio, Ronald Reagan, and a fallen Cuban dictator: Miami Beach during the Fabulous Fifties had it all.

First Impressions

My first impression of Miami Beach was that I couldn't find the beach. I anticipated that I would go there and see the beach—I mean, the beach. But you don't get to see the beach in Miami Beach. You have to follow the signs inside your hotel and go through a back door somewhere in order to see the beach. Strange.

SHELLEY BERMAN, COMEDIAN

The Center of the Universe

The Club Scene

The thing about Miami Beach in the 1950s was if you could make it there, you could make it anywhere. The focus was not yet in L.A. or Las Vegas. It was New York and Miami Beach—the two hot places. And oh, Lord, was it wild.

KAY STEVENS, SINGER

There will never be anything like Miami Beach in the 1950s. It was clean and beautiful and not crowded yet. There was a real intimacy at the nightclubs—the performers interacted with their audiences, and there was a closeness that just doesn't exist anymore.

Although the place was great, for me personally it was tough. It was a time in my life when I never thought I was going to make it. I kept saying I was going to quit comedy and go back to college. My favorite thing was going to the racetracks; I was a complete degenerate when it came to the horses. I was also drinking a lot, going out to bars after my shows. They say Jews don't drink, so I made up for about 15,000 of them. I was a mess—I had an agent, a conductor, and a psychiatrist on my payroll.

SHECKY GREENE, COMEDIAN

Every superstar in the world came to Miami Beach in the 1950s. It was a very different element than what you find today. There were big names then—really big names. There were over 40 nightclubs with a need for 350 performances a week, so I was booking acts like crazy.

COURTESY OF JERRY GRANT

Jerry Grant.

I remember booking Don Rickles when he was just getting started, when he was a nobody working at obscure clubs up North. I booked him into Murray Franklin's club—paid him $250 a week. When he started playing, everyone recognized that he was ready to take off. He ripped them right apart. Harry James, the bandleader, was in the audience, and Rickles went to work on him. It was hilarious. Soon after, he went off to California and on to greater notoriety.

I booked Jackie Mason into the Attaché, and it was one of the most successful runs I ever had on the Beach. Jackie took his work seriously. He was very up on world affairs. You couldn't talk to him between 6:00 and 7:00 p.m. because he was watching the evening news. I also booked Rodney Dangerfield into a lot of the hotels on Collins, doing three to five shows a week for about $60 a show.

I booked Redd Foxx, and he was a real nightmare. When he worked the Fontainebleau, he insisted that he get paid $1.00 more than any white act that was performing there at the time. He was a hot performer, but he was cocky and he had a real attitude. I got him a gig paying $55,000 a night. In the end he stiffed me—refused to pay my commission. Some people were making big money then. Foxx, Sinatra of course, Bing Crosby, and Judy Garland all brought in big bucks.

But then the hotels started doing their own entertainment and that killed the nightclubs. And then someone invented this thing called the condominium and that killed everything. If was as if the nightclub scene of the 1950s just self-strangulated—death by condo.

JERRY GRANT, TALENT AGENT

In the early 1950s my Uncle Charlie booked a lot of acts in Miami Beach. The entertainers then were snowbirds, too, working in the Catskills in the summer and Miami Beach in the winter. For many of the small-name acts, the pay wasn't as good as it was in the Catskills and they didn't get free room and board, so they complained a lot. But there was plenty of work to go around—so much so that in a strange way, Miami Beach ruined some of the comedians' careers. I had a few tell me that they made enough money by working both the Catskills and Miami Beach that they never moved to California to pursue the big time. They really lost out.

HOWARD RAPP, TALENT AGENT

In the 1950s I was doing my "Singing Southern Belle" act at the Paddock Club. Lenny didn't have any gigs at the time, and he couldn't stand it that I was making money and he wasn't. So he got together with a couple of other guys, including Buddy Hackett, and they decided to create this foundation for themselves in order to make some money. They became Brother Buddy and Brother Bruce of the Brother Mathias Foundation. That's when Lenny started dressing up like a priest.

He found a black suit at the Salvation Army, and he put a white thing around his neck and started knocking on people's doors, asking for money. He'd say, "Hello, my name is Father Bruce, and I'm with the Brother Mathias Foundation." He actually looked like a man of the cloth, holier than John the Baptist, and he had a real gift for gab, so it worked pretty well. He would drive my car—a yellow Chevy with leopard skin seats and HOT HONEY HARLOW written on the side—to rich people's houses on the Beach. And he was smart enough to park far away from the houses so they wouldn't see the car. Then one day a woman on the Beach asked him what parish he was from. Lenny was Jewish, so he didn't know details like that. And the woman tipped the police off about it. Soon after, the cops pulled him over while he was driving and said, "Father Bruce, we need to talk to you."

Lenny told them that he was an entertainer and that he and some other guys got a charter to be able to raise money for a leper colony in South America. That was legit. It wasn't a total scam; he did

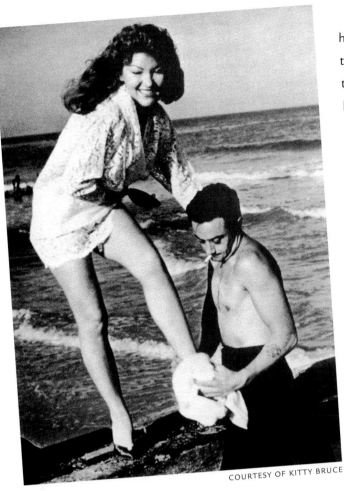

COURTESY OF KITTY BRUCE

Honey Bruce Friedman with her husband, Lenny Bruce.

have a charter, and he did send some of the money to the lepers. He just didn't send all of the money to them. Anyway, Lenny invited the cops to our hotel room at the Floridian, and when they started looking around they opened the closet and found the frilly satin dresses I used in my act. Lenny told them, "Don't worry, I'm not a drag queen." He showed them his charter papers and proof that he had shipped money to South America. The cops took Lenny down to the Miami Beach police station, but in the end they didn't have anything to arrest him on and they let him go.

It was about that time that Lenny and I really started using drugs. There was a doctor in Miami Beach who loved Lenny's act, and we became friends. He started giving us some type of morphine derivative for fun. Some fun, huh? Everyone knows how that fun ended for Lenny.

HONEY BRUCE FRIEDMAN,
FORMER STRIPPER (WHO PERFORMED
AS HONEY HARLOW) AND WIFE OF
COMEDIAN LENNY BRUCE

I arrived in Miami Beach in 1953 with $4.00 in my pocket, and I had a wife and a kid to support. I signed a contract for $290 a week at a place called the Dream Bar. From this I had to pay my agent and pay off people who helped me get the job. I moved into a tiny dump, but I thought, "Where the hell else could I live across from the ocean for a 100 bucks a month?" So I stayed.

One of the first people I worked with was Joel Gray, and he was a real pain in the ass. He was headlining at the Nautilus Hotel, and he was only about seventeen years old. He demanded that the lighting on the stage be just the way he wanted it. Eddie Albert also appeared then and sang with his wife, Margo.

Then I started getting more comedy gigs. I was Italian, but it didn't matter. I came from Brooklyn, so I knew some Yiddish and I became the favored goy comedian on the Beach. There were so many comedians around in the 1950s who later became famous, and I knew many of them—Pat Cooper, Mickey Rooney, Tubby Boots, Buddy Hackett, Larry Storch, Myron Cohen, Jack Carter, Jackie Vernon, Dick Shawn, Jackie Mason, Joey Bishop, Rodney Dangerfield, Frank Gorshin, Rip Taylor.

There were famous people all over the place then. My boss once introduced me to a guy who was

IN PERSON
RECORDED LIVE AT THE AZTEC

DRIFTWOOD RECORDS

DON SEBASTIAN

DOZ WERE THE GOOD OLE DAYS

IN BROOKLYN
(FOR ADULTS)

DRIFTWOOD RECORDS

sitting at the bar. I asked the guy what he did for a living, and my boss smacked me in the back of the head. Turned out it was Mickey Mantle. I even had Dwight Eisenhower in the audience once. And one night the whole cast from *Bonanza* came to my show. I wound up inviting them home for an Italian dinner. They ate a lot of spaghetti.

DON SEBASTIAN, COMEDIAN

The Club Scene

Colorful Characters

In the 1950s the place was full of hookers, just full of them. Blondes, brunettes, redheads. Fat ones, skinny ones, short ones, tall ones. Most were call girls, high-class acts that weren't controlled by pimps and didn't walk the streets. Whatever a guy wanted was here, and the bellhops at the hotels knew how to get it for them. While their wives were out shopping, guys staying at the big hotels would have a hooker come to their rooms. Some would hire a hooker for an entire week.

SHELDON MILLER, REALTOR

I always thought the most interesting aspect of Miami Beach in the 1950s was the public golf courses, especially Normandy, which was full of guys in the Mob—tough guys from New York or New Jersey who talked out of the sides of their mouths and played high-stakes gambling. They had strange names that you didn't want to ask any questions about—Joey Blue Nose, Ice Pick Willie. There were also a lot of real hustlers around then, golf hustlers who played for big money. Slick guys; guys who were so good that they could have been professional golfers but instead they enjoyed the hustle. It was a tough crowd out there. You had to be careful.

IRVING MILLER, REAL ESTATE DEVELOPER

I started modeling in the early 1950s. Every day there was a picture of a bathing beauty in the paper. So I called the City of Miami Beach and offered to pose for them—for free. They even made me pose with a piece of cheesecake in my hand. Tacky, huh?

I never planned on becoming a photographer, but I needed to save money because portfolios were expensive; so I started taking pictures of myself and of other models. Most of those early photos were shot on a little beach behind the old Firestone estate that later became the Fontainebleau. It was very easy to find models then, and many of them posed for me for free. They also trusted me; I had no ulterior motives. I even made exotic bikinis for them, and that's what sold the photos. They weren't wearing boring Jantzen suits with fluffy little skirts.

Then in 1954 I met Bettie Page and shot the cheetah photos of her. I sent them to *Playboy*. Hef [Hugh Hefner] called and said he was excited about them. He fell in love with Bettie right away. He used the photos in his 1955 issue and paid me $100 for them. Then I started shooting more for *Playboy*. I even invited Hefner down to Miami Beach for his first time. I took him to a house on Palm Island and drove him around the Beach. He looked like a little boy staring up at a Christmas tree full of twinkling lights. He thought it was really special—like "Wow!"—and he fell in love with the place. It was a perfect place for Hef—wild and exciting.

BUNNY YEAGER, PHOTOGRAPHER

Photographer Bunny Yeager.

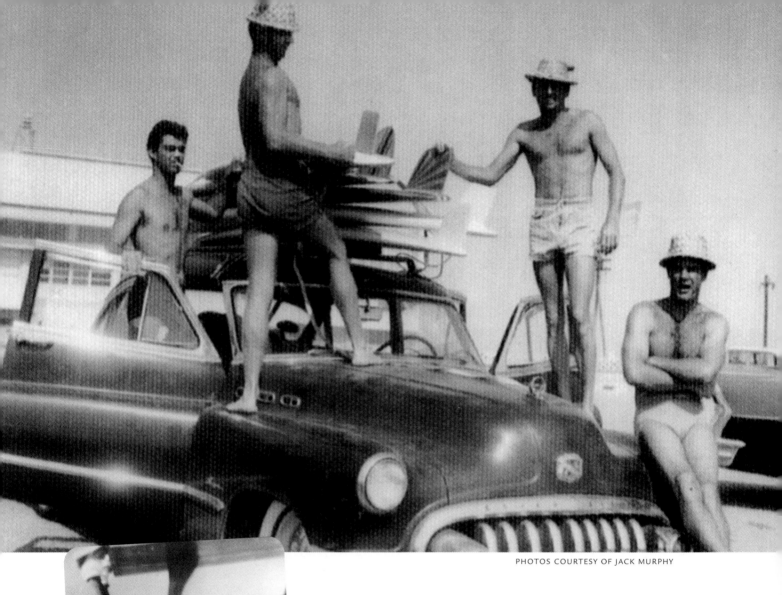

I first came in 1955 and fell in love with Miami Beach. There was a real mystique about it—incredible excitement, wild all the time. My first job was a chef's assistant at the Algiers Hotel, and then I went to work at the Robert Richter Hotel as a cabana boy. Every hotel had dive shows as part of their entertainment, so there were many great divers and swimmers around. Florence Chadwick, the champion English Channel swimmer, was managing cabanas. I also worked as a tennis pro at the Fontainebleau, and for Bobby Riggs at the Roney Plaza. I basically did whatever needed to be done. If the

Above: Jack "Murf the Surf" Murphy (third from left) with pals loading surfboards on top of a Buick. Left: Murphy hanging upside down from a diving board during a water show at the Versailles Hotel in 1957.

The Center of the Universe

weather was good, I gave swimming lessons. If the weather was bad, I taught a dance class—Mambo Mania was the big deal then. And then sometimes I worked the charm schools for young Jewish girls, giving them *charm* lessons.

I also worked as a driver for Lou Walters, Barbara Walters's father, when he did the Gay Parisian Show at the Carillon Hotel. He was a holy man to be around because of his background with Ziegfeld and the other great impresarios of that era. He was already a legend when he got to Miami Beach. His office was this sanctified place with a huge wall of photos of all the great stars he had worked with—Charlie Chaplin, Mary Pickford. I never met Barbara, but I knew her sister Jackie, the handicapped one, because I drove her around, too.

One time Lou was promoting a show on a barge, and I worked on it. We had the chorus girls from the Gay Parisian Show, a trampoline act, and the top water-ski show in the country—a lot of razzle-dazzle, barefoot-backward skiers. The money was some guy from Scotland. The show was just starting to get some great reviews, and then the money guy ran off with the secretary and the show went kaput. Poor Lou Walters wound up with egg on his face. His later years in Miami Beach were not so good.

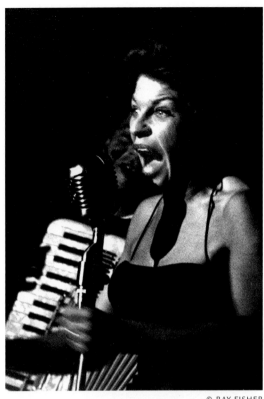

© RAY FISHER

Martha "Big Mouth" Raye at the Five O'Clock Club in 1952.

I remember a lot of great bars around at that time, especially the Dream Lounge. It was run by some mobsters out of New York, and Buddy Rich was often there playing drums. Gary Crosby, Walter Winchell, and Martha Raye would all come in. The Singapore was also a great place; they had all these old Cuban and Puerto Rican musicians who didn't want to travel anymore, so they lived in Miami Beach and just played there. When they finished playing at the Eden Roc, they would go out to the neighborhood bars to jam for fun. And there were a handful of great gals, including Patsy Abbot and Belle Barth, who did these bawdy shows that were X-rated.

One of my favorite characters on Miami Beach was Silver Dollar Jake. He was a real strong presence, a robust and funny guy. He had been in the military, so he used to give military guys a ride in his car and would buy them drinks. He always wore a great big hat and drove a convertible. On the back seat of the car was a sign that said GO NAVY.

He gave silver dollars to kids, but I also remember him handing out these silver-dollar-size tinfoil-wrapped prophylactics to all the guys. He also had this thing he called the Peter Meter: It was a cellophane paper thing that was about an inch wide and a foot long with measurements on it. For every inch of length, he had an obscene slogan written on it. He'd hand guys the Peter Meter, give them a handful of prophylactics, and ask, "Do you measure up?"

JACK "MURF THE SMURF" MURPHY, PRISON MINISTER AND FORMER JEWEL THIEF

Colorful Characters

Jake's name was Jake Shriver. He came from a wealthy family that owned a movie theater company in Detroit. He always had a parrot on his shoulder, always wore a big cowboy hat. He lived on one of the islands, and he had a big spotlight on his balcony. When the ships would sail out of the port, he would shine the spotlight at them, and the ships would flash their lights back to him. Everyone called him Silver Dollar Jake because he gave silver dollars to kids, but he was also famous for this other thing he gave out called the Silver Dollar Jake Peter Meter. The name speaks for itself.

RAY FISHER, PHOTOGRAPHER

Celebrity Sightings

People forget that Miami Beach in the 1950s was the center of the world's entertainment industry. There were many heroic figures around, people who were larger than life. My family had a cabana at one of the big hotels, and I always saw celebrities sitting around the pool—celebrities who were in the movies and on TV. When they walked by, people fainted. But there they would be, lying in the sun in a not-so-flattering bathing suit, acting like ordinary people. I had the same feeling then that I do today as a journalist—witnessing magical people doing astounding things, yet realizing that they are human.

My parents would sit me in a corner at their restaurant late at night, and I would watch the people come in—Don Rickles, Roberta Sherwood, Harry Belafonte. I remember overhearing their personal stories and their laughter and the fun they were having. I remember seeing Eddie Fisher and Liza Minnelli and Johnny Mathis just standing alone in the corner at a party. The first time I met Walter Winchell, I was terrified—the reverence of him was so heavy. And I remember Milton Berle, who was always around town and knew me when I was a kid.

JEANNE WOLF, ENTERTAINMENT REPORTER

Left: Joe Hart, father of Jeanne Wolf. Below: Wolf as a child.

© RAY FISHER

COURTESY OF JEANNE WOLF

In 1951 I photographed Ronald Reagan, who came to town for a birthday party at the Copa City nightclub for Sophie Tucker. Josephine Baker was singing, and Reagan went up on the stage and said happy birthday to Tucker.

When he was playing at the Deauville, I was sent to shoot Harpo Marx. When I got there he didn't have his wig on; he was totally bald. I had to wait until he put the wig on, and then he let me photograph him.

And while he was living at the Roney Plaza, I

photographed Walter Winchell quite a bit. He had a really big ego. It was funny because years later, during the Republican Convention of 1968, I saw him wandering around. Nobody knew who he was. He had to beg for press credentials to get in and seemed to be in a daze—like a legend fading away.

RAY FISHER, PHOTOGRAPHER

COURTESY OF ROSE RICE

During the 1950s my mother and I used to go to a hair salon on Euclid Avenue owned by a woman named Sadie Nathan. A lot of society women went to Sadie for a wash and set, and so did entertainers. One of Sadie's regular customers was Sophie Tucker. While getting her hair done, Sophie would sit under the dryer and sing. She and my mother became close friends, and Sophie would come over to our house for dinner. She was a down-to-earth mama who loved my mother's cooking, and boy could she eat. So much of her act was about being a tough cookie, a real Jewish broad. But underneath that exterior she was really a gentle person.

Above: Rose Rice. Below: Ruth Regina with Judy Garland backstage at the Fontainebleau Hotel.

ROSE RICE, ADVERTISING EXECUTIVE

COURTESY OF RUTH REGINA

During the 1950s I worked on Kate Smith when she performed at the Fontainebleau and went on stage with a broken leg. And Harry Belafonte and Liberace and Jerry Lewis and Belle Barth. I once even made a special hairpiece—bright orange—for Lucille Ball.

One of the people that I became very close to at that time was Judy Garland. I would go to her hotel room, and she would just sit there in her bathrobe as I made her up. She once told me her whole life story from beginning to end. Judy and I were both Geminis, and when we got together she would refer to us as "the four of us." People never knew what to expect with Judy. They were always worried that she might not make a show. But she made all her shows when I worked with her. And she was a wonderful mother to her girls—very loving and warm.

RUTH REGINA, HAIR AND MAKEUP ARTIST

The Center of the Universe

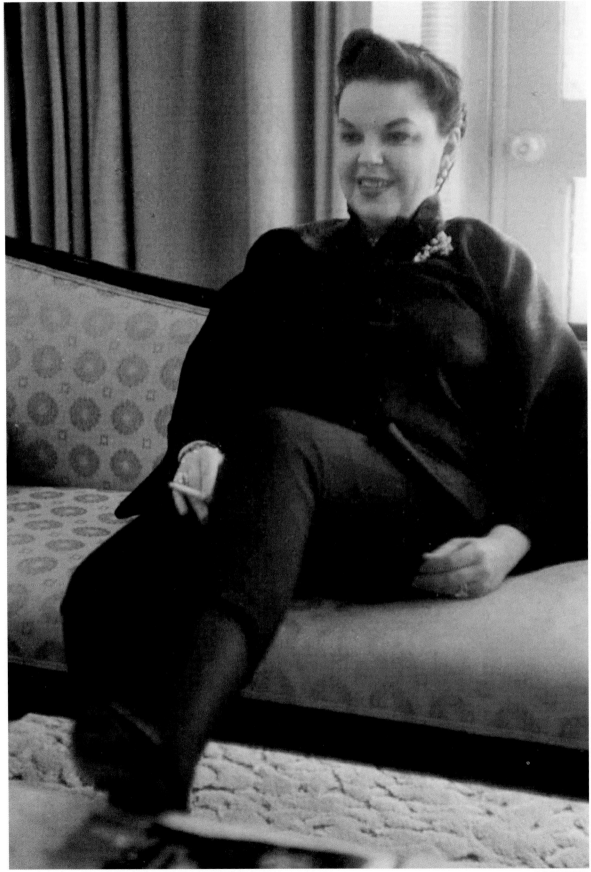

© RAY FISHER

Judy Garland at the Fontainebleau Hotel in 1959.

In 1955 the Shah of Iran came to Miami Beach for a vacation. He was here with his wife, the empress Soraya. He later divorced her because she couldn't have children. Anyway, they were staying at a hotel, and Rocky had to escort them around Miami Beach. Rocky described her as a real common woman, a gum-chewing broad with no class. Although they went to some fancy places, one of the things the empress wanted to do was go to a joke store. So Rocky took them to a little joke store on Washington Avenue. The empress bought a bunch of plastic junk. The shopkeeper, a little Jewish guy, kept saying to her, "Hey kveenie, come here, I got something to show you; you'll like it." He showed her some plastic dog poop and she fell in love with it—bought an entire case to take home to Iran. That's what impressed the empress of Iran in Miami Beach: fake dog poop.

HOPE POMERANCE, WIDOW OF MIAMI BEACH POLICEMAN ROCKY POMERANCE

Hope and Rocky Pomerance.

COURTESY OF HOPE POMERANCE

I took care of Debbie Reynolds's and Eddie Fisher's kids. I would go to their house or to the hotels where they were performing. She was a great mother, very concerned about her kids.

I was also often called out to take care of [Dominican] President Trujillo's kids. When I went to his house, an armed guard would let me in. But I usually treated his kids on his yacht. He was a strange father, but he received me graciously, and I can't complain because he always paid me on time. He would send a man with a briefcase full of cash to my office. The only problem I had with Trujillo was that he stole my favorite nurse. She worked for me, and he took her away with him to Europe.

And I remember I once got a call during the 1950s from a hotel where Judy Garland was performing. She was stoned, and they wanted me to come and treat her. I wouldn't do it. No thanks.

HOWARD ENGLE, PEDIATRICIAN

Because my father worked for Wometo Theaters, I grew up with movie stars coming to my house for dinner all the time. When I was in fourth grade, James Garner showed up at my dad's office, and he wound up taking him home. One the way he picked me up at school. I remember getting called into the principal's office and not knowing what was going on. When I walked in, there was Maverick with my dad. We all went home, and I called my buddies and said, "Get your guns and come to my house; you're not going to believe who is here." A group of kids came over, and we had a fast-draw contest with James Garner in my living room.

Another time we had Gregory Peck over for dinner. He sat right there and ate with us. When they were still married, Debbie Reynolds and Eddie Fisher used to come over a lot. And Henny Youngman just about lived at my house. His mother lived in Miami Beach, and whenever he was away performing, my father took good care of her. And although I didn't get to see him, my dad met Howard Hughes. Hughes owned RKO at the time, and my father wanted to play their movies and invite Rita Hayworth to an opening. So he went to see Hughes while he was staying on a yacht, and Hughes gave him the distribution rights. Hughes also arranged to have Rita Hayworth come for an opening.

JOHN SHEPHERD, CONTRACTOR AND SON OF MOVIE THEATER MANAGER SONNY SHEPHERD

Customers used to be dropped off at my father's shop on Lincoln Road in Rolls Royces and then walk in wearing mink stoles. Everyone came—socialites, gangsters, celebrities. The girlfriend of [Carlos] Prio, the ex-president of Cuba, came in and she would shop like a drunken sailor. Meyer Lansky came by to buy diamond earrings for his wife. Anthony Quinn came in often, and so did Liberace. There was such affluence on the Beach that business was incredible. My father was designing rings that cost $20,000 and $30,000 apiece, and he had no trouble selling them. The bar mitzvah business was huge and so was the first pearl necklace for teenage girls.

SCOTT KING, JEWELER

Temptresses of the Tease

What we did in Miami Beach in the 1950s was still an art form. It wasn't like the strip joints of today; it was true burlesque and great entertainment. We had elaborate costumes, and when we took them off, we took them off *slowly*. We were treated like stars—they had airplanes flying overhead, towing banners with our names on them. The theaters were packed with rich society people. We were professionals, and we made good money doing what we did.

I started out in Miami Beach performing at Place Pigalle on Twenty-second Street with B. S. Pulley—as in Bullshit Pulley. He played in *Guys and Dolls* and was a real character. He had a gangster voice and did a lot of tough-guy jokes, things that were raw. But he was great. I worked for six years there without a day off, doing three shows a night. I was paid $350 a week, but I also got tips and commissions on drinks. We were under a lot of pressure to make money for the club; we had to hustle to crack the nut. The managers never wanted you to leave. You had to stay all night and mingle. I used to get off work at 4:45 a.m., and afterwards I would race to the Black Orchid on Seventy-ninth Street to relax. Jerry Lee Lewis was often there. He wasn't famous yet, just some crazy guy at the piano who tore the place up.

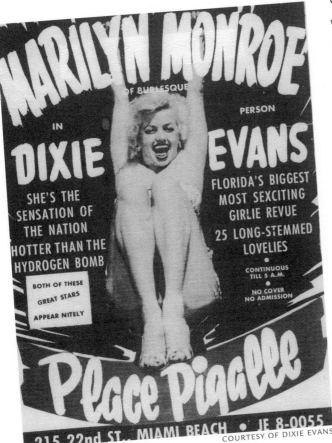

COURTESY OF DIXIE EVANS

Poster of Dixie Evans as Marilyn Monroe.

The great thing about working at Place Pigalle was that celebrities came in every night. One night my boss told me to go and talk to Joe DiMaggio. I had just done my Marilyn Monroe routine, and he wanted to meet me. I was wearing a pink satin gown with a Yankees cap on. DiMaggio had just broken up with Marilyn and was very quiet, very reserved. I wound up going out with him a few times—usually to Wolfie's, where people rushed up to him and asked for his autograph.

Frank Sinatra came in to see our shows all the time, and he often flirted with me, tried to get me to go out with him. But I was going out with Joe E. Lewis at the time, so I didn't. Debbie Reynolds and Eddie Fisher came in a lot, too. One time I told Eddie that I had dated a jockey, and he got fascinated. I couldn't figure out why. Then he told me that he was once in love with a girl who ran off with a jockey, and he wanted to know what they were like.

Poor little Debbie just sat there shrinking as he told the story. Another time Desi Arnaz came in, and he just got up on the stage with me and started doing the cha-cha.

Right after Castro took over, Fulgencio Batista came into Place Pigalle. Word was that he had stolen millions of dollars before he left Cuba, and he was strutting around like a big shot. He came in with a couple of beautiful girls and an armful of trophies—dance trophies. I didn't know who he was. He asked me to go out with him and his girlfriends; one of these girls was wearing a diamond the size of a mothball. When he realized that I didn't know who he was, he opened his wallet and started flipping out all of these little cards with a list of his credentials. He puffed up his chest and said, "I am Fulgencio Batista." He was offended that I wasn't impressed. And once, just once, Gypsy Rose Lee came into the club. She never said a word to me, just nodded at me and smiled. I was thrilled.

DIXIE EVANS, BURLESQUE MUSEUM CURATOR AND FORMER STRIPPER

I worked at Place Pigalle in the late 1950s. During that era strippers still had class. We considered it a career and worked hard at it. We were not in it just for some fast money, like young girls today. I loved working in Miami Beach then, and if I could turn back the hands of time, I would. The money I made was terrific, and there was always something fun to do. There were no couch potatoes sitting in front of TVs yet; people went out at night for entertainment.

There were a lot of great people around then, and I hobnobbed with all of them. We would all meet at Wolfie's for coffee before our shows. I remember seeing Roberta Sherwood when she was just getting started. I used to go out with Mickey Rooney all the time and Frank Sinatra and all the Rat Pack guys. In fact, Jerry Lewis and Dean Martin gave my career a big boost: They said that I had the best two props in show business, and after that I was on my way. And I dated a lot of wonderful men, including Sammy Davis. Being a country girl from Georgia, going out with Sammy was a very provocative thing at the time. I realize now I could have been tarred and feathered for it. But I didn't care.

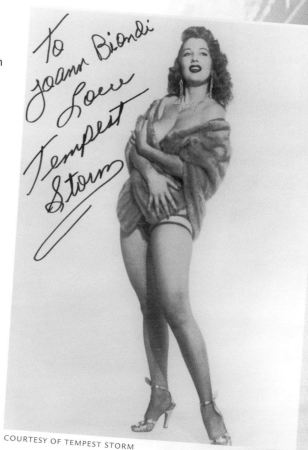

COURTESY OF TEMPEST STORM

TEMPEST STORM, FORMER STRIPPER

Temptresses of the Tease

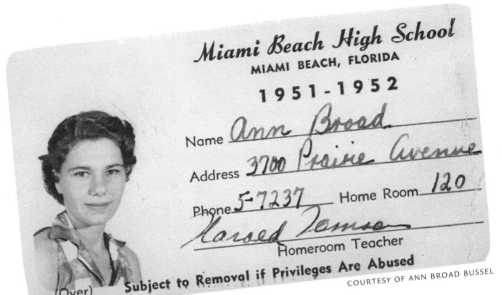

Ann Broad's Miami Beach High School ID card for 1951–52.

Miami Beach High

What I loved most about Miami Beach High was the close-knit nature of it all. It was a very warm environment, where the overall feeling was one of security and unity. Life was easy. Many of us eventually became liberal minded and socially conscious, but that happened later in life, not from experiencing any hardship ourselves. And what's curious to me is that even today, all of my friendships that span a great deal of time are from Beach High, not college.

It's also astounding how good an education we got from that tiny strip of land. Even the basketball players were well educated. Now I do remember one experience that put me in the closet as a writer for a while. I was in the eleventh grade, and I turned in a story for the school's literary magazine. The teacher thought it was good but also thought that my parents had helped me with it. That wasn't true, but I was too stupid or too proud to contest it. After that I never let anyone know that I was writing avidly, stowing it away. But then in the twelfth grade, a teacher named Irene Roberts really got me into writing. Her love of literature was very important in my development as a writer.

MARK MEDOFF, PLAYWRIGHT

I had a friend who was driven to school every day by a chauffeur, and almost every girl I knew got her nose fixed. They'd go away for the summer and come back with a new nose. Appearances were very important, and we were always dressed up—we wore Capezio shoes and Lanz dresses with nipped-in waists.

I never knew that the lifestyle at Beach High was different from how the rest of country lived. I went to either a bar mitzvah or a sweet-sixteen party every Saturday at the big hotels. And these were extravagant affairs. The girls wore gowns and the boys wore tuxedos. Rather than going out for pizza on a Friday night, we went to see Frank Sinatra. Our senior prom was at the Fontainebleau, not the school gym. When Jerry Lewis came to speak at school, it was no big deal. We thought all of this was normal.

KAY ROSENFELD, *MIAMI HERALD* COLUMNIST

COURTESY OF KAY ROSENFELD

I found Beach High to be horrendously materialistic and vain, and I thought it was dreadful. You were expected to have a new dress for each new party, and you had to buy gifts for all of the parties. And if you didn't belong to the right sorority and have the right kind of cashmere sweater, you were out. Out.

Above: Kay Rosenfeld as a Miami Beach High School senior.
Below: Mary Lee Adler (second from left) at her sweet-sixteen party.

After we finished school, we had no prospects for a career. We were supposed to be married by the time we were twenty-one. We were supposed to find a man, preferably a man with money. It was important that he be educated, but it was more important for him to have money. Among the upper middle class, the experience was like arranged marriages. The amount of men to choose from was limited, so it almost became an inbred society.

MARY LEE ADLER, ARTIST

COURTESY OF MARY LEE ADLER

I remember the 1950s as a time when you could walk around barefoot and go fishing from the ocean's edge. But I really can't say that I consider those years as a halcyon period. I don't have enormously fond memories of growing up on Miami Beach. I don't think I was conscious of it at the time, but looking back, I see that Miami Beach was very segregated at the time. It was a one-class society. And it was not at all an intellectual place.

Prior to the time I attended Miami Beach High in the 1950s, it might have been a great school. But when I went there, I'm not so sure it was such a good school anymore. In fact, when I got to Harvard, I quickly realized that so many of the kids had gone to prep school and were much better prepared than I was. During orientation they discussed topics that I was barely aware of—philosophical topics that I had never heard discussed at Beach High. That was a rude awakening for me.

ROBERT E. RUBIN, FORMER U.S. TREASURY SECRETARY

PHOTOS COURTESY OF ROBERT E. RUBIN

Left: Robert E. Rubin as a boy. Above: Rubin as a Miami Beach High School senior.

In the 1950s the big thing for seniors to do was to go to Cuba. Groups of us flew there from Miami on class trips. And let me tell you: If you heard someone talking about Superman at Beach High, they weren't talking about the caped crusader. Superman was the hottest act in Havana. He was a performer who did a live sex show. He had a humongous you-know-what and he did weird things with a donkey. He was all the Beach High kids talked about.

But Beach High was also a very clean-cut school. A bad kid was someone who smoked. When one of the kids' mothers ran away with the cantor from Temple Beth Shalom, it was a big scandal. Oh, what a scandal! I think the most outrageous thing that ever happened was the T-shirt rebellion. Guys were supposed to wear collared shirts to class, and one day one hundred guys showed up wearing T-shirts and sunglasses. This was considered brazen and antisocial.

Because it was the era, Beach High was also very sexist. I knew a lot of bright women who were not encouraged to become anything but professional wives. Why did Miami Beach High girls go to college in the 1950s? To find a man.

GARY BROOKS, ATTORNEY

COURTESY OF GARY BROOKS

Gary Brooks's Miami Beach High School yearbook photo.

Food, Glorious Food

Food was such a major part of life in Miami Beach. You would have breakfast, lunch, and dinner, and then you'd go to a movie and afterwards go to Wolfie's for a sandwich and a sundae. The quantity of food people ate was unbelievable. It was like the stereotypical Jewish mother constantly pushing food at you, a case of disgusting overindulgence. This was hard on us young girls because being thin was also very important. So we ate and ate, and then our mothers took us to the Fat Doctor for pills. There were a lot of girls addicted to diet pills—and a lot of girls shoving their fingers down their throats.

MARY LEE ADLER, ARTIST

COURTESY OF MARY LEE ADLER

Mary Lee Adler on the rooftop of the Allison Hotel.

COURTESY OF KAY ROSENFELD

Kay Rosenfeld at her sweet-sixteen party.

We were all Jewish, so we ate and we ate and we ate, and then we ran off to the Fat Doctor. The Fat Doctor was Dr. Harry Needleman, and for the record he was *fat*. My mother went to him and took me also. He gave me a bunch of pills in a plastic box. You took two reds and a blue in the morning and then some yellow and green ones at night. They must have been full of diuretics and speed, because I once lost eleven pounds in three days.

KAY ROSENFELD, *MIAMI HERALD* COLUMNIST

In 1951 I was working on the Beach as a lawyer, doing tax returns for $5.00 apiece. My wife ironed my shirts for me. It was difficult, and I needed to make some money because she was pregnant. Next door to the little apartment where I lived was a guy named Paul Carvin. His father owned a little bar on Forty-first Street called Lums that also sold hot dogs. Paul used to bring me hot dogs a few times a week, and they were really good.

Soon after, my brother came to Miami Beach, and together we bought the hot-dog bar. They were asking $25,000 for it, and we thought the whole place was only worth about 300 bucks, but we bought it anyway. Paid $10,000 down—which I had to borrow—and our total income for the first year was $3,500, selling hot dogs for 15 cents a piece. My brother worked seven days a week.

That first Lums was really small, only about eight feet wide. It was too small to have a door; we just had a metal canopy that we pulled down at night. But I think this was one of the reasons for its success. It was not an intimidating place. People could stop by, eat a hotdog, have a beer, and leave. And it eventually started to make more money than we ever thought it would, so we were able to open more of them.

Our next one was on Collins and Seventy-first Street, near a place called Jake's Bar. Jake's was a raunchy little place that had a stripper. You could smell the whisky when you walked in the door, and occasionally Lenny Bruce would perform there. He also came into Lums for hot dogs. This was a time

The Center of the Universe

106

when the Beach was full of little bars like this—places where they soaped up the windows so locals could drink during working hours and no one would know.

At the second Lums we sold beer and wine along with hot dogs—which were not kosher—steamed in beer. And then we added the Lumsburger, which was basically my sister-in-law's recipe for sloppy joes. The business kept growing, and a few years later we owned several hundred Lums. In 1960 it became a public company. All of this from a little hot-dog joint on Miami Beach. Even I'm amazed.

CLIFF PERLMAN, ATTORNEY

COURTESY OF CLIFF PERLMAN

Cliff Perlman (far left) with his father, Bernard, and brother, Stuart, in 1956 at the original Lums.

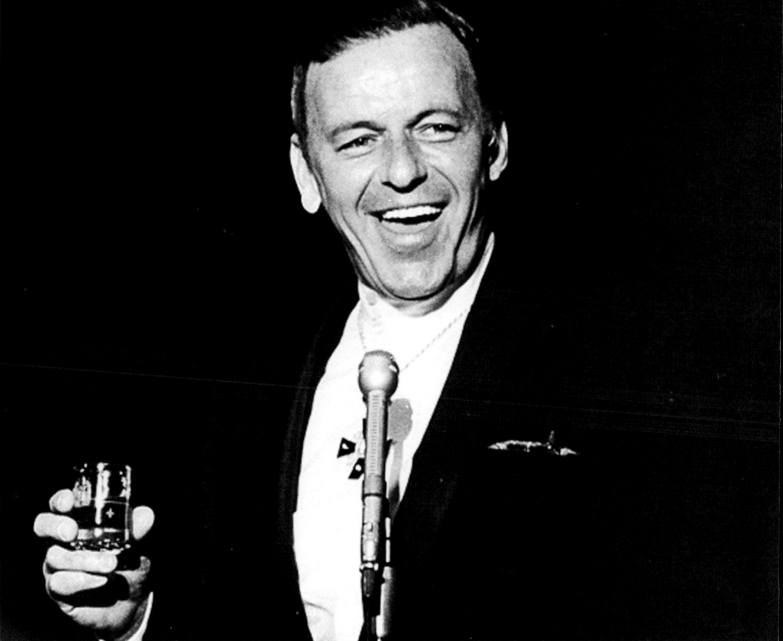

Frank Sinatra on stage at the Fontainebleau.

Old Blue Eyes and the Rat Pack

··

My wife gets very nervous when I talk about Sinatra, so I've got to be careful. But I always found it interesting to work with him. You never knew who was going to show up. One minute there would be some classy dame like Claudette Colbert, and the next there would be his hoodlum friends—guys with names like Sammy Pineapple or Joey Apple. Guys that let you know you had to make Frank happy.

The Center of the Universe

One of the things I remember most about Frank is that he loved Boston cream pies. I used to go to The Famous restaurant a lot, where Morris Lerner and his wife were real sweet to me. So I once asked Morris to bake a pie for Frank. He did, and when I took it to Frank he guarded it with his life, treated it like it was gold. Told his guys, "Don't touch that pie; it's mine."

SHECKY GREENE, COMEDIAN

NBC-TV

Comedian Shecky Greene on stage.

One time Shecky Greene was supposed to do a twenty-minute warm-up act at the Fontainebleau for Sinatra, and he wound up doing forty-five minutes. Sinatra got mad, real mad. He had his boys beat up Shecky in the Poodle Lounge; they broke a few of his ribs. I saw it happen. Shecky had to go to Mount Sinai Hospital to be taped up. Later on he worked it into his act. He'd say, "Frank Sinatra once saved my life. These guys were beating me up, and Frank said, 'Enough.'"

BERT SHELDON, ENTERTAINMENT DIRECTOR

Sinatra used to perform at the police benefits, so most of the cops loved him. But one time Shecky Greene did something that offended him, and he had his goons beat him up. Shecky wound up in the hospital, and my husband, Rocky, had to go there to file a police report. Rocky tried to find out what happened, but Shecky wouldn't fink on Sinatra. He said nothing happened, that he just fell up a flight of stairs.

HOPE POMERANCE, WIDOW OF MIAMI BEACH POLICEMAN ROCKY POMERANCE

When Frank came into the Fontainebleau, he got in a lot of fights. He once beat up an old bellboy for no good reason. Poor guy didn't even see it coming. Sinatra beat up a lot of people like that. And when it was too much for him, he'd tell his boys—Joe Fish or some other bodyguard—to finish the job. The place was always full of Sinatra's bodyguards, his personal goons.

He used to sit at the bar and get drunk—just plastered. One time he was sitting there, sipping whisky and talking about Ava Gardner. He said, "She was the most beautiful wife I ever owned." He could be a tough ass, but he was also good to a lot of people, especially Sammy Davis Jr. Sammy was not at all like Sinatra. He was like a kid, running around, dancing all the time. He smoked seven packs of cigarettes a day, and when you walked into his room all you saw was big cloud of smoke.

MAC MCSWANE, FONTAINEBLEAU BELLHOP

COLUMBIA PICTURES

Kay Stevens.

I have always resented people who say negative things about the Rat Pack, about the booze and the broads. They were perfect gentlemen with me—Sammy, Frank, Dean, all of them. They were kind and generous. They were also hardworking guys who would bleed for their audiences. They were perfectionists who gave a lot of themselves. So what if they drank a little too much at the Boom Boom Room? They put on a great show.

KAY STEVENS, SINGER

I photographed Sinatra once in the 1950s when he was working at the Beachcomber and his career was in a slump. It was right before he starred in *From Here to Eternity,* and he bombed on the stage. The club was empty and he was playing to snow—a sea of white tablecloths with no people sitting at them.

RAY FISHER, PHOTOGRAPHER

Sinatra never bought anything from our jewelry store because another jeweler down the block used him as a spokesperson and gave him rings for free. But the other guys came in all the time—Sammy Davis was one of our best customers. He loved jewelry and bought tons of it: rings, bracelets, gold chains. We even once designed a ring specifically for Dean Martin. It was a black star sapphire encrusted with diamonds. Once word got out about that ring, people started coming in asking for the same thing, and it became known as the Dean Martin Ring.

SCOTT KING, JEWELER

Dean Martin (right) and Jerry Lewis at the Beachcomber nightclub.

I got to know most of the Rat Pack guys. I saw Dean Martin around, and he was not at all like what he appeared. He was not a drunk. Peter Lawford was around, too, and the guys often gave him a hard time because of his connections to the Kennedys. Jerry Lewis was on the scene, and I remember him as not a very nice person.

And then there was Sinatra. Frank had enormous personal problems, really strange things happening to him all the time—women trouble, fights. Mostly things he brought on himself. Frank could get mean when he drank; he often provoked people. He would call me in the middle of the night all worried that something bad was going to happen to him. He said the wrong thing to the wrong guy who was connected to the Mafia, and he was afraid they were going to knock him off. So I would calm him down and advise him about what to do.

Frank had a good friend named Gillie. Gillie's wife, Honey, had blue hair, and she would walk around Miami Beach wearing a long fur coat. She got into a little trouble for owning one of the largest abortion clinics in New Jersey, but that's another story. They had a boat called *Gillie's Yen,* and we would all have dinner on the boat. Those are some of my fondest memories of Frank.

I once had a bar mitzvah at my house for my son, and Frank was supposed to come. Woody Allen was there, and so were Dyan Cannon and a lot of great people. Gillie called and told me Frank had a problem and couldn't make it. Apparently Mia Farrow locked herself to his door at the Fontainebleau with handcuffs. Frank couldn't get out of the room and had to call someone to cut Mia free. He showed up at my house at about 2:30 a.m., and the party was over. That was Frank.

AL MALNIK, ATTORNEY

Sammy Davis was one of the most devilish, entertaining men I ever met. And he took being Jewish very seriously. He once got sick and was rushed to St. Francis Hospital. He called me from the hospital in a panic. "This place is full of nuns. Get me out of here before something bad happens," he said. So I went and got him and took him to Mount Sinai. He was greatly relieved.

MARGORIE COWAN, HOTELIER

I always found Frank Sinatra to be a real gentleman, especially when he was around my wife. There were a couple of times when we were at the Fontainebleau and he pulled me aside and told me that there was about to be a little problem—his goons were going to have to rough someone up. He told us to leave so my wife wouldn't have to witness it.

IRVING COWAN, HOTELIER

I saw a lot of Frank Sinatra while I was in Miami Beach. We both performed there at different times, and when we weren't working we went off together and played. I think Frank really liked Miami Beach as a place, but he hated the beach itself. Never wanted to walk on the sand or go in the water. He was fussy like that.

I had known Frank since I was fourteen years old, and we were very close. He told me about his dreams—like his dream about being the ambassador to China. He told me all about the problems in his marriages. And it was in Miami Beach that Frank started to warn me about my marriage to Gordon. Gordon was drunk all the time, and everyone knew it. He once passed out at the Deauville, and I had to call for help. It was horrible. Frank was there for me at that time. He even asked me to marry him. It was a very difficult but also very romantic time in my life.

SHEILA MACRAE, ACTRESS

Sinatra stayed at the Fontainebleau a lot, but the truth is he didn't tip very well. He had a special suite at the hotel, and when he wasn't here we would put his furniture in storage. Every time he showed up, we had to take the furniture out of storage for him and put it in his room. The problem with Sinatra was that he drank a lot and he could get real mean. Sammy Davis was different; he was a fun guy, mellow. But he didn't tip too good either. The funny thing about Sammy was that sometimes if you looked at him, you almost thought he was white. Something about the way he acted when he was around the Rat Pack made him seem white and not black.

LEVI FORTE, FONTAINEBLEAU DOORMAN
AND FORMER HEAVYWEIGHT BOXER

One time Frank Sinatra was in the hospital—Mount Sinai—and I was sent over to take a photo of him. I was worried because I had heard he often spit at reporters. His bodyguards let me get near him, and as I started shooting the photos, one of them came up to me and said, "Honey, Frank only wants you to shoot his right side."

EDNA BUCHANAN, FORMER *MIAMI
BEACH SUN* REPORTER

CAROL PUBLISHING

**Sheila MacRae on the cover
of her autobiography.**

One time Sammy Davis Jr., Frank Sinatra, and Belle Barth came into the Gaiety Theater when I was running it. We had a Chinese dinner together, and then we started watching the coming attractions for an X-rated film that was going to be running. For fun we shut the sound off and the three of them—Frank, Sammy, and Belle—improvised the sounds to go along with the scenes. They were all moaning and groaning and making funny noises. It was hysterical.

LEROY GRIFFITH, STRIP CLUB OWNER

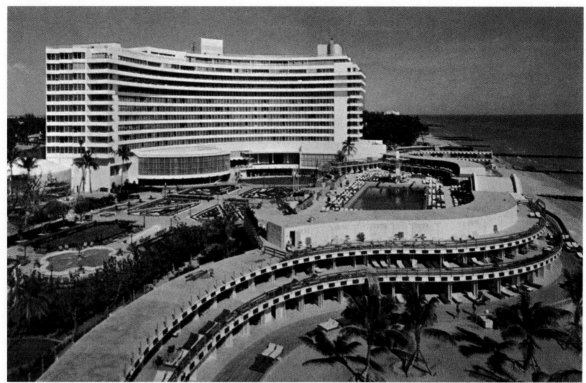

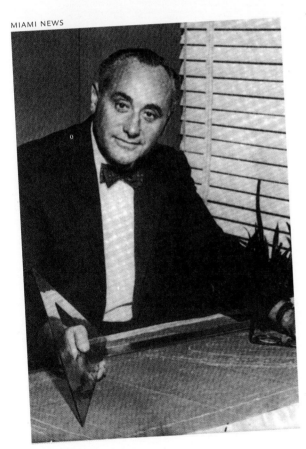

The Fabulous Fontainebleau

Ben Novack bought a lot of land from my mother on Collins Avenue in order to build the Fontainebleau. At the time we all thought he had flipped his wig. Nobody was building big hotels like that in Miami Beach. And when the place turned out to be a howling success, we were all shocked. But as they say, it is impossible to underestimate the bad taste of the American public.

STANLEY WHITMAN, REAL ESTATE DEVELOPER

Above: Postcard of the Fontainebleau Hotel. Left: Fontainebleau architect Morris Lapidus.

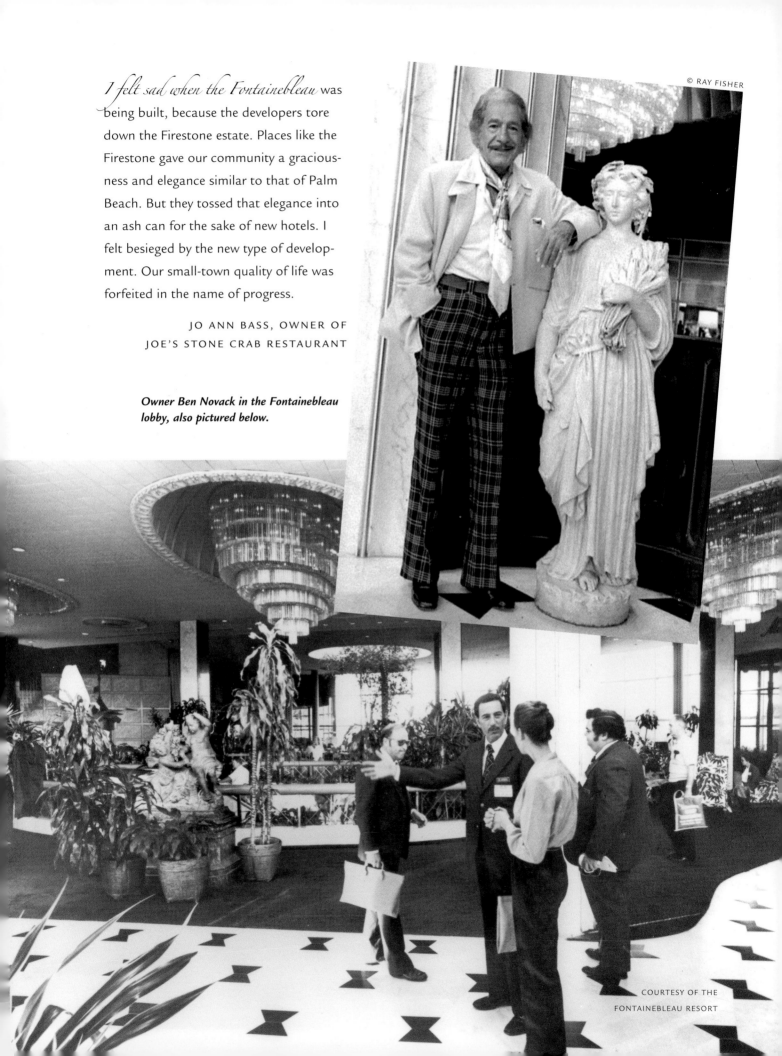

I felt sad when the Fontainebleau was being built, because the developers tore down the Firestone estate. Places like the Firestone gave our community a graciousness and elegance similar to that of Palm Beach. But they tossed that elegance into an ash can for the sake of new hotels. I felt besieged by the new type of development. Our small-town quality of life was forfeited in the name of progress.

JO ANN BASS, OWNER OF
JOE'S STONE CRAB RESTAURANT

Owner Ben Novack in the Fontainebleau lobby, also pictured below.

© RAY FISHER

COURTESY OF THE
FONTAINEBLEAU RESORT

I watched them build the Fontainebleau and thought it was a monstrosity. Frank Lloyd Wright came down to see it. He wasn't kind. He said, "When you design a hotel for ants, it's going to look like an anthill."

MAIDA HEATTER, COOKBOOK AUTHOR

When the Fontainebleau first opened, I remember that there was an uproar among a lot of us who lived on the Beach. We thought it was just awful—full of bad taste; a big, gaudy, pretentious place. We made fun of it by calling it "the Finklehauf."

MARY LEE ADLER, ARTIST

COURTESY OF GILLER & GILLER ARCHIVES

**Architect
Norman Giller.**

When the Fontainebleau was built, it was a reflection of what American society wanted. That period followed the Depression and World War II, two events that had a tremendous impact on our country. By the time the 1950s came, Americans had been deprived of the recreational part of life for a long time, and they wanted some fun. They were bursting with desire for fun. The Fontainebleau and the Eden Roc filled that void. They looked toward the future, rather than the past. They reflected the country's affluence, and they proclaimed "We have arrived." I don't think the architects who built them were consciously aware of it at the time. It is only now, looking back, that we can surmise that that is what happened. Now we call these buildings MiMo—Miami Modern.

Along with the Fontainebleau, the 1950s also brought Motel Row, a new phenomenon at the northern tip of Miami Beach. Motels used to be places you drove to and slept in. They were not destinations. The Miami Beach motels of the 1950s changed that concept. They looked like traditional motels for families. People carried their suitcases themselves, and most motels had nothing but a TV room for entertainment. But for the first time on the Beach, people had to pay for their rooms as soon as they

checked in. And most importantly, these motels became a destination themselves because of the ocean. The demographics of the country were changing, and these new motels catered to a new middle class trying to claim its stake in America.

<div align="right">NORMAN GILLER, ARCHITECT</div>

Ben Novack was a wonderful old codger, very innovative. If he liked you, he invited you to sit at his personal table at the Poodle Lounge for happy hour. Cocktails were $5.00, and everyone drank Cutty on the rocks. They sat around and talked about the shows and the broads and what was going down. There was always a surplus of girls, especially girls who ran after the Rat Pack guys. Novack was hard of hearing and he refused to wear a hearing aid, so you had to yell in his ear. He wore outlandish clothes, bright green sports jackets and moccasins with no socks. When I was finally invited to join his table, I thought I had arrived—I was now one of the Young Jewish Important People. That was how the social hierarchy of the day worked: Who you were was where you sat at the Fontainebleau.

<div align="right">AL MALNIK, ATTORNEY</div>

I've worked at the Fontainebleau for a long time, and I've loved every minute of it. Mr. Novack was a great guy to work for. The hotel was his little kingdom, and all the big guys were his friends—I once saw him walking around with Howard Hughes. He was one cool guy, Novack. For his wife's birthday he had all the plumbing in their suite turned into gold.

In the 1950s lots of stars came there. One time Bette Davis checked in, and I took her to suite 862. I knew she was famous, but I wasn't sure who she was, so I said, "Are you Joan Crawford?" She got mad and said, "Don't you ever call me Joan Crawford. I hate her." I apologized, and she said she forgave me. The weird thing is that a few minutes later, Joan Crawford checked into the hotel. I checked Aretha Franklin in once, and she had quite a bit of luggage—whew. But she was a nice lady. She sang the blues but talked religion. And I once checked James Brown in, and he told me that he had been a fighter and a shoe shiner. He was a humble guy.

The best tipper I ever had was a guy named Mr. Seismore. He checked into the hotel looking like a bum, drunk and stumbling around. Nobody wanted to wait on him, so I offered to help. When we got to his room, he told me that he wasn't drunk; he was just playing around to see how people would treat him. A few days later, just before it was time for him to go home, he took me to a Cadillac dealer and bought me a brand-new Cadillac—a yellow and brown Coupe de Ville. Paid cash for it and put it in my name. Now that was a good tip.

The only bad memory I have of the hotel is the time some guy jumped from the roof of the building—committed suicide—with a briefcase chained to his hand. They got that body out of there real quick. What man on the roof? Whatever happened at the Fontainebleau stayed there. Nobody talked.

<div align="right">LEVI FORTE, FONTAINEBLEAU DOORMAN AND FORMER HEAVYWEIGHT BOXER</div>

<div align="center">*The Fabulous Fontainebleau*</div>

I grew up at the Fontainebleau. My father provided the marble for the hotel, and they couldn't afford to pay him so they gave him an apartment instead. We moved in a month before it opened in 1954. Looking back, I remember that time as lush, lavish, and over the top. It was cafe society at its best, the most exciting way of life in the world. It was all about money and prestige and glitz and glamour and who had the biggest diamond. Now I see how ostentatious it was, but back then, more was definitely better.

The entire place was one star-studded experience after another. I got to meet so many famous people at that hotel—Garson Kanin, George Burns, Bennett Cerf, Maurice Chevalier, Red Skelton, Zsa Zsa Gabor, Elizabeth Taylor, Debbie Reynolds, Esther Williams, Lucille Ball. I used to play with Ronnie Burns, George and Gracie's son. We knew every nook and cranny of the hotel.

I remember one day when George Jessel and Jack Benny went swimming and Jack pulled George's toupee off and ran away with it. George came running to the cabana looking as bald as a billiard ball. I remember John Wayne coming to the hotel for dinner and how everyone stared at him while he ate. And I remember Marilyn Monroe walking by the pool in a cotton sundress, looking so incredibly beautiful. I remember hearing the buzz at the hotel when Truman Capote checked in. And I remember hearing the gunshots fired into the ceiling when Ben Novack found out that his wife was having an affair with Pupi Compo, the musician.

COURTESY OF MICHAEL ALLER

Michael Aller as a boy at the Latin Quarter nightclub.

MICHAEL ALLER, MIAMI BEACH TOURISM AND CONVENTION DIRECTOR

I worked the Fontainebleau, and when I did I made a lot of money and had a lot of fun. I also worked the Eden Roc, but didn't like it at all. Morris Lansburgh invited me to perform for him at Harry's American Bar. He put me in a crappy room, and he put my conductor in an even crappier motel room. It was pouring rain outside, and the hotel started to flood. I couldn't take it, so I quit.

SHECKY GREENE, COMEDIAN

The Center of the Universe

I once sat down in the Boom Boom Room at the Fontainebleau, and the bartender told me that I couldn't work that stool—that if I wanted to work the stool, I'd have to pay him for the privilege. I somehow missed that in translation and later realized that he thought I was a hooker.

PEGGY HELFOND, REALTOR

In the early days I worked for Mr. Novack. He was a good guy who ran a good joint, but he also had a lot of goons working for him—Chicago tough guys who would rough people up if they got out of hand. When we first opened the hotel, we had Chris Evert's dad, Jimmy Evert, working as our tennis pro. Chris was just a cute kid then who would come here to practice.

There were a lot of beautiful women at our bars, especially the Poodle Lounge—beautiful women sitting on a fortune. It was a real swingers' bar. And the girls took care of the bartenders in order to sit at the bar. Some of them made a lot of money. Back in the 1950s they would bring in about $200 a rattle. And they could do that several times a night.

And then there were the cabanas. Families used those beach cabanas, but to tell you the truth, a lot of them were sex dens—pure sex dens. They were used for wild parties with hookers or wife-swapping escapades. Sometimes married men used them and went there with their girlfriends while their wives were getting their hair done. A lot of wives let their husbands run loose back then, just looked the other way.

COURTESY OF THE FONTAINEBLEAU RESORT

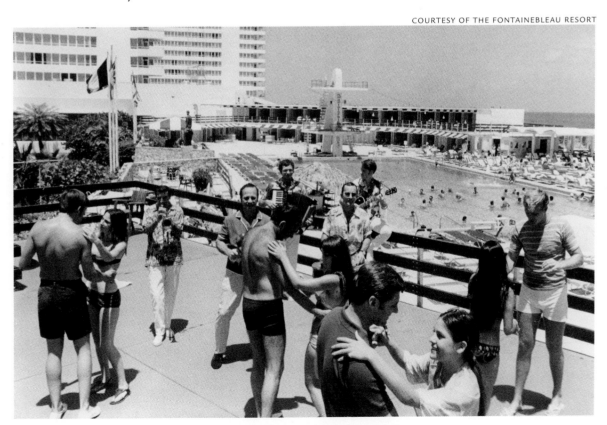

Dancing on the Fontainebleau pool deck.

And there were always a lot of movie stars—big movie stars. We used to call the big staircase in the lobby the Stairway to Nowhere, because we would make the movie stars get off the elevator at the mezzanine so that they had to walk down those stairs and make a grand entrance. So that everyone in the lobby would look up in awe.

Marilyn Monroe once checked in with some decrepit old man. I didn't know it at the time, but it turned out to be Arthur Miller's father. Every now and then she would sing in the La Ronde Room. She was usually drugged out or drunk, but people loved to look at her because she never wore underpants.

HE'S THE SILLIEST!!! -IN A SERIES OF SEQUENCES THAT ARE EVEN SILLIER!

JERRY LEWIS as

The Bellboy

WRITTEN, PRODUCED AND DIRECTED BY JERRY LEWIS · ASSOCIATE PRODUCER ERNEST D. GLUCKSMAN · A JERRY LEWIS PRODUCTION · A PARAMOUNT RELEASE

PARAMOUNT PICTURES

One time when she was here, she told some of the hotel staff that she was thinking about going to Washington to talk to the papers about the Kennedy boys. She was dead about five weeks later.

Judy Garland performed a lot, and she was almost always stoned on drugs. People were always worried: "Is Judy going to make it onto the stage tonight?"

For a long while Shecky Greene was living high on the hog here—drinking, partying, lots of girls. He once got so drunk he pushed a piano out the window from the fifteenth floor. When it hit the ground, boy did it make a lot of noise.

Joan Crawford used to stay at the hotel a lot, and when she went out in her limousine she always carried a big makeup case with her. "Oh no, I forgot my makeup case," she would say in a panic. And I would have to go upstairs and get it. Well, I once found out that there was no makeup in that makeup case. It was full of vodka.

When Liberace checked in, he had the most luggage of anyone I ever saw—huge wardrobe trunks full of fancy costumes that weighed one hundred pounds each.

MAC MCSWANE, FONTAINEBLEAU BELLHOP

Before he went to the Eden Roc, Morris Lansburgh was my partner at the Versailles. He was an arrogant guy, like Donald Trump. At the Eden Roc he was the front man, always talking to people, fawning over the guests—so much so that people used to laugh at him. He had a habit of bowing to women and saying, "Hi, I'm Morris Lansburgh." People thought, "Who the hell is this guy?" He was a jerk. Lansburgh was responsible for bringing the American Plan to the hotels. He wanted people to

The Center of the Universe

spend money at his hotel and no place else. So for a few bucks a day, people got breakfast and dinner. The restaurants on the Beach couldn't compete with the hotel prices, so many of them folded. As far as I'm concerned, the American Plan killed the Beach.

BERNIE BERCUSON, HOTELIER

© RAY FISHER

**Morris Lansburgh
at the Eden Roc Hotel.**

The decline of Miami Beach started in the late 1950s and was directly tied to Morris Lansburgh's American Plan. Once he put that policy in place, it cheapened the atmosphere. The Miami Beach experience went from dining at fine restaurants and going to nightclubs to staying at one hotel the whole time. This led to a less affluent crowd coming to Miami Beach. People with money went elsewhere, and the glamour and polish of Miami Beach began to fade.

IRVING MILLER, REAL ESTATE DEVELOPER

The 1950s weren't so fabulous for the people who worked in the hotel industry. Their work was seasonal, and they had no job security, no health insurance, and no pension benefits. They were not protected by federal labor laws. And yet these people had families to support, and they represented the cornerstone of the local economy.

I started practicing as a labor lawyer in 1953, and in 1955 I had the biggest labor battle ever. The AFL-CIO began to organize the workers and proposed a contract. The hotel association refused to sign the contract, so the hotel union called a strike. About twenty-five or thirty hotels went on strike. People were marching up and down Collins Avenue with picket signs.

The hotels got an injunction to stop the picketing. They used this bizarre legal theory that only hotel employees were allowed to picket. So we had to rent a storefront and take depositions from the workers proving that they were hotel employees in order for them to picket. My co-counsel was Claude Pepper, and it took about a year, but we were finally able to get the hotel workers union recognized after an appeal to the U.S. Supreme Court. We eventually got them a decent contract with health insurance and a pension fund. But it wasn't easy. Things got violent.

The strike hurt the Beach economically. Some hotels had to shut down for the Christmas season, and many people got angry. At the time, the *Miami Herald* had its own strike going on. They viewed all union activities as illegitimate expressions of the human spirit, and they were not supportive. Even Caesar Chavez came to town to encourage community support. But he couldn't get much sympathy from the Beach community—not from a place that crowed the success of capitalism.

JOSEPH KAPLAN, LABOR LAWYER

Ella Fitzgerald at the Eden Roc in 1958.

The Color Line

When I worked the nightshift at Joe's Stone Crab during the 1950s, the last bus to leave the Beach was at 2:00 a.m., and I knew I had better be on it or there would be trouble. If I missed the bus, the cops would be out there waiting for me, and I would have to call my boss and ask him to talk to the police, to verify that I was on my way home.

At the time, all the big stars came to the Beach clubs, and I wasn't allowed to go in to see them. Even if I had the money in my pocket, and many times I did, I was not allowed in. It didn't worry me too much because I got to see them at the Mary Elizabeth Hotel in Overtown. All of them—Louis Armstrong, Cab Calloway, Duke Ellington, Ella Fitzgerald—stayed there and put on shows for us blacks late at night. They were making money on the Beach, a lot of money, so they didn't complain too much. But you could tell that in the back of their minds it bothered them.

I'll never forget those times. Even today, when I walk into a restaurant in Miami Beach, I say out loud, "Thank you, Jesus. Thank you for making it better for us." My grandchildren don't know what I'm talking about.

PRINCE GEORGE GORDON,
RETIRED RESTAURANT COOK

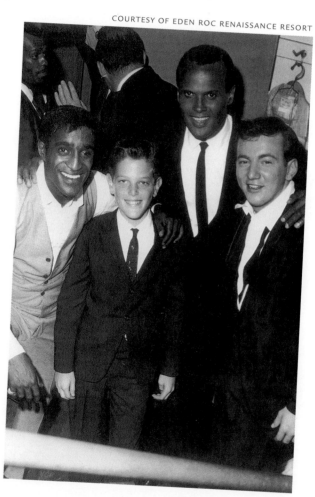

COURTESY OF EDEN ROC RENAISSANCE RESORT

*Sammy Davis Jr., Harry Belafonte,
Bobby Darin, and guest at the Eden Roc.*

During the 1950s my father often drove our black employees home after the night shift, especially if they missed the last bus. The local police claimed that there was never a law that forbid blacks from being on the Beach after dark, but they weren't treated nicely if they were found standing on a corner. If they wouldn't let Harry Belafonte stay in a Beach hotel, they sure weren't going to let black waiters wander around the streets at night. A lot of our black employees were regularly stopped and asked to show their ID cards, but I never heard of that happening to any of the white employees. This is an issue that has been conveniently swept under the rug. It's a part of Miami Beach history that people don't want to remember.

JO ANN BASS,
OWNER OF JOE'S STONE CRAB RESTAURANT

Before the 1950s there were two separate taxi services: one for blacks and one for whites. White people rode in cars with white drivers, and black people rode in cars with black drivers. I thought that was ridiculous, so I changed it. In about 1956 I started hiring black people to drive my taxis, and then people realized that it was OK to ride in a car with a black driver. They were no longer afraid of the idea.

STANLEY SEGAL, FORMER TAXICAB COMPANY OWNER

During the 1950s, my mother took me with her to clean houses in Miami Beach. It was common for maids to do that, and it wasn't for babysitting; it was so we could help with the work. Coming from Opa-Locka, it was beyond my imagination to see how these people lived. They had unlimited food, beautiful houses, clothes that were wonderful. They had stuff. My mother was working six days a week and making about $10 or $15 a day.

Except for gardeners, not too many black men worked on the Beach. Black women were able to get work aplenty in hotels and houses, but black men weren't allowed to get any of the better hotel jobs. When I was a boy and wanted to make some money, my father said, "Go east, young man, and cut grass." And that's what I did.

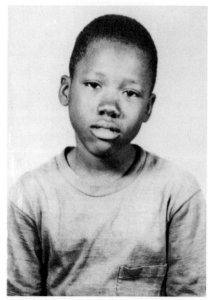

COURTESY OF MARVIN DUNN

Marvin Dunn as a child in the 1950s.

All of the families we worked for were Jewish. I think their attitude towards us was not necessarily condescending, but it was paternalistic. There was a sense among the Jews that they should help us. They gave us food and bought us Christmas presents and treated us well, and they would sometimes drive us home at night. But they always made us sit in the backseat, never in the front.

If you were caught on the Beach after dark, the police would put you in their car and escort you off the Beach—drive you across the causeway and deliver you back where you belonged. They told you, "One time." Meaning next time you're in trouble. The mere threat of violence or of losing your job was enough to keep blacks in control, to keep them in their place.

This was a time when the white population was undergoing tremendous change. By the 1950s the white Southern ruling class of Miami Beach was losing its power to northerners—northern Jews in particular—and it was a time of great transition. It was tumultuous. For blacks Miami Beach was a little bit better than the mainland, where they did have the occasional lynching and the Ku Klux Klan was in full force. For the most part the Jews were more liberal, and they tempered the climate.

Back then, if I wanted to go swimming I went to Virginia Key because if I tried to go swimming on

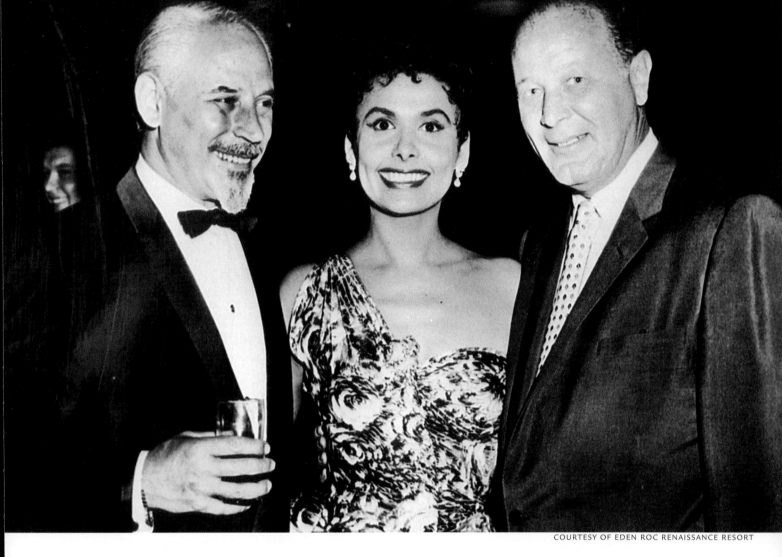

Lennie Hayton, Lena Horne, and Harold Mufson at the Eden Roc.

Miami Beach, I would have gotten arrested. There was no legal basis for this; nobody ever went to jail, but the police were called if they saw blacks trying to go into the ocean on Miami Beach. I never even dreamed of going swimming on Miami Beach. Like going to Jupiter or Pluto, it was just beyond comprehension. I was a grown man before I ever stepped foot on the sand of Miami Beach.

MARVIN DUNN, PROFESSOR

I worked with Lena Horne on the Beach in the 1950s. Here was a woman who got standing ovations everywhere she performed—a truly remarkable woman. She was even married to a white man at the time, Lennie Hayton. But she couldn't stay in the local hotels. She never spoke about it. She was a real lady about the whole thing. That kind of thing seems impossible today.

WOODY WOODBURY, COMEDIAN

The Color Line

While Nat King Cole was performing at my nightclub in the 1950s, I invited him to stay at my home on the Beach. Blacks still weren't allowed to stay at local hotels, and Nat told me that as long as his fellow musicians could not stay at hotels on the Beach, he just could not stay with me. Instead he stayed at the Sir John's Hotel in downtown Miami with his band. He didn't want it to appear as if he was getting better treatment.

JERRY COHEN, GENERAL CONTRACTOR

CITY OF MIAMI BEACH ARCHIVES

Burnett Roth.

The Civil Rights era was a very emotional time on the Beach. There was a lot of tension. We had to fight so many battles—desegregation of the schools, voting rights. Each battle was hard. I remember when a black Methodist church group was planning to hold a convention at the Blackstone Hotel on Miami Beach. It was 1954, and it got very tense. There were threats from the Ku Klux Klan—bomb threats. Even the synagogues were placed on alert.

BURNETT ROTH, CIVIL RIGHTS ATTORNEY

I worked as a lawyer on the legal process of bringing desegregation to Miami Beach schools in the late 1950s. It was just before the *Brown v. Board of Education* ruling, and it wasn't easy. There were a lot of people who were upset about it. We started busing kids in from Overtown and Liberty City. That was when a lot of the Jewish parents started taking their kids out of the Beach public schools and putting them in private schools. Many people believed that it was the right thing to do, but when it affected their kids, they didn't like it.

HARRY B. SMITH, ATTORNEY

The Promised Land

As Jewish kids in the 1950s, we led very protected, insulated, middle-class lives. The Beach was very Jewish, except for the few parts that were very not Jewish. I think I only had one non-Jewish friend the whole time I went to high school. And the few kids that weren't Jewish made believe they were so they didn't have to come to school on the Jewish holidays. In many ways it was very comforting to be surrounded by other Jews. It was like living in the new Promised Land. I didn't appreciate this until I went away to college in Michigan and someone asked me where my horns were.

KAY ROSENFELD, *MIAMI HERALD* COLUMNIST

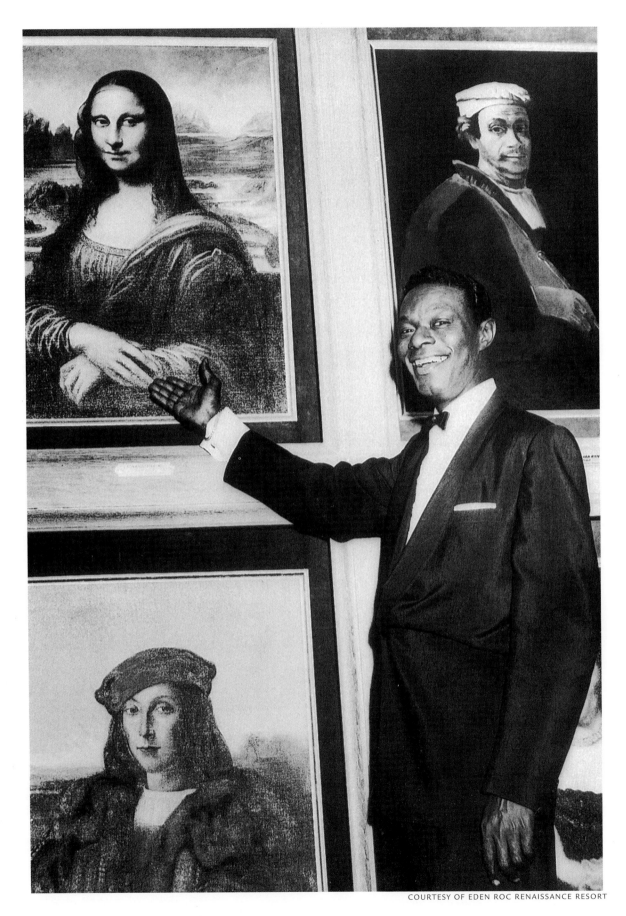

Nat King Cole in front of a Mona Lisa reproduction at the Eden Roc.

THE Kenilworth MIAMI BEACH, FLORIDA

COURTESY OF AUTHOR

For me, being a Jew in Miami Beach was like being a Gentile anywhere else. When you went to school, you weren't taunted or made fun of; you felt like part of the mainstream. Now, when you went across the causeway to Miami, things were different—but on the Beach we were king. I remember when they named Forty-first Street after Arthur Godfrey. Give me a break. The Jews were outraged by this. Godfrey was one of the biggest anti-Semites on the Beach. He did his show from the Kenilworth Hotel, and it didn't allow Jews as guests.

GARY BROOKS, ATTORNEY

I always thought of Miami Beach as being very white and very Jewish. Even our Gentiles were Jews. And we all deeply resented it when they named Forty-first Street after Arthur Godfrey. I still won't call it that.

MARK MEDOFF, PLAYWRIGHT

I was very much aware that I was growing up in a Jewish enclave, but for me the consequence of growing up in a Jewish enclave was that I wasn't really conscious of being Jewish. That wound up happening later on when I left.

ROBERT E. RUBIN, FORMER U.S. TREASURY SECRETARY

Miami Beach was so Jewish during the 1950s—so aggressively Jewish—that it made me grow to dislike everything Jewish. I found it all so annoying and overwhelming that it just turned me off. I don't like admitting it, but it almost turned me, a Jew, into an anti-Semite.

MARY LEE ADLER, ARTIST

By the late 1950s the Jewish community was very strong, and our high holy days at Temple Emanu-El were so popular that we often had over 3,000 people. One year we decided to use the Miami Beach Auditorium during Yom Kippur because the crowds were going to be so big, but it was already booked for a Teamsters convention. My husband was worried because there was no other venue of that size. So he went to see Jimmy Hoffa and begged him, just begged him. He said, "Please, Mr. Hoffa. The Jews will bless you forever if you let us have it." Fortunately, Mr. Hoffa agreed. But then we had to go into the auditorium and clean up all the beer cans and cigar butts.

BELLE LEHRMAN, WIFE OF THE LATE RABBI IRVING LEHRMAN

I came from a Jewish neighborhood in Chicago and had always heard that the New York Jews were arrogant. But when I fell in with the New York Jewish comedian crowd of Miami Beach and the Jewish audiences, my feelings changed. Deep in my heart I am a Jew, and I loved being around them. And basically I loved Miami Beach because of that. I hung out with other Jewish comedians like Lenny Bruce and Buddy Hackett. I also got to know Jackie Mason. But I got to tell you, after meeting Mason I almost—almost—became an anti-Semite.

SHECKY GREENE, COMEDIAN

I only played Miami Beach a few times, and I just never found myself to be a Miami Beach type. Most of the guys working on the Beach got their sea legs in the Catskills, and I hadn't. They were strictly stand-up guys who did Jewish jokes about early-bird specials. They were Jewish comedians who did a lot of Jewish shtick.

I was a Jew and I was a comedian, but I was not a Jewish comedian. I didn't put a Jewish twist on everything, that marvelous Jewish flavor that most of the other guys used. Now, I did feel very comfortable with the Jewish audiences. I told them that with Jews you don't have an audience, you have a committee. They have to take a vote to decide if they enjoyed the show. But I never became one of the guys. I never felt as though I fit in with the Jewish comedian crowd. Maybe I was just a snob.

VERVE RECORDS

SHELLEY BERMAN, COMEDIAN

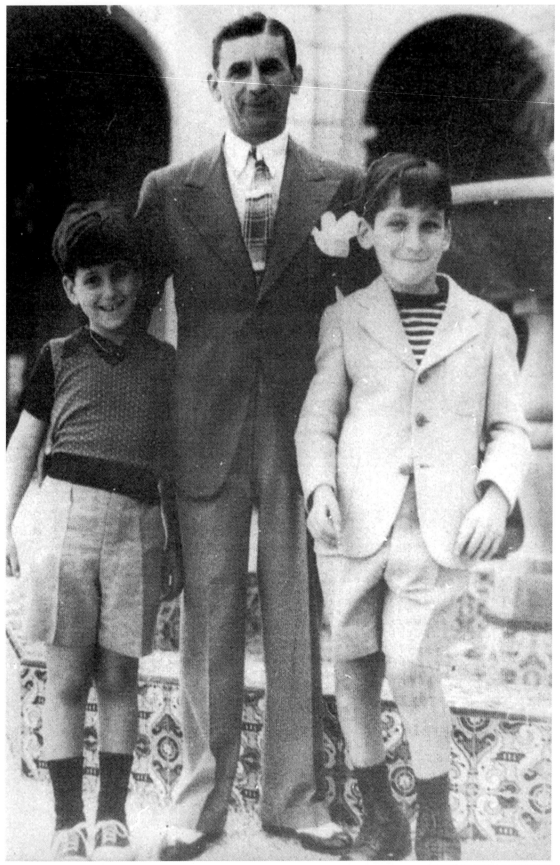

Meyer Lansky and his sons.

Little Big Man

I used to take walks with Meyer down Collins Avenue with his dog. He was a simple, nice Jewish man. Here was a guy who was always careful not to let his dog poop in the wrong place, so I could never imagine him saying, "Yeah, go ahead, kill 'em."

SHECKY GREENE, COMEDIAN

My mother met Meyer Lansky on an El Al flight from Israel to Miami. They played cards while FBI agents watched them the whole time. Then they became friends in Miami Beach, and my father wasn't happy about it. She told him that Lansky was a nice, little man and that she didn't care what people thought. She even sent him homemade banana bread.

MARGORIE COWAN, HOTELIER AND DAUGHTER OF SAM FRIEDLANDER, FOUNDER OF THE FOOD FAIR GROCERY CHAIN

Lansky kept a cabana at the Fontainebleau, and I used to see him all the time with his dog. He looked more like a preacher's son than a gangster—just a nice little Jewish guy who couldn't punch his way out of a paper bag. But he had some tough-guy friends. Of that you can be sure.

MAC MCSWANE, FONTAINEBLEAU BELLHOP

My father worked as a doctor at Saint Francis Hospital, and he once got an emergency call to treat Meyer Lansky. I don't know what the problem was, but I'm certain it wasn't a gunshot wound.

MARK MEDOFF, PLAYWRIGHT

I ran into Meyer Lanky one time when I was shopping in a grocery store. He came up to me and asked me to help him find bread crumbs for his wife. He was this little guy who looked totally lost in the produce aisle. I don't think he knew who I was, but I sure knew who he was.

TEMPEST STORM, FORMER STRIPPER

Meyer Lansky used to come to my office at the Eden Roc a lot, and we'd go to the coffee shop and have lunch. He had stories that you wouldn't believe—stories about Lucky Luciano and his other associates, stories about how they got things done. But he was a sweet guy who spoke in a low voice and was always mild mannered. He talked to me like a friend, like a normal guy, about his kids, about his life.

He had a son who graduated West Point and another one that was handicapped. He was a very normal father and a very clean-cut guy. He didn't drink and he didn't eat much. He was a cheap lunch date.

JERRY WITTELS, FORMER EDEN ROC HOTEL MANAGER

Contrary to popular belief, I never worked for Meyer Lansky. I knew him, and he was a good friend who I spent a lot of time with, but I never represented him in legal matters. To me, Meyer was quite the grandfather type. If you knew him and talked to him, you could never imagine that any of the stories you heard about him had any veracity. You could never imagine that he was responsible for doing the things people said he did. He was not a person to give in to rage.

AL MALNIK, ATTORNEY

Because Rocky was a Beach cop, he avoided Lansky like the plague. All the cops did. Now, Lansky never did anything bad on Miami Beach, but the Feds were always watching him, and the cops wanted to avoid any kind of association with him. Lansky used to go to a deli to buy bagels and lox, and one time Rocky ran into him there. Rocky panicked—just grabbed his change and ran out of the deli, afraid of this little old Jewish man buying bagels and lox.

HOPE POMERANCE, WIDOW OF MIAMI BEACH POLICEMAN ROCKY POMERANCE

Meyer Lansky came into Joe's many, many times. And it was not uncommon for him to be having dinner with Jimmy Blue Eyes while J. Edgar Hoover was in the restaurant at the same time, eating with Walter Winchell.

JO ANN BASS, OWNER OF JOE'S STONE CRAB RESTAURANT

The funny thing about Meyer was that he was a real soft-spoken guy. He had a table at Wolfie's, and people would come by to say hello like he was the nicest guy in town. He did not resemble a gangster—but you sure didn't want to piss him off.

I once dated Meyer's niece—Ricky Roberta Lansky, Meyer's brother Jake's daughter. Jake was a tough, hands-on kind of guy who did a lot of the dirty work for Meyer. I was afraid of him. Nervous the whole time I dated his daughter. Wasn't going to try any funny stuff with her. One time I went to pick Ricky up at their house, and Jake asked me where I was taking her. When I told him that I was taking her Ciro's to see Dean Martin and Jerry Lewis, he said, "Those bums are no good." I just kept my mouth shut.

PAUL ROSEN, REAL ESTATE DEVELOPER

Meyer Lansky had a son named Buddy who was a good friend of mine. He was a cripple who suffered from cerebral palsy, and he worked as a switchboard operator at a motel. Buddy was Meyer's firstborn son from his first wife, and he looked just like a young version of Meyer.

COURTESY OF ROSE RICE
Rose Rice.

Buddy and I used to go out to dinner, or he would come to my house and I would cook meatloaf for him. Buddy used to read a lot, and he would pass books on to me that his father had given to him—usually biographies or books about politics and philosophy. Most of them had things underlined in them by Meyer, as if Meyer was trying to pass some wisdom onto Buddy through the books. Buddy loved his father; never said a bad word about him.

For someone associated with Mob—he told me about meeting Bugsy Siegel when he was a kid, and hanging out with Jimmy Blue Eyes—Buddy was a sweet man. You would never guess he was a gangster's son. He had the sharpest mind in the world. But he was also his own worst enemy. He loved to gamble, and the bookies came after him when he didn't pay his debts. Occasionally the bookies would call Meyer about Buddy's debts, and Meyer told them, "Don't bother me. Go after Buddy." Unfortunately, toward the end of his life Buddy became destitute. He was living in a dump.

ROSE RICE, ADVERTISING EXECUTIVE

My husband, Ralph, and I ran a restaurant on Kane Concourse called Inside, and I baked all the desserts. Eventually we decided to sell it. One night Ralph called me late from the restaurant and said, "There are two people still sitting here. They are either going to rob me or buy the place." Those two people turned out to be Mr. and Mrs. Schwartz, Meyer Lansky's stepson and daughter-in-law. They told Ralph that they would pay his asking price and they would pay in cash. And they did.

Soon after, we had a call from Meyer and his wife, Teddy. She asked me if I would teach her how to bake the cheesecakes for the restaurant. We became friends, and I taught her how to bake. Teddy was so happy baking those cakes. Every day a big black limousine would pull up at the restaurant and deliver Teddy's cakes. She said it was the most exciting thing she had ever done in her life.

My husband and I became good friends with Meyer and Teddy, and they would come over to our house for dinner quite a bit. He was a brilliant man, Meyer—spoke several languages and read all the deep philosophers. And he had no qualms about telling us about some of the hot stuff that had taken place in his life. Sometimes we all went out to dinner. I tell you, I've been out to dinner with Wolfgang Puck, and that is nothing compared to what it was like to go out to dinner with Meyer Lansky in Miami Beach. People treated him like God.

MAIDA HEATTER, COOKBOOK AUTHOR

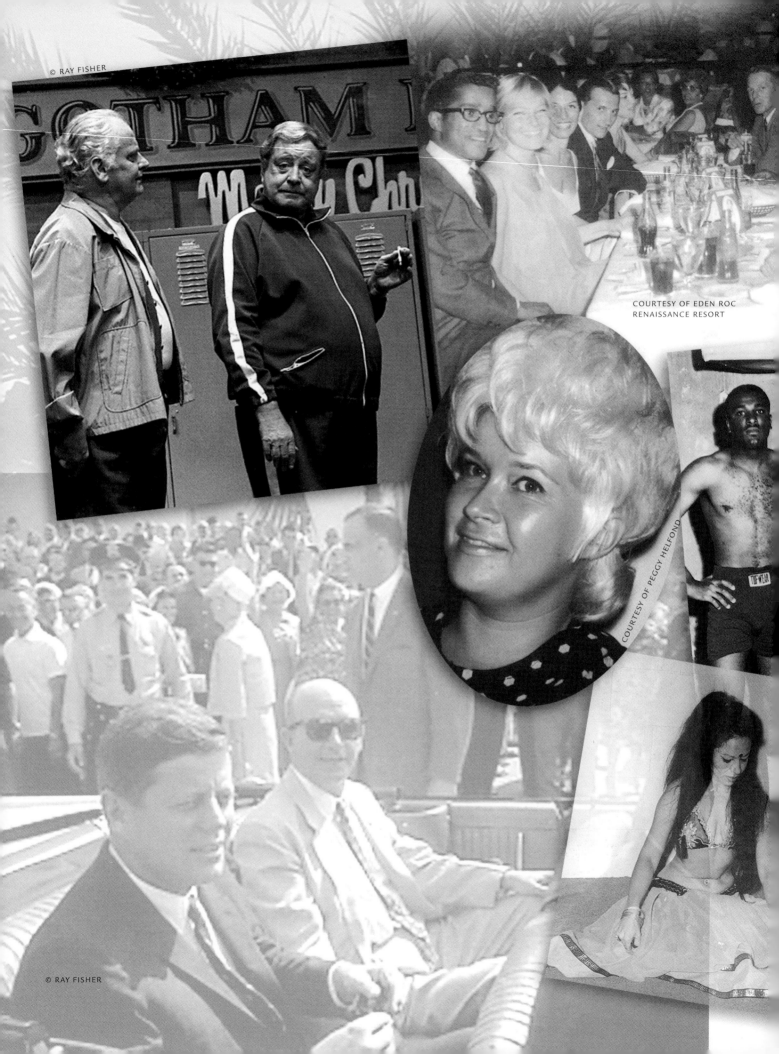

© RAY FISHER

COURTESY OF EDEN ROC
RENAISSANCE RESORT

COURTESY OF PEGGY HELFOND

© RAY FISHER

The End of an Era

COURTESY OF HANK KAPLAN

COURTESY OF EDNA BUCHANAN

1960–1969

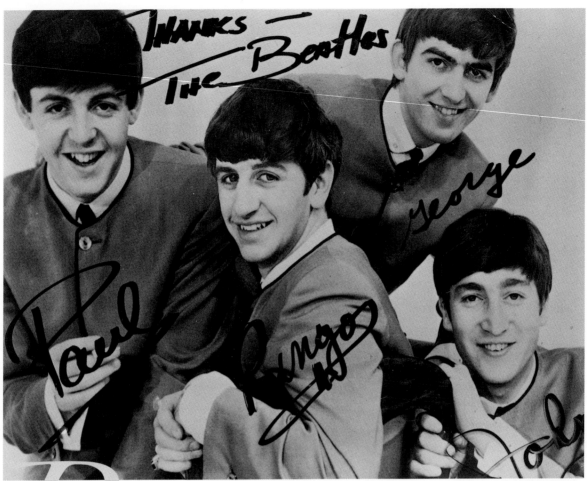

Fan club photo signed by the Beatles.

By the 1960s, most of the United States was primed for immense cultural and social change. Yet Miami Beach tried its best to extend the excesses of the 1950s—to remain largely a place of fun and frivolity, studded with celebrities. The island had a banner year in 1964, beginning with a February 16 visit from a certain foursome with pudding-bowl haircuts and pointy black boots.

In Florida for their second U.S. appearance, the Beatles arrived at Miami International Airport and found more than 7,000 screaming fans there to greet them. This madness continued wherever they went, with countless local teenage girls skipping school to catch a glimpse of John, Paul, George, and Ringo.

Their performance on the *Ed Sullivan Show,* broadcast live from the Deauville Hotel on Collins Avenue, created a traffic jam never before seen in town. Although they were scheduled for only a two-day stop, the Beatles were so enthralled with the Beach that they stayed for a week, fishing on yachts and mugging for the ever-present photographers. "It was just like paradise because we had never been anywhere where there were palm trees," Paul McCartney said years later in the *Beatles Anthology* documentary. In some ways, the Beatles' visit foreshadowed a turning point for Miami Beach. Rock 'n' Roll was here to stay, and change was in the air.

Just a few days later, a different kind of star was on the rise. On February 25 the world came to know Muhammad Ali when he fought Sonny Liston for the heavyweight boxing championship of the world at the Miami Beach Auditorium. Born Cassius Marcellus Clay in Louisville, Kentucky, Ali had come to Miami Beach as a brash, handsome kid eager to learn and eager to fight. At the Fifth Street Gym, trainer Angelo Dundee took him under his wing, confident that the clean-cut Clay was as good as he claimed to be. Confident that he would one day make good on his blustery boasts.

Each morning Clay ran the four miles from his lodgings in one of Miami's black neighborhoods across the MacArthur Causeway and onto the island of Miami Beach. And each evening he ran back home. At the time, Miami Beach was still a segregated city—Clay could train on the Beach, but he could not eat at local restaurants or stay in local hotels. Faced with such treatment, Clay found himself drawn to the black separatist philosophy of the Nation of Islam and its charismatic leader, Elijah Muhammad. Like his role model Malcolm X, Clay dropped his "slave name" and forged a new identity with a new name.

As he swaggered into the Miami Beach Auditorium for the fight, Clay uttered his most famous words: "Float like a butterfly, sting like a bee." And to his opponent he growled, "I'm the champ. You the chump." Tension was in the air that night, not so much because of the matchup but because Clay's conversion to Islam had become known. After he knocked Liston silly and won the title, he

COURTESY OF EVERETT M. LASSMAN

Joe Lewis with Miami Beach boxing commissioners.

proclaimed his new name—Muhammad Ali. And soon after, the Fifth Street Gym became world famous, with boxing lovers, tourists, and locals all dropping in to watch the world champ train.

Ali was not the only great boxer to come out of the Fifth Street Gym. Sugar Ray Robinson, Ezzard Charles, Jimmy Ellis, Willie Pastrano, and Joe Lewis all sparred there as well. And because of the gym and Angelo Dundee, Tuesday boxing matches became very much a part of the Miami Beach social scene, with big-time celebrities vying for "Fight Night" front-row seats. When the city tore down the termite-ridden gym in 1993, it was a sad day. Many wonderful memories were created in that little sweatbox of a storefront.

Yet another "great one" made his Miami Beach splash in 1964. Tired of life in New York and enticed by Florida's lenient divorce laws, Jackie Gleason boarded a private train with an entourage of 260 and headed south. Called the Great Gleason Express, the sleek train had several well-stocked bars to keep its namesake and his cohorts in good spirits for the ride. When the train arrived in Florida, Gleason was starting a new chapter in his life in the "Sun and Fun Capital of the World"—a place where he could play golf every day, go carousing at night, and act as if he were once again on top of the world.

From September 1964 until 1970, *The Jackie Gleason Show,* with its highly stylized vaudeville-like shenanigans, aired once a week. More than forty million people tuned in to watch. Art Carney was part of the team, as were the high-stepping June Taylor Dancers. An invaluable publicity boon for Miami Beach, the show became synonymous with the city and added a shot of much-needed adrenaline to the local tourism industry. For several years Gleason was the self-proclaimed king of Miami Beach. Many people adored him; others did not.

Gleason was joined by another king—Larry. The Brooklyn native started his broadcasting career in Miami Beach in the late 1950s at WAHR, a scrappy little AM station where he worked as a disc jockey and sports-show host. After about a year, he changed his name from Larry Zeiger ("It's too Jewish," said his general manager) to King and moved on to bigger things—namely, WKAT and another radio show in which he invented a character who broke into traffic reports with crazy commentary in a Broderick Crawford accent.

So popular was King's Captain Wainright that he was offered another new gig: a live radio broadcast from Miami Beach's Pumpernik's restaurant. It was there, during the 1960s, that King started interviewing celebrities and really began to shine. The show eventually moved to a more colorful venue—a houseboat across the street from the Fontainebleau. A local celebrity himself, King had a devoted following in Miami Beach. In his spare time he wrote columns for the *Miami Beach Sun-Reporter, Miami News,* and *Miami Herald.*

He also developed a bad gambling habit, borrowing money from friends and running up countless debts that totaled well over $300,000. That's what eventually ran him out of town, but not before he was charged with grand larceny and accused of stealing $5,000 from Miami Beach financier Louis Wolfson. Although the charges were eventually dropped, King's name was tarnished in Miami Beach. He declared bankruptcy and split. To this day, there are many people who wonder why he has never paid back the money he still owes them. Some locals snarl at just the mention of his name.

An Island in Denial

As Larry King interviewed visiting beauty queens and Jackie Gleason whooped it up around town, the world outside of Miami Beach was undergoing tumultuous changes. Protesters raged against the Vietnam War. The Civil Rights Act finally ended official segregation. Counterculture hippies denounced corporate greed and middle-class values. Robert F. Kennedy and Martin Luther King Jr. were assassinated. Women's liberation burst into the public consciousness. And the music of Bob Dylan surpassed that of Frank Sinatra on the Billboard charts.

And yet Miami Beach seemed oblivious to it all.

Still caught up in the superficial mentality of the early part of the decade, the Beach was not quick to embrace change. It held on tightly to its old ways—an island in denial. While Richard Nixon accepted his party's presidential nomination at the 1968 Republican National Convention in Miami Beach, a race riot erupted across the causeway in Miami.

Slowly but steadily the demographics of the island were changing—thousands of Cuban immigrants, mostly Cuban Jews, settled in the Beach after fleeing the Communist takeover of their homeland. Tensions began to build among the new-arrival Cubans, the African Americans who were displaced from the workforce, and the older non-Hispanic whites who felt as if they no longer belonged. All this was taking place as Miami Beach went about its daily life as if nothing was going on.

COURTESY OF EDEN ROC RENAISSANCE RESORT

Miss USA pageant contestants at the Eden Roc.

Whether it wanted to or not, Miami Beach had undergone a major metamorphosis by the time the 1960s ended. Flashy hotels like the Fontainebleau saw a drop in occupancy rates. South Beach slipped into decline, with elderly Jews on small pensions moving into crumbling Art Deco hotels. "God's Waiting Room" replaced the "Sun and Fun Capital of the World" as the island's moniker.

It was the end of a golden era.

Miami Beach's resistance to change was not the only reason for its waning popularity. Many other factors entered into the equation, then and later. They included the 1971 opening of Walt Disney World in Orlando; the growth of jet travel, which made vacations in the Caribbean affordable; the 1970s economic recession; the conversion of many hotels into condominiums; an increase in the local crime rate; and the onslaught of the illegal drug trade and the cocaine cowboys who came with it.

Not until the early 1990s and the revival of the Art Deco District hotels would Miami Beach be resurrected and transformed once again into a favored island in the sun.

First Impressions

I fell in love with Miami Beach the first time I saw it. It was 1961 and my memory of that sight is still vivid. From the back of a taxi cab, I saw this beautiful, pastel fairy tale city with a perfect blue sky and sparkling water. Soon after, I got my first job as a society reporter for the *Miami Beach Sun.* My salary was $75 a week, and I had an apartment across from the Fontainebleau where my rent was $100 a month. I was starving, living on corned beef hash from a can. But I loved it and knew I was going to stay.

EDNA BUCHANAN, FORMER *MIAMI BEACH SUN* REPORTER

COURTESY OF EDNA BUCHANAN

Edna Buchanan in the Miami Beach Sun *newsroom proudly displaying early journalism awards.*

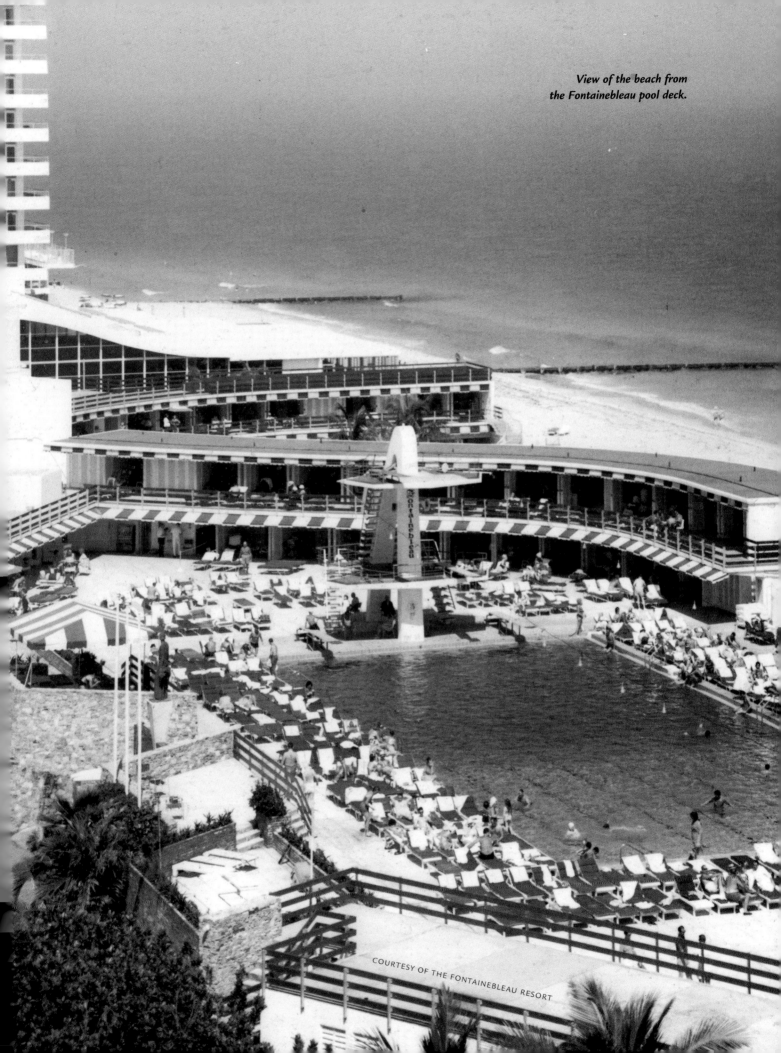

View of the beach from the Fontainebleau pool deck.

John, Paul, George, and Ringo

I was doing dive shows at the Deauville, and I remember standing by the pool with Barney Cipriani—the famous diver—and laying in front of us on lounges were these four scrawny white kids with a whole lot of hair. There were about 8,000 schoolgirls out in front of the hotel screaming their lungs out, and they clogged up Collins Avenue for days.

JACK "MURF THE SURF" MURPHY, FORMER DIVE INSTRUCTOR AND JEWEL THIEF

It was the craziest thing I had ever seen. I was about twelve at the time and I went with my sister to the Deauville to see the show. Somehow we got separated. There I was, wearing my little suit, surrounded by thousands of screaming girls, and I was terrified. Total madness everywhere you looked. My sister, however, later got to spend a day with them, and she taught Ringo Starr how to fish. All I got was crushed in the crowds.

JOHN SHEPHERD, CONTRACTOR

I was working at the Deauville when the Beatles came to town. It was chaos, sheer chaos. Imagine 20,000 girls surrounding the hotel just to get a glimpse of the Beatles. *Screaming teenage girls.* It reached the point where the only way we were going to get them out of the hotel was to put them in laundry baskets and cover them with sheets. Then we wheeled them into the alley and put them inside a truck with a liftgate. I was glad to see them go.

JERRY WITTELS, FORMER EDEN ROC HOTEL MANAGER

PERSONALITY ANNUAL

The Beatles grace the cover of Personality Annual magazine.

The End of an Era

I remember the day the Beatles came into the Fifth Street Gym—four little ugly guys who had gone out in the sun and came back red as lobsters. They looked like every other English dolt tourist who came to Miami Beach in the winter. Except for Paul McCartney, they were really goofy-looking things. Ali lifted them up in the air and played with them. He made believe he knocked them out, and they all passed out on the floor. The photographers went crazy.

FERDIE PACHECO,
FORMER "FIGHT DOCTOR" FOR THE FIFTH STREET GYM

I stayed with the Beatles the entire time they were in Miami Beach—did their hair and makeup for the *Ed Sullivan Show* and went around town with them. Even they were shocked at the reaction they got. They were so innocent at the time, just fresh-faced boys. I remember being in their hotel room with them, and we could hear the girls screaming downstairs. They would go over to their window and try and see what was going on. It wasn't frightening, just strange—all this commotion over four young boys.

RUTH REGINA, HAIR AND MAKEUP ARTIST

Ruth Regina with the Beatles at the Deauville Hotel.

COURTESY OF
RUTH REGINA

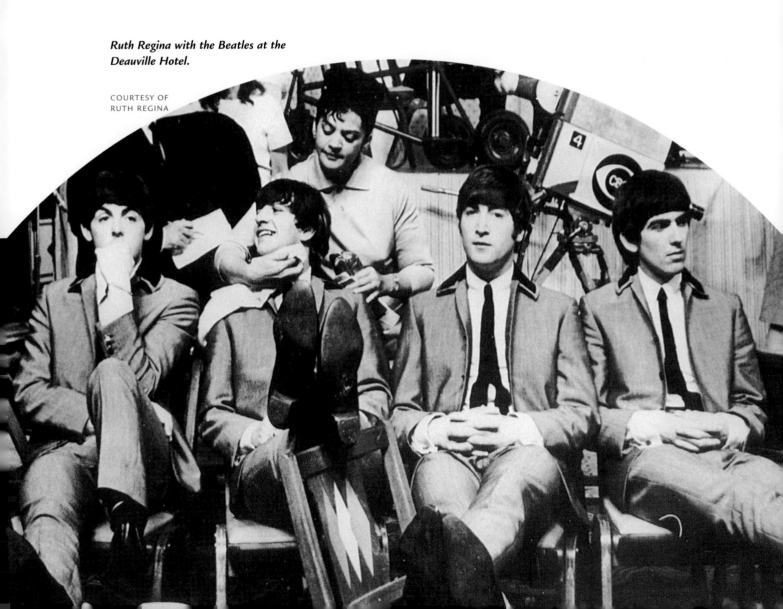

Fight Night and the Fifth Street Gym

There was a referee named Sy Godfrey in the late 1940s who had gotten hold of my brother, Chris, and told him about the Miami Beach Auditorium and that they wanted to put on fights. So Chris came down from New York and started doing Tuesday night fights. It was the perfect place—seated 4,000 people and it was always packed.

In the early 1950s we decided to open a gym, and we wanted it to be right on the Beach, where all the action was. Originally it was a Chinese restaurant with a drugstore downstairs. Nearby was a shoemaker, a liquor store, and the old Food Fair grocery store.

We started out with mostly local kids. But things picked up fast, and soon all the big names were coming to train—guys like Sugar Ray Robinson, Ezzard Charles, Ralph Dupas, Willie Pastrano, Joe Lewis, and Jimmy Ellis. We trained them all—lightweight, middleweight, heavyweight. The proximity to Cuba also helped 'cause I used to go there almost every other week, bringing American talent to fight in Cuba.

At the time, Miami Beach was the *in* place to go. I can't begin to tell you how many people of world renown came to see our fights. Boxing draws from all walks of life, and you never knew who was going to show up—movie stars, opera lovers, high-society people, football players. It was a major social gathering, and it was an amazing thing to see all those famous faces in the front rows. Sinatra was a fight lover, and he always came when he was in town. Jackie Gleason and Art Carney came, too. So did Sammy Davis and Dean Martin. I think they all saw it as an art form.

We started training Cassius Clay at Fifth Street in the early 1960s. He was just a sweet young kid, easy and fun to work with. Then things started coming out in the media about his becoming a Muslim, that he was seeing Elijah Muhammad. He never really spoke to me about religion, and I never wanted to put my nose into his personal life. But he came to me just before the Liston fight and said, "Ange, I want you to know, I'm a Muslim."

Muslim? Who the hell knew what a Muslim was back then? I thought it was a piece of cloth. I didn't care what he wanted to call himself as long as he put on a good fight. But other people were worried. Our coproducer, Bill MacDonald, threatened to cancel the fight if Cash didn't stop with the Muslim routine. But Cash wouldn't back down, and the fight went on. And he went in there and kicked the hell out of Liston. Battered him with his left jab and knocked him off balance. This tough guy, Sonny Liston, got licked by the kid with the big mouth and didn't even see it coming. Liston's cloak of invincibility was gone.

ANGELO DUNDEE, FOUNDER OF THE FIFTH STREET GYM

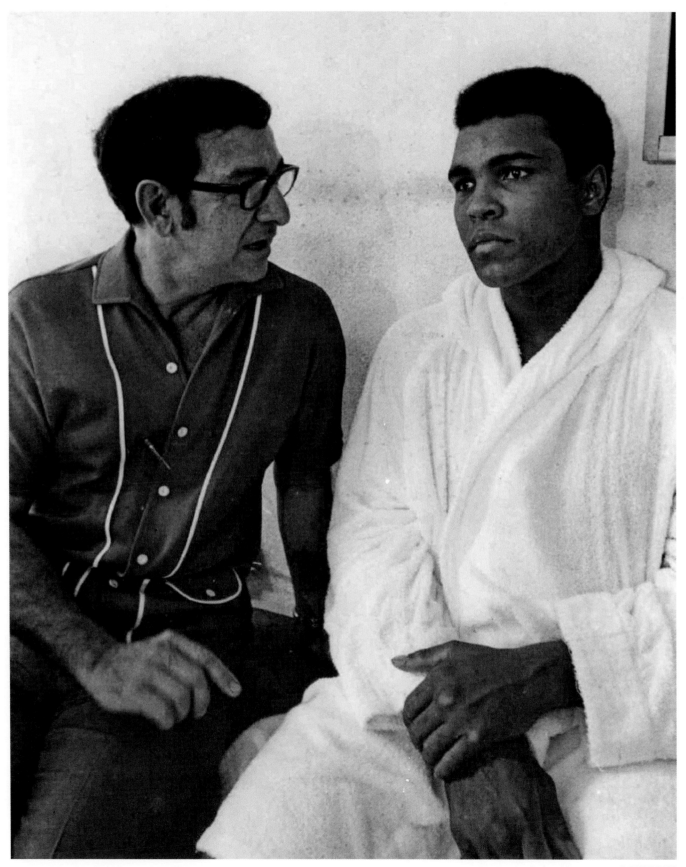

Angelo Dundee and Muhammad Ali at the Fifth Street Gym.

People tell me that the world will always remember me for being Muhammad Ali's fight doctor. There's nothing wrong with that. It's like being the Queen of England's gynecologist: You don't do much, but you get a lot of publicity.

I started going to the fights to relieve the pressures of practicing medicine, and then I became the gym's doctor. Took care of everyone who had anything to do with boxing—the boxers, their mothers, their wives, their kids. Then I started working inside the ring with Angelo during fights, with all the sweat and blood. Freshened the guys up and fixed broken noses.

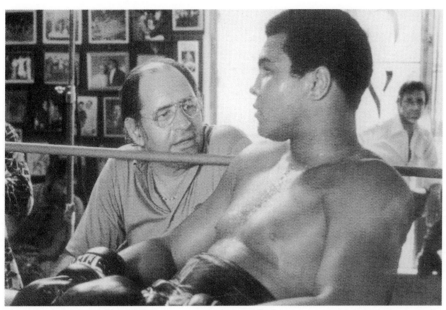

© LUISITA PACHECO

Muhammad Ali with Ferdie Pacheco at the Fifth Street Gym.

I remember when Cassius Clay began training at Fifth Street. He was very confused about his role as a black man in white society. Miami Beach was still very segregated in the early 1960s, and Cassius ran smack into the wall of segregation. He couldn't go into the restaurants or hotels. He had to stay at the Mary Elizabeth Hotel in the black neighborhood of Miami. He never wanted to cause trouble, but he couldn't figure out where he fit in. While he was at the gym, he would ask me how this all worked. How was it that he could be famous and be on television, but he could not sit down to eat at a diner in Miami Beach? I tried to tell him that it was going to get better and that the best way he could fight segregation was to display the greatness that Joe Lewis did before him.

Clay's conversion to Islam took place while he was training in Miami Beach. One day his brother took him to Red's Barber Shop on Second Avenue in Miami, and they got to talking to Captain Sam. Sam was an ex-con who did time and had become a minister with the black Muslims. Captain Sam told him that black was beautiful and that he shouldn't kiss the white man's ass, and that was exactly what Ali wanted to hear. He was a lost soul, a young kid trying to find his way in the world. And once he heard all that talk about the black Muslims, he started going to a mosque in Miami and declared himself a Muslim.

FERDIE PACHECO,

FORMER "FIGHT DOCTOR" FOR THE FIFTH STREET GYM

The Clay-Liston fight was the biggest boxing event ever to take place in Miami Beach. Here was this highly respected champion going up against this young, loquacious kid. Cash was the underdog; the odds against him were seven to one.

Clay produced one of the biggest upsets in boxing history on that night, and its historic significance was monumental. He exploded the myth of Sonny Liston and shook up the world with his victory. After years of listening to him say, "I am the greatest," he finally proved it.

Cash came out about being a Muslim just a few days before that fight. He never talked much about it, but the Nation of Islam guys would come to the gym. It was a big controversy at the time. Ticket sales were slow because the Muslim thing worried people, and they were afraid to come. But the fight went on. I sat seven rows behind the ring. There were celebrities all around me—Joe DiMaggio, Frank Sinatra. After the fight Rocky Marciano walked out with me and said, "I can't believe how fast this kid is."

In many ways I was like a big brother to Cash. He was just a kid, eighteen when he first came to Miami Beach. Every afternoon after we trained I would buy him a Coca-Cola from the vending

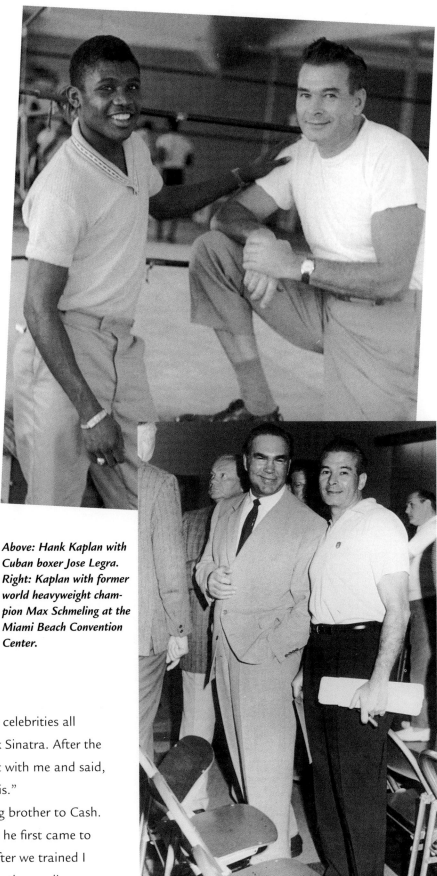

Above: Hank Kaplan with Cuban boxer Jose Legra. Right: Kaplan with former world heavyweight champion Max Schmeling at the Miami Beach Convention Center.

PHOTOS COURTESY OF HANK KAPLAN

machine. It was a treat for him 'cause he was really broke. One day I was talking to a sportswriter, and I guess I didn't buy Cash the Coke on time, so he put his hands in my pocket and started jingling the coins. What little money Cash made he sent to his family in Louisville. He was staying in a room at the Mary Elizabeth, and the rent was $5.00 a week. He lived a quiet life.

One night in 1961 or 1962, I came across him peeping in the doors of a Miami Beach nightclub where B. B. King was playing. He didn't want to go in, just wanted to look at what was going on. We started kidding around, and Ali grabbed a cigarette out of my shirt pocket and told me I shouldn't smoke. He then took a pen from my pocket and signed his name on the cigarette. A while later I gave that cigarette to a man who collected boxing memorabilia. And a few years ago I heard that Christie's in New York sold that cigarette for $1,900.

HANK KAPLAN, BOXING HISTORIAN AND FORMER PUBLIC RELATIONS
CONSULTANT FOR THE FIFTH STREET GYM

Boxer Rocky Marciano (right) with Ed Lassman, president of the World Boxing Association.

Chris Dundee had the fight scene in Miami Beach all sewed up. You had to go through him or Angelo if you wanted to box. There was no choice; they called all the shots. Some of their boxers made it big, but most of them didn't.

One time I fought Ali's brother, Rudy Clay, at the Auditorium. Ali was fighting in the big show that night, and we were the early fight. Ali wanted to watch us ringside. Angelo told him not to, but Ali wouldn't listen. He was worried about his brother—didn't want him to get hurt.

That night I beat Rudy; hit him so hard his head looked like a rocking chair. But they gave Rudy the fight—he won on the books. Angelo knew I beat him. So did Ali, who saw the whole thing. Nothing I could do about it.

Levi Forte.

LEVI FORTE,
FORMER HEAVYWEIGHT BOXER

I remember when Liston and Clay were getting ready for their fight. Liston was training at the community center in Surfside, and Clay was down at Angelo's. I used to go up to Surfside to see Liston train, and sometimes Clay would come in there to badger him. He would stand in the back and yell and holler and run his mouth off, drumming up publicity. In the background would be music playing—*Night Train,* Liston's theme song. And when you looked around that room there would be no less than a dozen former champions just standing there watching—guys like Rocky Graziano and Jake LaMotta. And then Joe Lewis would walk in and the place would go silent, silent with jaw-dropping awe.

JACK "MURF THE SURF" MURPHY,
PRISON MINISTER AND FORMER JEWEL THIEF

Fight Night and the Fifth Street Gym

To the Moon, Alice

I went to New York with Hank Meyer, the PR man, to talk Jackie Gleason into coming to Miami Beach. Jackie was already convinced, but we had to play the game with him. He did his temperamental star thing, asking for a place to stay and financial incentives. At the time, most of his close friends were gone and New York had lost its hold on him. He was ready for a change, and Miami Beach was an easy sell.

IRVING COWAN, HOTELIER

In the 1960s I did some work on the *Jackie Gleason Show.* Jackie paid me $5,000 to play the role of Armand, the great entrepreneur. Just twenty minutes before show time, Jackie began tearing up the script and making changes. He and Art Carney were tossing ideas back and forth, joking around. Once we started I had to take what they threw at me and run with it. It almost shattered my nerves. I hated working with him.

DON SEBASTIAN, COMEDIAN

Working on Gleason's show was the worst experience of my life. Everyone was tense all the time, afraid that Jackie would explode. Here was a man of great talent, but it was astounding how mean he could be. He just yelled and screamed all the time, and it was worse when he was drunk. When I was hired I was told, "Don't talk to Jackie; just stay out of his way," and that's what I did.

REY BAUMEL, MUSICIAN

I was a regular singer on the *Jackie Gleason Show,* part of the Jerry Breslin Singers, and I never had more fun than working on that show. It was one of the best experiences of my life. Gleason was a gem, and the other performers were all brilliant in their own right. The show went like clockwork.

JUDY NELSON DRUCKER, ARTS IMPRESARIO

I did the Gleason Show in Miami Beach a few times, and I absolutely loved working with Jackie. We had known each other since we were kids, so we had a special bond. And he paid me well—always $5,000 a performance.

ROSE MARIE, ACTRESS

I was called to audition for a part in the *Gleason Show,* and when I showed up, there was Jackie sitting in his boxer shorts—big boxer shorts. I think he did it to test me, to see how I would react. Well, I didn't react well. I was stunned and didn't think it was funny at all.

KAY STEVENS, SINGER

The End of an Era

Art Carney and Jackie Gleason.

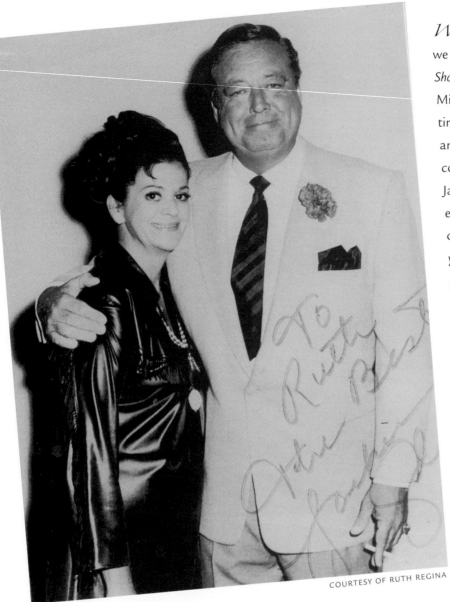

COURTESY OF RUTH REGINA

Ruth Regina with Jackie Gleason.

When Channel 7 got started, we used to carry the *Mike Douglas Show,* and it was taped at the Miami Beach Auditorium. One time I was there for the taping, and Jackie Gleason was acting as cohost. Mike came out with Jackie, and they did the audience warm-up. Suddenly some old guy with a New York accent yelled out, "Hey Jackie, are you going to do some condominium dates?" Gleason yelled back, "Is that figs or broads?" He was quick.

ED ANSIN, TELEVISION EXECUTIVE

I worked on his show many years, and I made that curled-up mustache that Jackie wore when he played the Italian organ grinder. I was always on the set, just sitting there with a comb and brush and box of Kleenex to wipe the sweat from Jackie's brow. Jackie was wonderful to work with. If you did your job well, he was happy and he let you know. To me, he was a gentle soul and a very sensitive man.

RUTH REGINA, HAIR AND MAKEUP ARTIST

Jackie Gleason was always a mythic figure to me—a man with a big talent, a big appetite, and a big genius. When I was a kid in Miami Beach, he was *it.* I once did a TV interview with him, and I'm afraid my face was just a bit too adoring because of how I felt about him.

JEANNE WOLF, ENTERTAINMENT REPORTER

The End of an Era

As far as I'm concerned, Jackie Gleason was the best. He was great to me—even bought me a white Thunderbird as a gift. His show was so popular that people were paying $300 apiece for tickets even though they were supposed to be free. The only complaint I have is that he made me dye my hair red in order to play Alice, and it turned green when I went in the ocean.

Art Carney was great, too. Art could be somber at times, but he could also be a lot of fun. He once asked me to go with him to a club on Miami Beach where there were lesbians—or as he liked to say, "Dames with dames." When we got there, Art said, "See that girl over there? I want you to tell her that I'll give her $200 if she lets me put on her dress." I told the girl, and Art put on her dress and danced around the club for hours. Because he played crazy Norton, Art got away with weird things like that.

Publicity photo from **The Jackie Gleason Show;** *Sheila MacRae is at bottom left.*

Another time Jackie took us all out to a strippers' club. When we walked in, everyone cheered. Jackie felt right at home; he told me as a young kid he went to strip clubs all the time. The place was really a dump with old strippers and old comedians telling corny jokes. It was full of drug addicts and drunks. Jackie gave the strippers big tips and rechoreographed their acts. I think he felt sorry for them. But Jackie was also very cautious. He didn't want anyone to photograph us while we were there. He was always concerned about his image.

SHEILA MACRAE, ACTRESS WHO PLAYED ALICE KRAMDEN IN *THE HONEYMOONERS*

Tell It to the King

I used to go to his show when he had a crummy little studio. For those of us who knew him then, it's hard to believe he became such a powerful guy. There are a lot of people in Miami Beach who are still angry with Larry, a lot of people he still owes money to. He makes enough money today to pay them back, but it seems as though he has blocked that part of his life out of his mind.

IRVING COWAN, HOTELIER

As a kid I remember seeing a guy around who today is a little famous. He worked for my dad as an usher at the Carib Theater on Lincoln Road. He wore a bow tie and collected tickets and used a flashlight to help people find their seats in the dark. His name was Larry King. Ha! Larry King collecting tickets in a theater.

JOHN SHEPHERD, CONTRACTOR

I remember Larry King when he did fashion shows in Miami Beach. Some designer would give him a sports jacket to wear to a nightclub, and he would walk around the club wearing the jacket. He then got to keep it. Larry was not one not to take things for free. And he liked expensive clothes.

RAY FISHER, PHOTOGRAPHER

Larry King was a loser. Everyone knew it. He rented a home from my parents, and he moved out in the middle of the night. Just skipped town, owing two months' rent. He stiffed them, this big shot Larry King. I watch him on TV every night and I can't believe it. But what am I going to do, call his show and ask for the money?

SHIRLEY ZARET, RETIRED SECRETARY AND BOUTIQUE OWNER

I met Larry King in about 1960 when he was working on local radio. He was a nobody then, but he was funny as hell. I once saw him in a hotel lobby standing with another guy, and I went up to him and told him that I liked his show. He said, "Thank you. I'd like you to meet my friend, Mel Torme. Now I know that I have arrived because you noticed me instead of Mel Torme." He was charming.

KAY ROSENFELD, *MIAMI HERALD* COLUMNIST

Larry King was a good friend of my dad's, and my dad loaned him money just like everyone else loaned him money. I think they were compatible because they suffered from the same weaknesses—gambling and women.

JO ANN BASS, OWNER OF JOE'S STONE CRAB RESTAURANT

Larry King modeling a sports coat at a Miami nightclub.

Larry King was a total jerk when he was in Miami Beach. He borrowed money from my father and never paid it back. He called me once and said, "Hey Jack, how much did I owe your father?" I told him it was $5,000. I thought he was planning to pay him back. But no, he was filing for bankruptcy and wanted to tally up his debts.

JACK COURSHON, BANKER

I performed for Larry King at two of his weddings when he lived in Miami Beach—did it for free because he was a friend. He still owes me $20 that he borrowed at the track one time.

DON SEBASTIAN, COMEDIAN

Yes, I knew Larry King. And I think I still have the NSF—nonsufficient funds—checks to prove it.

AL MALNIK, ATTORNEY

I went on Larry's show at Pumpernik's, and he was great to work with. I think the only reason he didn't try to borrow money from me is because he knew I never had any. When he left town, he totally reinvented himself—like a phoenix rising out of the ashes. He was no longer this little deadbeat guy from Miami Beach.

REY BAUMEL, MUSICIAN

I knew Larry well. He interviewed me on his show when I first got into politics. He owed me money, but I think he finally paid me back. Larry acted like it was a sin to pay his debts—just couldn't bring himself to do it.

WILLIAM LEHMAN, LATE FLORIDA CONGRESSMAN

I used to see Larry at the home of a friend of ours, Toby Simon, a lawyer. This was when Larry was doing the show on the houseboat and he was a local hotshot. He was a wise-guy New York Jew who never stopped talking and was a lot of fun to be around. But he owed money to guys with ties to the Mafia, and we heard rumors about death threats. It got scary.

EDYTHE SCHINDLER KLEIN, WRITER

Not too long ago Larry King was nominated to be on the Miami Beach Walk of Stars, but the board voted him down. That tells you what people think of him around here.

HOPE POMERANCE, WIDOW OF MIAMI BEACH POLICEMAN ROCKY POMERANCE

The End of an Era

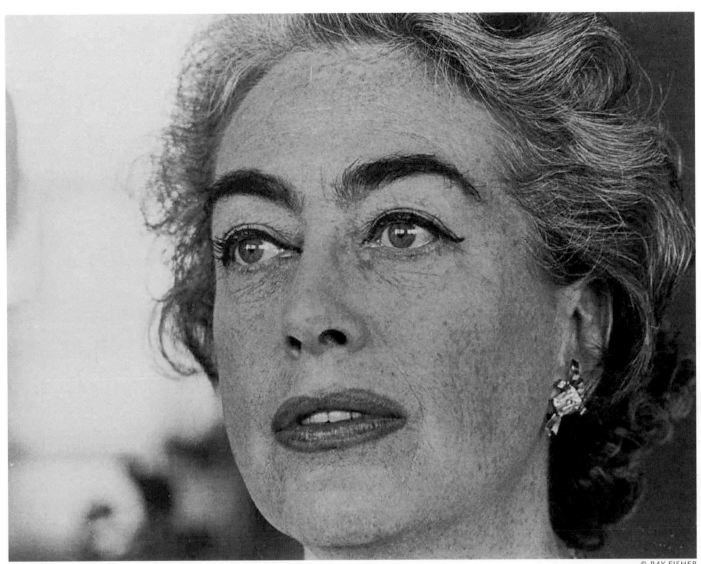

© RAY FISHER

Joan Crawford at the Fontainebleau in 1963.

More Celebrity Sightings

I photographed Joan Crawford at the Fontainebleau during the 1960s when she was representing the Pepsi Company. She was the only movie star I ever photographed who sent me a thank-you note. I also shot J. Edgar Hoover at Joe's Stone Crab, and he had his boyfriend—or *assistant*—with him, Clyde Tolson. And right after he became president, John F. Kennedy was doing a fund-raiser at the Fontainebleau. He stayed at a private house on North Bay Road, and I took pictures of him over the fence as he was putting on his coat, smoking a cigarette.

RAY FISHER, PHOTOGRAPHER

I ran into Joan Crawford at a party on the Beach. She accidentally brushed her cigarette against my dress, and she was so apologetic about it. Her husband had just died, and she told me how lonely she was. She was not at all like the hanger witch her daughter tried to make her out to be.

EDNA BUCHANAN, FORMER *MIAMI BEACH SUN* REPORTER

I worked on Elvis Presley right after he got out of the army and was doing his first show on the Beach. We had a cup of coffee together before the show. He was very polite and sweet. He told me that he was nervous, so I said, "Elvis, don't be nervous." He said, "Hey, Miss Ruth, that rhymes."

RUTH REGINA, HAIR AND MAKEUP ARTIST

I was putting on the Miss Miami Beach beauty pageant, and one of my contestants was a girl named Jo Ann Pflug. She didn't win, but she was a really pretty brunette who later went on to star in the movie *MASH*. The MC that night was comedian Jack Carter. When he presented her he said, "Boy would I like to Pflug her." Oy.

SHELDON MILLER, REALTOR

President John F. Kennedy after a Miami Beach church service in 1962.

© RAY FISHER

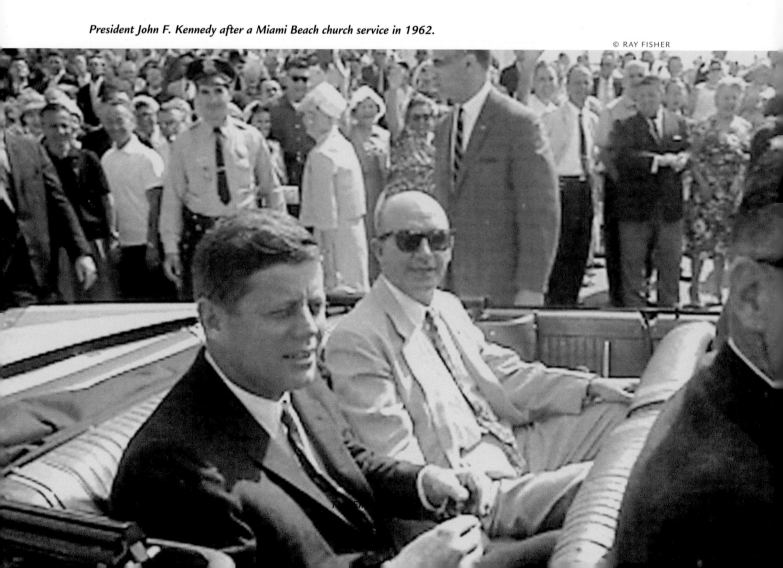

Grace Weiss, J. Edgar Hoover, and Clyde Tolson.

© RAY FISHER

I remember seeing John F. Kennedy outside of the Fontainebleau right after he delivered a speech in 1962. He was just standing on the front steps alone, with no security around him. About a year later he was killed. I had just begun running Channel 7 then, and after the assassination we ran the clip of Kennedy at the Fontainebleau for days. Everyone at the station was in shock. We couldn't believe how we had just seen him in Miami Beach and everything was fine.

ED ANSIN, TELEVISION EXECUTIVE

J. Edgar Hoover was around a lot in the 1960s, and Jesse Weiss from Joe's Stone Crab arranged a dinner at the restaurant for me to meet him. Hoover was a natty guy who fiddled with his cufflinks and rearranged the silverware. While we were eating, he asked me if I had a mother, and when I said yes, he wanted to know how often I called her. He told me that mothers are the most important thing in life. "Strange," I thought. Clyde Tolson was with us at the dinner. He was the deputy director of the FBI at the time, and he acted very reverential toward Hoover. We all heard the stories that they were gay, but they both acted in a very manly and dignified manner.

Shortly after I had dinner with him, Hoover called me up and said, "Al, I heard about your entrepreneurial abilities, and I have an idea I'd like to discuss with you. We live in a house in Washington, and in the winter we like to keep our bedroom window open. But in the middle of the night, it gets cold and we have to get out of bed to close the window. Clyde invented this device; he had it patented. You set a particular temperature on a dial, and when the weather drops to that tempera-

More Celebrity Sightings

© RAY FISHER

Swifty Morgan watching a ball game at Flamingo Park.

ture, it automatically closes your window for you. I think it's going to make a fortune, and I want you to help me sell it." Nothing ever came of that device, but it certainly sounded to me as though Hoover and Clyde slept in the same room.

Swifty Morgan was still around at that time, too, and he was a client of mine. Swifty's claim to fame was that Damon Runyon wrote a book called the *Lemon Drop Kid* with a character that was modeled after him. He looked like a cherubic grandfather, but he had a nasty mouth. One of his routines was selling gold coins for triple the price of their worth. If he tried to sell you some and you said no, he would go around bad-mouthing you, telling everyone you were a cheap bastard. Needless to say, a lot of people in Miami Beach bought Swifty's coins.

AL MALNIK, ATTORNEY

The Color Line

In the early 1960s I owned Sir John's Hotel on Biscayne Boulevard in Miami with a partner, Jay Weiss, and we had many of the black entertainers as guests because they still couldn't stay at Beach hotels. Dorothy Dandridge, Billy Eckstein, Gregory Hines, Sammy Davis, Louis Armstrong, and an act called Buck and Bubbles: They all stayed there. They also performed for us. They certainly didn't like what was going on—they complained about it among themselves—but the Beach hotels paid them a lot of money, so they tolerated it. At the Sir John's we paid them about $5,000 a week to do two shows a night, six nights a week. A gig on the Beach would pay them $25,000 a week, and that was a lot of money back then.

This was about the time when Frank Sinatra asked Ben Novack to finally let Sammy Davis stay at the Fontainebleau. Novack knew that Sammy was upset about the race issue, but he told Frank that he was worried about what his guests would think if he let a black man stay at the hotel. He told Frank he was afraid to do it. Frank got pissed and told Novack, "You either let Sammy stay here or I quit; I won't sing for you anymore." Novack eventually gave in and allowed Sammy to stay there. But the deal was Sammy couldn't hang out in the lobby or take the regular guest elevator up to his room. Of course Sammy did just the opposite: He was always in the lobby, being flashy about it, making a statement. It was great. Novack didn't like it, but he wasn't about to do anything about it.

AL MALNIK, ATTORNEY

The End of an Era

Sammy Davis Jr. with May Britt and guests at the Eden Roc.

The Changing Times

·······································

I worked as a cocktail waitress in the 1960s, and it was still a relatively carefree time. My entire wardrobe consisted of bathing suits and cocktail dresses. There was no in-between. Booze was still the drug of choice, and people drank like fish—hard liquor every night. And they *drove* when they drank hard liquor every night; nobody thought twice about it.

But it was also a strange time because it was as if the whole hippie era missed the Beach. Political protests were going on across the causeway in Miami, and women were still walking around the Beach with big hair, wearing blue eye shadow and go-go boots. People were trying very hard to hold onto the past.

PEGGY HELFOND, REALTOR

Peggy Helfond.

Above: Al Malnik. Below: Bernie Berns.

The 1960s was a very pompous era in Miami Beach. The hippie movement was beginning to happen, and the older people on the Beach—the ones drinking liquor and acting like it was never going to end—kept holding onto that era. The place seemed immune to the rebellions taking place elsewhere. It was still caught up in its materialist and artificial ways. It was a time when what you owned was who you were, when the biggest question people asked was "Who made your suit?" Miami Beach was a dinosaur that went about its business under the pretense that it was immune to change. It ignored the signs of the times, the social and intellectual currents that were flooding in, and held onto its old lifestyle way too long. Nobody recognized this at the time, but the 1960s signaled an end of an era.

AL MALNIK, ATTORNEY

Miami Beach held onto its vain values for a long time. Even when the hippie era began to take hold elsewhere, it didn't seem to affect the Beach. There was practically no social awareness and very little interest in the civil rights movement. All people cared about was drinking and dancing and having a good time. It's as if they were in denial about what was going on in the world around them.

MARY LEE ADLER, ARTIST

Working as a comedian in Miami Beach in the 1960s was depressing. The Beach was in decline, and the club owners were cheap. Most of us comedians fell into the same spider's nest: We had to earn a living, so we

The End of an Era

worked gigs for $75 a pop—for bupkis. We got almost ten times that amount when we worked the Catskills. On the Beach they tried to convince us that it was worth it because it was warm and they had palm trees. Palm trees didn't pay my rent.

I was working the Eden Roc, and one day Morris Lansburgh decided he wouldn't even pay me the $75 for a show; said he would only pay $66. Now here was a guy with a Rolls Royce, the Donald Trump of his day, and he was only willing to pay $66 a show. That's when we started calling Miami Beach Route 66.

To make ends meet we had to work the lobby shows. They were the worst— early-bird shows at the small old hotels down in South Beach, places like the Tides and the Cordozo, where the old Jewish people lived. People who could barely breathe, let alone laugh. You had to bring your own piano player if you wanted music. They had microphones, but the speakers were outside, not inside the lobby where the show was going on. So people walking by outside enjoyed the show, but the people inside just stared at you, couldn't hear a thing.

BERNIE BERNS, COMEDIAN

Comedian Shecky Greene and his girlfriend, flamenco dancer Luisita Sevilla.

I moved from Cuba in the early 1960s, and when I first got to Miami Beach I wasn't treated very well. I remember standing in line at a food store, and somebody came up to me and said, "Go back to Cuba." Most of the Christian Cubans settled in Miami, but us Cuban Jews settled in Miami Beach because there was already a big Jewish population there. But the local Jews saw us as Cubans, not Jews, and they did not open their arms to us even though many of us spoke Yiddish. They wouldn't even rent apartments to us.

OFELIA RUDER, SECRETARY

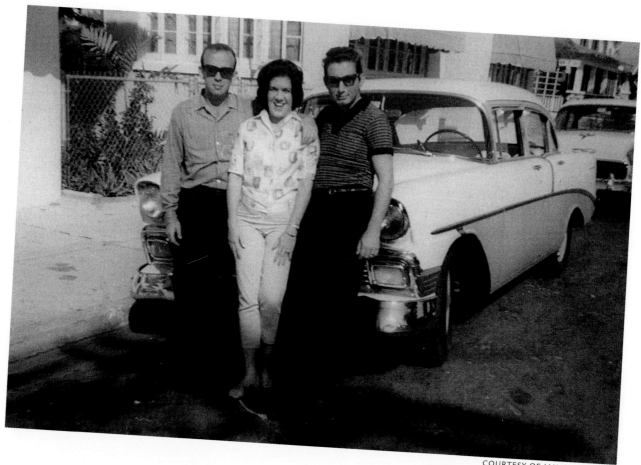

Jaime Suchlicki (left) with fellow Cuban exiles Norma Parapar and Semy Hallives in 1961.

When I first arrived in 1960, I lived in the Majestic Hotel—a place run by a Cuban Jew—and I shared a room with another guy. It was not a fun time. The local Jews didn't want to hear from the Cubans; they didn't want to lend a hand. A lot of them were retired, and it was as if they were old and tired and just didn't want to be bothered with helping immigrants.

I struggled to make a living, smuggling cigars into the U.S. and selling them at the Elks Club on Miami Beach. When I tried to get a job, I would knock on doors and nobody would answer. One day I got the idea that I might be treated better if I carried the *Forward* with me so they would see that I was Jewish. But even that didn't help. People either ignored me or told me to shut up.

And then there was the fact that the Cubans began replacing the African Americans on the Beach. The tourism-industry employers hired the Cubans to work, basically because they were white, and the African Americans then began to resent the Cubans. Those years were very difficult in Miami Beach. Ethnic tensions were building.

JAIME SUCHLICKI, PROFESSOR

The End of an Era

Miami Beach in the 1960s still had its semi-innocence. Crime was not rampant; it was offbeat and penny-ante stuff: petty crooks, B-girls, and old gangsters on the run from the law. And a few bizarre crimes that tend to happen to people living in the tropics—crimes brought about by the low altitude, the steamy heat, the pull of the tides, and the full moon.

There was the Fat Man Gang, a group of guys that mostly robbed jewelry from posh homes. There were hookers working the Poodle Lounge at the Fontainebleau who used to call me about the cops who were shaking them out. There was also a homicide at the Fontainebleau, when a frustrated employee went on a rampage and killed people, and a shooting at Place Pigalle, when a drunk shot the leg off of an exotic dancer.

There were still laws on the books about wearing an American flag on your clothing and about loitering and lollygagging. The definition of *lollygagging* was up to the cops, so this meant that they could harass anyone they wanted. They took criminals to the golf course near Meridian Avenue and beat them up and let their dogs urinate on them. I saw this because I lived nearby. Or they would drive them across the causeway and dump them in downtown Miami.

And there were a lot of senior citizens around—tough old immigrants, many of them Holocaust survivors, who didn't trust banks and kept their money under their mattresses. They walked slowly and drove slowly, but they pushed to get ahead of you at the grocery store; the

COURTESY OF EDNA BUCHANAN

Edna Buchanan as a bathing beauty in the early 1960s.

checkout line looked like the chariot race from *Ben Hur*. They were also real gadflies who gave me leads for stories, and I loved them.

This was the tail end of the golden and glamorous years—the "Sun and Fun Capital of the World" days, when Miami Beach was still a southern city, one with a touch of the exotic; before the riots and the refugees and the cocaine cowboys took over. By the time 1970 rolled around, the golden era was gone.

EDNA BUCHANAN, FORMER *MIAMI BEACH SUN* REPORTER

Cast of Characters

Mary Lee Adler moved to Miami Beach from New Jersey in 1937, when she was three months old. Her father, Arthur Adler, managed several Miami Beach hotels, including the Flamingo and the Allison. Mary Lee is an artist who lives in northern Florida.

Michael Aller lived with his family at the Fontainebleau from 1954 to 1968. Known as "Mr. Miami Beach," he is the tourism and convention director and chief of protocol for the City of Miami Beach. He was born in Detroit in 1939.

Ed Ansin moved to Miami Beach from Massachusetts in 1951. He is a real estate developer and CEO of Sunbeam Television; since 1962 he has been at the helm of Miami's WSVN Channel 7.

Lois Applebaum was born and raised in Miami Beach. Her uncle, Charlie Friedman, was a member of the S & G, a local gambling syndicate. She has worked as a school-teacher.

Jo Ann Bass was born in Miami Beach in 1931 and grew up with gangsters, movie stars, and presidents coming to dinner. She is the owner of Joe's Stone Crab restaurant, founded in 1913 by her grandparents, Joe and Jennie Weiss. Her parents, Jesse and Grace Weiss, managed the legendary eatery for decades as well.

Rey Baumel was born in Brooklyn in 1925 and moved to Miami Beach in 1938. He has worked as a singer, an actor, a comedian, and a corporate speaker. During the 1940s and 1950s, he performed in Miami Beach as Rey Mambo, a Latin music singer.

Antonio Benjamin was born in the U.S. Virgin Islands in 1925. He came to Miami Beach in 1943 to serve in the U.S. military, and during the 1950s and 1960s he worked as a chauffeur on the Beach.

Bernie Bercuson came to Miami Beach from Detroit in 1939. For many years he managed and owned oceanfront hotels, including the Aztec and the Singapore.

Shelley Berman is a comedian who performed in Miami Beach in the late 1950s and early 1960s. A regular on the *Ed Sullivan Show,* his list of acting credits includes *The Prisoner of Second Avenue, I'm Not Rappaport, Divorce American Style, Night Court,* and *Curb Your Enthusiasm.* He was born in Chicago in 1926 and was the first stand-up comic ever to perform at Carnegie Hall.

Bernie Berns is a New York–based comedian who performed at the Eden Roc and Deauville Hotels during the 1950s and 1960s.

Chuck Bransfield was born in 1918 in Chicago and first came to Miami Beach in 1923. At that time his maternal grandparents owned the Miller Hotel. During the 1930s he attended St. Patrick's School, where his classmates included Desi Arnaz and Sonny Capone. Bransfield is a retired oil driller.

Gary Brooks moved to Miami Beach from New York in 1950, when he was in the fifth grade. He is an attorney who specializes in commercial litigation.

Edna Buchanan moved to Miami Beach from New Jersey in 1961. She started her career as a society-page writer for the *Miami Beach Sun* and worked as a crime reporter for the *Miami Herald* for more than fifteen years. In 1986 she was awarded the Pulitzer Prize. She is the author of more than a dozen books, including *The Corpse Had a Familiar Face, Never Let Them See You Cry, Act of Betrayal,* and *The Ice Maiden.*

Ann Broad Bussel moved to Miami Beach from New York in 1940. She has worked as a receptionist, bank teller, and English teacher. Her father, Shepard Broad, was a Miami Beach lawyer who created the community of Bay Harbor Islands and built Broad Causeway, a highway that crosses Biscayne Bay.

Jim Casey was born in Chattanooga, Tennessee, in 1930. He moved to Miami Beach in 1934 and lived there for more than thirty years. He has worked as a police officer, an insurance salesman, and a construction worker.

Jerry Cohen was born in New York in 1926 and moved to Miami Beach in 1946. He is a contractor who built several

Miami Beach restaurants, including Wolfie's and Copa City.

Mike Cooper was born in 1923, moved from New York City to Miami Beach in 1946, and has lived on the Beach ever since. He has owned several Florida motels. His father, Saul Cooper, was co-owner of The Famous, a restaurant in Miami Beach, from 1945 to 1948.

Jack Courshon was born in 1924. He is an attorney, banker, and hotelier who moved to Miami Beach from Chicago in 1937. With his brother, Arthur, he founded Washington Federal Savings and Loan and Jefferson Bank.

Irving Cowan was born in New Jersey and moved to Miami Beach in 1945, when he was thirteen years old. He is a hotelier who has owned and managed the Shelbourne and Marco Polo Hotels in Miami Beach and the Diplomat Hotel in Hollywood, Florida.

Margorie Cowan moved to Miami Beach from Philadelphia in 1942, when she was a small child. Her father, Sam Friedlander, founded the Food Fair grocery store chain and built the Shelbourne Hotel in Miami Beach and the Diplomat Hotel in Hollywood, Florida. Margorie has been married to Irving Cowan for more than forty years.

Leome F. Culmer was born in Miami in 1925. Her late husband, Father John E. Culmer, presided over St. Agnes Episcopal Church in Miami for more than thirty years. She is a community activist and church volunteer.

Irving Cypen moved to Miami Beach in 1946 from St. Petersburg, Florida. He has worked as a lawyer, a prosecutor, assistant city attorney for Miami Beach, and a Dade County Circuit Court judge.

Ken Dinnerstein is a lawyer and hotelier who first came to Miami Beach in the winter of 1940, when he was five years old. At the time, his family owned the Stevensville Hotel in the Catskills; later they owned several Miami Beach hotels.

Judy Nelson Drucker was born in New York and moved to Miami Beach when she was eight years old. As a teenager she sang at the Latin Quarter; in 1945 she graduated from Miami Beach High. In 1967 Drucker founded the Concert Association of Florida, a cultural force that has

brought countless performers—Luciano Pavarotti, Plácido Domingo, and Mikhail Baryshnikov among them—to South Florida stages.

Angelo Dundee was born in Philadelphia in 1923. With his brother, Chris Dundee, he founded Miami Beach's Fifth Street Gym. For more than twenty years, he worked as Muhammad Ali's trainer; he also trained Jimmy Ellis, Sugar Ray Leonard, and George Foreman. Dundee has served as a television sports commentator, and in 1994 he was inducted into the International Boxing Hall of Fame.

Marvin Dunn was born in Deland, Florida, in 1940 and moved to Miami in 1950. Throughout the 1950s he assisted his mother, who worked as a maid in Miami Beach, and his father, who worked as a gardener. Dunn is now an associate professor of psychology at Florida International University.

Howard Engle is a pediatrician who moved to Miami Beach from Chicago in 1947. He practiced medicine on the Beach for more than fifty years.

Dixie Evans was born in 1926. A Marilyn Monroe look-alike once billed as "the sensation of the nation, hotter than the hydrogen bomb," Evans worked as a stripper in Miami Beach from 1954 to 1960. Her life story was featured in the 1998 documentary film *The Unveiling*. She is now the curator of Exotic World, a burlesque museum in Helendale, California.

Sissi Perlman Feltman was born in Miami Beach in 1934 and spent much of her childhood at Joe's Broadway Deli, an eatery her parents owned from the 1930s to the 1950s. Feltman taught first grade at North Beach Elementary, the same school she attended as a child.

Ray Fisher moved to Miami Beach from New York in 1940 and graduated from Miami Beach High in 1943. He is an award-winning photographer whose work has appeared in *Time, Life, Forbes, Sports Illustrated, Playboy,* the *New York Times,* and the *Miami Herald.* In 1989 Lincoln Center honored him with an exhibition of his work, entitled "Focusing on the Performing Arts." His photographs are in many collections, including those of the Museum of the City of New York, Indiana Historical Society, Jewish Museum in New York, and Historical Museum of South Florida.

Levi Forte was a professional heavyweight boxer who trained at the Fifth Street Gym in Miami Beach and competed in more than seventy fights. He has worked as a doorman at the Fontainebleau Hotel since the early 1960s.

Honey Bruce Friedman worked as a stripper—using the stage name Hot Honey Harlow—in Miami Beach from the mid-1940s to 1951. From 1951 to 1959 she was married to comedian Lenny Bruce, who called her his "red-haired shiksa goddess." She died in 2005.

Norman Giller was born in 1918 and moved from Jacksonville, Florida, to Miami Beach in 1929. A fellow of the American Institute of Architects, he is one of Miami Beach's most recognized postmodern architects. He is also a banker and civic leader with ties to the Jewish Museum of Florida and the City of Miami Beach Design Review Board.

Prince George Gordon was born in Miami in 1928. He worked as a handyman, driver, and cook in Miami Beach during the 1940s and 1950s. His father, Nathaniel Gordon, worked for Miami Beach pioneer Carl Fisher.

Jerry Grant was born in Toronto in 1928. He moved to Miami Beach in 1950 and has operated Gerry Grant Productions, a talent agency, in South Florida ever since. His client list has included Don Rickles, George Jessel, Redd Foxx, and Rodney Dangerfield.

Shecky Greene is a comedian and actor who performed in Miami Beach from the late 1940s through the 1960s. Along with stand-up comedy, his acting credits include *Tony Rome, The Love Machine, Laverne & Shirley, Roseanne,* and *Mad About You.* He was born in Chicago in 1926.

Leroy Griffith moved from Missouri to Miami Beach in 1960. For more than forty years, he has owned and managed strip clubs in Miami Beach, including the Paris, Roxy, and Gaiety Theaters.

Maida Heatter has been described by the *New York Times* as "the doyenne of desserts, queen of cookies, and sultana of sweets." She is the author of ten best-selling cookbooks, including *Maida Heatter's Book of Great Desserts.* Born in New York in 1916, she moved to Miami Beach in the mid-1940s with her parents. Her father, Gabriel

Heatter, was one of America's most respected radio commentators, known for his trademark opening line, "Ah, there's good news tonight."

Peggy Helfond is a real estate broker who moved to Miami Beach from Michigan in the early 1960s. Before getting into real estate, she worked as a cocktail waitress at the Versailles, Newport, and Shoremede Hotels.

Iona Holmes was born in Tampa in 1908 and moved to Miami in 1936. During the 1930s and 1940s, she worked as a hotel maid in Miami Beach.

Richard Jacobs is retired a financial planner. He was born in New York in 1939 but moved to Miami Beach when he was one month old. His father, Walter Jacobs, built Miami Beach's Lord Tarleton Hotel.

Stuart Jacobs was born in 1929 and moved from Cleveland, Ohio, to Miami Beach in 1934. He is an insurance agent.

Sydney Josepher moved to Miami Beach from New Jersey in 1934, when he was in the fifth grade. He graduated from Miami Beach High, where he served on the school's newspaper staff. He has worked as seafood wholesaler and stockbroker.

Hank Kaplan, a 2006 inductee to the International Boxing Hall of Fame, is one of the most respected boxing historians in the United States. For more than twenty years, he worked as a public relations consultant for Angelo Dundee at Miami Beach's Fifth Street Gym. The founder of *Boxing Digest,* Kaplan owns the largest private boxing archive in the world. He was born in Brooklyn and has lived in Miami since 1945.

Joseph Kaplan has lived in Miami Beach since 1953. Originally from Chicago, he is a labor attorney who represented Miami Beach hotel employees during their 1955 strike.

Herbert Karliner was born in Germany in 1926. He was one of 937 Jewish refugees aboard the SS *St. Louis* when it tried to dock in Miami after being denied entry to Cuba in 1939. Karliner moved to Miami Beach in 1948 and has worked as a baker in the hotel industry.

Hal Kaye was born in New York in 1927 and moved to Miami Beach when he was a few months old. He has

worked as a painter, sculpture, woodworker, and photographer.

Scott King was born in Miami Beach in 1950. His family has owned and operated Martin King Jewelers in Miami Beach since 1938.

Edythe Schindler Klein moved from New York to Miami Beach in the late 1930s and lived there off and on for more than twenty-five years. She has worked as a journalist and magazine editor.

Everett M. Lassman has worked as a restaurateur, lawyer, and stockbroker. He moved to Miami Beach in 1946, when he was fifteen years old, and spent his teens eating a lot of corned beef sandwiches. His father, Edward Lassman, was one of the original four owners of Wolfie's delicatessen.

William Lehman moved to Miami Beach from Alabama in 1936. He served as a Florida congressman, representing South Florida's Northeast District from 1973 to 1993. He also served as chair of the House Appropriations Committee and was a member of the Transportation Appropriations Subcommittee. He died in 2005.

Belle Lehrman is the wife of the late Rabbi Irving Lehrman, founder of Miami Beach's Temple Emanu-El. She has lived in Miami Beach since 1943.

Bennett M. Lifter is an attorney, general contractor, and real estate developer who has owned and managed several Miami Beach hotels, including the Marco Polo and Waikiki. Born in Pennsylvania in 1925, he moved to Miami Beach in 1936 and has lived in the Miami area ever since.

Sheila MacRae is an actress and comedienne. Born in London in 1925, she first came to Miami Beach in 1946 with her husband, singer Gordon MacRae. Years later she performed at the Fontainebleau Hotel. Her acting credits include *I Love Lucy*, *The Ed Sullivan Show*, and *The Jackie Gleason Show*; in the latter, she played Alice Kramden.

Al Malnik is a restaurateur, a title loan lender, and an entertainment attorney whose clients have included Lou Walters, Frank Sinatra, Sammy Davis Jr., Jackie Gleason, and Don Rickles. He was born in Missouri and moved to Miami Beach in 1959. He has owned the Forge restaurant in Miami Beach since 1968.

Rose Marie is an actress and comedienne who was born in New York in 1923. As a child she had her own radio show and starred in a film with W. C. Fields. She is best known for her role as Sally Rogers on *The Dick Van Dyke Show*, but she has also been celebrated for her performances in *Gunsmoke*, *The Bob Cummings Show*, *Call Me Madam*, *Bye Bye Birdie*, and *Kojak*. She performed in Miami Beach in the late 1940s and 1950s.

Mac McSwane was born in Kentucky in 1921 and moved to Miami Beach in 1954. He began working as a bellhop at the Fontainebleau Hotel on the day it opened in 1954, and he continued to do so until a few days before his death in 2005. He had a minor role playing himself in the Jerry Lewis film *The Bellboy*.

Mark Medoff won a Tony Award for his 1980 play *Children of a Lesser God* and an Obie Award for his 1973 play *When You Comin' Back, Red Ryder?* He is the author of more than twenty-five plays and ten movies, including *City of Joy*. He was born in Illinois in 1940 and lived in Miami Beach from 1949 to the early 1960s.

Irving Miller is a lawyer, land developer, and hotelier who moved to Miami Beach from Massachusetts in 1951.

Sheldon Miller is a real estate broker who wintered in Miami Beach as a child in the 1940s. He moved to Miami Beach from New York in 1951, and from 1956 to 1960 he produced the Miss Miami Beach beauty pageant.

Jack "Murf the Surf" Murphy lived in Miami Beach during the 1950s and 1960s, working as a pool boy, tennis pro, and dance instructor. In 1964 he pulled off the largest jewelry heist in history when he broke into New York's Museum of Natural History and stole the 563-carat Star of India sapphire. After serving two years in prison, he returned to Miami Beach. In 1968 he was convicted of first-degree murder and served another nineteen years in Florida prisons. Today he is the director of Bill Glass Champions for Life, a prison ministry service.

Paul Nagel was born in 1926 and moved from Monticello, Florida, to Miami Beach in the early 1930s. For fifty years he served on the faculty of the University of Miami Communications Department. He also has worked as a disc jockey, radio host, and documentary filmmaker. Nagel is the author of *A Shaygets in Paradise,* an autobiographical novel set in Miami Beach.

June Levy Newbauer moved to Miami Beach in 1926 when she was just a few weeks old. She has worked in real estate management. Her father, Henry Levy, was one of the Beach's early pioneers who developed the towns of Surfside and Normandy Isle.

Ferdie Pacheco was born in Tampa, Florida, and has lived in Miami since 1952. He is a doctor, a writer, an artist, and a television boxing analyst. For fifteen years he served as the "fight doctor" of Miami Beach's Fifth Street Gym, caring for Muhammad Ali and other champs. In 1989 Pacheco won an Emmy for his work as producer and reporter of *The Championship 1964.* He is the author of several books, including *Muhammad Ali: A View from the Corner.*

Cliff Perlman is an attorney who came to Miami Beach from Philadelphia in 1947. In 1951 he bought a tiny hot dog stand at Forty-first and Collins and later transformed it into Lums, an international chain with more than 300 locations. He has also owned the Caesar's Palace hotels in Las Vegas and Atlantic City.

Enid Pinkney was born in Miami in 1931. She has worked as a teacher, guidance counselor, school principal, and community preservationist. Her parents, Lenora and Henry Curtis, worked as domestic servants in Miami Beach from the late 1920s through the 1950s.

Frank Pinkney was born in Miami in 1933. As a child he worked as a shoe-shine boy in Miami Beach, and for many years he owned an auto transport business. He is married to Enid Pinkney.

Hope Pomerance is an actress who moved to Miami Beach from New York in 1947. Her late husband, Rocky Pomerance, served on the Miami Beach Police Department for more than twenty-five years, first as a beat cop and later as chief of police.

Howard Rapp is a partner in Charles Rapp Enterprises, a New York talent agency founded by his late uncle, Charlie Rapp, in 1935. Charles Rapp Enterprises represented many entertainers who performed in Miami Beach.

Ruth Regina is an award-winning professional makeup artist and hair stylist who has worked in Miami Beach since 1948. She served as the director of hair and makeup for the *Jackie Gleason Show,* and her many clients have included Judy Garland, Sophie Tucker, Lena Horne, Frank Sinatra, Sammy Davis Jr., Jerry Lewis, Elvis Presley, and the Beatles.

Robert Reilly was born in Chicago in 1916 and moved to Miami Beach in 1923. For more than forty years, he operated his family-owned Miami Beach Awning Company.

Janet Reno served as U.S. attorney general for nearly eight years during the Clinton administration. Prior to that she served as state's attorney for Dade County, Florida. She was born in Miami in 1938.

Rose Rice moved to Miami Beach from Rhode Island in 1948 and has lived there ever since. She is the owner of Rose Rice & Associates, an advertising agency in Sunny Isles.

Paul Rosen moved to Miami Beach from New York in 1951, when he was twenty-one. He has worked as a salesman and real estate developer.

Kay Rosenfeld was born in New York and moved to Miami Beach in 1950. In 1958 she graduated from Miami Beach High, where she served as the features editor for the school newspaper. She has worked as a court reporter and writes the "Bubbe Says" advice column for the *Miami Herald.*

Bernie Rosenfield moved to Miami Beach in 1931. For more than thirty years, he worked as a service manager at Red Top Sedan and Yellow Rent-a-Car.

Burnett Roth moved to Miami Beach a few months after he was born in 1912. He is a civil rights attorney who practiced law in Miami Beach for more than forty years.

Robert E. Rubin is director of Citigroup Inc. Born in New York in 1938, he moved to Miami Beach in 1947 and

graduated from Miami Beach High in 1956. He spent twenty-six years at Goldman Sachs before becoming director of the White House National Economic Council in 1993. From 1995 to 1999 he served as the U.S. Treasury secretary in the Clinton administration.

Ofelia Ruder was born in Cuba in 1928 and moved to Miami Beach in 1961. She has worked as an office manager at Temple Beth Shmuel Cuban Hebrew Congregation in Miami Beach since 1962.

Celia Sandys is the granddaughter of Sir Winston Churchill. She is the author of *Churchill: Wanted Dead or Alive*, *From Winston with Love and Kisses*, and *Chasing Churchill*, a book that traces the British prime minister's travels around the world, including his 1946 vacation in Miami Beach.

Don Sebastian is a comedian who has performed at many Miami Beach venues—including the Nautilus, Albion, Fontainebleau, and Aztec—for more than thirty years. He also appeared on *The Jackie Gleason Show*. He was born in Brooklyn in 1928 and has lived in South Florida since 1953.

Stanley Segal moved to Miami Beach in 1925, when he was five years old. His father, Morris Segal, founded Segal Safety Cabs, one of the first taxicab companies in the area. For more than forty years, Stanley operated several companies in Miami Beach, including Red Top Cab, Greyhound Bus, Yellow Cab, and Yellow Rent-a-Car.

Bert Sheldon is a comedian and singer who worked as the entertainment director for the Fontainebleau Hotel in the 1960s.

John Shepherd is a contractor who was born in Miami Beach's Mount Sinai Hospital. His father, Sonny Shepherd, was a theater manager for the Wometco theater chain in Miami Beach from the 1930s to the 1970s.

Harry B. Smith was born in 1926 and moved to Miami Beach from Pennsylvania in 1941. He is an attorney with the law firm of Rudin, McLuskey.

Jim Snedigar is an insurance agent who was born in Miami Beach in 1924. His father, Louis "Red" Snedigar, served four terms as mayor of Miami Beach before being elected to the Dade County Commission.

Kay Stevens is a singer and actress who performed during the 1950s and 1960s at many Miami Beach venues, including the Fontainebleau and Eden Roc Hotels. She was born in Pittsburgh in 1939.

Tempest Storm is a stripper who worked in Miami Beach off and on for more than twenty years, starting in the late 1950s. She was born in Georgia in 1928 and is the author of *Tempest Storm: The Lady Is a Vamp*.

Stella Suberman was born in Union City, Tennessee, the setting for her memoir, *The Jew Store*. She moved to Miami Beach in 1933, when she was eleven years old, and lived there until the mid-1940s. She has worked as a museum director and book reviewer and is the author of *When It Was Our War: A Soldier's Wife on the Home Front*.

Jaime Suchlicki is director of the Institute for Cuban and Cuban-American Studies at the University of Miami. He was born in Cuba in 1939 and moved to Miami Beach in 1960. He is the author and/or editor of many books, including *Cuba, Castro, and Revolution*.

Buffalo Tiger is a Miccosukee Indian who was born in 1920 and raised in the Florida Everglades. From 1962 to 1984 he served as tribal chairman of the Miccosukee Tribe of Florida. Together with Harry A. Kersey, he wrote *Buffalo Tiger: A Life in the Everglades*.

Joseph L. Wessel was conceived in Miami Beach but born in Iowa. His mother took him back to Miami Beach in 1926, when he was just a few weeks old, and he lived there until 1958. He has worked as a fireman, singer, and corporate sales manager.

Dudley Whitman is a filmmaker, pilot, and surfing aficionado who patented the world's first underwater camera. He was born in Miami Beach in 1920. His father, William Whitman, was one of the Beach's early pioneers and an associate of Carl Fisher and John Collins. William played an important role in the development of Miami Beach's Espanola Way and owned several of the Beach's early hotels.

Stanley Whitman moved to Miami Beach in 1918 from Evanston, Illinois, when he was just a few months old. He is a real estate developer who created the Bal Harbour Shops, a luxury mall built on the grounds of a

former POW camp. He is Dudley Whitman's older brother.

Leonard Wien was born in 1909 and lived in Miami Beach from the 1930s until his death in 2004. One of the founders of Miami Beach's Mount Sinai Hospital, he built three South Beach hotels—the Tudor, Kent, and Palmer House—and was a local civic leader and philanthropist.

Jerry Wittels moved to Miami Beach from Oklahoma in 1951, when he was twenty-six years old. He is a hotelier who has been associated with many Miami Beach hotels, including the Deauville, Sherry Frontenac, Casablanca, Vanderbilt, and Eden Roc.

Jeanne Wolf was born in New York and moved to Miami Beach when she was a child. She attended Miami Beach High during the 1950s and started her journalism career at Miami's public television station. She is one of America's leading entertainment reporters, contributing to *Entertainment Tonight, CNN, Nightline, Access Hollywood, The View, US Weekly,* and *Redbook.* Her father, Joe Hart, owned several Miami Beach restaurants, including Pickin' Chicken.

Woody Woodbury is a comedian and actor who was born in Minnesota in 1924. He moved to South Florida in 1946 and performed at many Miami Beach hotel nightclubs during the 1940s and 1950s. From 1962 to 1963 he hosted the TV quiz show *Who Do You Trust?,* and in 1964 he starred in the film *For Those Who Think Young.*

Bunny Yeager was born in Pennsylvania and has lived in Miami since the late 1940s. She started her career as a beauty queen and model, then moved behind the lens. In 1953 she was proclaimed the "World's Prettiest Photographer," and in 1959 she was named one of the top ten women photographers in the United States by the Professional Photographers of America. Best known for her cheesecake photos of Bettie Page, Yeager has photographed countless models and *Playboy* Bunnies.

Burton Young moved to Miami Beach from Philadelphia in 1940, when he was twelve years old. He is an attorney who specializes in family law and commercial litigation. In 1969 he became the first Jewish president of the Florida Bar Association.

Shirley Zaret moved to Miami Beach from Philadelphia in 1940. She fell in love with a soldier stationed in Miami Beach during World War II, and they were married for more than fifty years. She has worked as a secretary, waitress, boutique owner, and full-time mother.

Selected Bibliography

Armbruster, Ann. *The Life and Times of Miami Beach*. New York: Knopf, 1995.

Bass, Jo Ann, and Richard Sax. *Eat at Joe's: The Joe's Stone Crab Restaurant Cookbook*. New York: Clarkson, Potter, 1993.

Bergreen, Laurence. *Capone: The Man and the Era*. New York: Simon & Schuster, 1996.

Bruce, Honey, with Dana Benenson. *Honey: The Life and Loves of Lenny's Shady Lady*. Chicago: Playboy Press, 1976.

Buchanan, Edna. *The Corpse Had a Familiar Face*. New York: Random House, 1987.

Capitman, Barbara. *Deco Delights*. New York: E.P. Dutton, 1988.

Dunn, Marvin. *Black Miami in the Twentieth Century*. Gainesville: University Press of Florida, 1997.

Greenbaum, Andrea, ed. *Jews of South Florida*. Lebanon, NH: University Press of New England, 2005.

Hack, Richard. *Puppetmaster: The Secret Life of J. Edgar Hoover*. Beverly Hills: New Millennium, 2004.

Hatton, Hap. *Tropical Splendor: An Architectural History of Florida*. New York: Alfred A. Knopf, 1987.

Henry, William A. *The Great One: The Life and Legend of Jackie Gleason*. New York: Doubleday, 1992.

Kanfer, Stefan. *Ball of Fire: The Tumultuous Life and Comic Art of Lucille Ball*. New York: Knopf, 2003.

Kefauver, Estes. *Crime in America*. London: Victor Gollancz, 1952.

King, Larry. *Tell It to the King*. New York: G.P. Putnam's Sons, 1988.

Kleinberg, Howard. *Miami Beach: A History*. Miami: Centennial Press, 1994.

Kofoed, Jack. *Moon Over Miami*. New York: Random House, 1955.

Lacey, Robert. *Little Man: Meyer Lansky and the Gangster Life*. Boston: Little, Brown, 1991.

Lapidus, Morris. *Architecture of Joy*. Miami: E.A. Seemann, 1979.

Lavender, Abraham D. *Jews, Hispanics, Blacks, and Others in Miami Beach*. Miami: Florida International University, 1992.

———. *Miami Beach in 1920*. Charleston: Arcadia, 2002.

Levy, Shawn. *Rat Pack Confidential: Frank, Dean, Sammy, Peter, Joey and the Last Great Show Biz Party*. London: Fourth Estate, 1999.

MacRae, Sheila, and H. Paul Jeffers. *Hollywood Mother of the Year: Sheila MacRae's Own Story.* New York: Carol, 1992.

Nash, Eric P., and Randall C. Robinson Jr. *MiMo: Miami Modern Revealed.* San Francisco: Chronicle Books, 2004.

Pacheco, Ferdie. *Muhammad Ali: A View from the Corner.* New York: Birch Lane, 1992.

Parks, Arva Moore. *Miami: The Magic City.* Miami: Centennial Press, 1991.

Redford, Polly. *Billion-Dollar Sandbar.* New York: E.P. Dutton, 1970.

Suberman, Stella. *When It Was Our War: A Soldier's Wife on the Home Front.* Chapel Hill, NC: Algonquin, 2003.

Index

About the Author

Joann Biondi has worked as a flight attendant, college professor, newspaper reporter, and travel writer. She began her journalism career at the *Miami Herald,* where she started out writing obituaries— a less-than-glamorous job that turned out to be perfect training for eventually interviewing living, breathing people.

Along with ten books, she has published more than 100 articles in national newspapers and magazines, including the *New York Times, USA Today, National Geographic Traveler, Islands,* and *Travel & Leisure.* Although she writes on many topics, her favorite subject is people. In the past fifteen years, she has interviewed more than 1,000 people from all walks of life, including presidents, prime ministers, musicians, artists, writers, dancers, farmers, fishermen, chefs, scientists, airline pilots, native Indian chiefs, Zen masters, ship captains, athletes, and housewives.

© MARIA LAYACONA

Subjects of her magazine profiles have included singers Jimmy Buffett, Celia Cruz, and Ziggy Marley; Nobel Prize–winning authors Derek Walcott and Isaac Bashevis Singer; Jamaican Prime Minister Michael Manley; U.S. National Security Advisor Zbigniew Brzezinski; and Pulitzer Prize–winning authors Herman Wouk and James Michener.

Biondi lives in Miami, where she has taught at Miami Dade College and Florida International University. A strong believer in the value of oral histories as a way of preserving memories and documenting a soon-to-be forgotten sense of place, she also operates a writing service dedicated to ushering personal stories into print. For more information about Biondi, visit www.your-story.net.